JUN
2012

Flip Video™ FOR DUMMIES®

by Joe Hutsko and Drew Davidson

WILEY

Wiley Publishing, Inc.

Flip Video™ For Dummies®

Published by
Wiley Publishing, Inc.
111 River Street
Hoboken, NJ 07030-5774

www.wiley.com

Copyright © 2010 by Wiley Publishing, Inc., Indianapolis, Indiana

Published by Wiley Publishing, Inc., Indianapolis, Indiana

Published simultaneously in Canada

For general information on our other products and services, please contact our Customer Care Department within the U.S. at 877-762-2974, outside the U.S. at 317-572-3993, or fax 317-572-4002.

For technical support, please visit www.wiley.com/techsupport.

Wiley also publishes its books in a variety of electronic formats. Some content that appears in print may not be available in electronic books.

Library of Congress Control Number: 2010934749

ISBN: 978-0-470-87916-0

Manufactured in the United States of America

10 9 8 7 6 5 4 3 2 1

WILEY

Dedication

Both authors wholeheartedly dedicate this book to Sue Godfrey.
"You said . . ." :-)

Authors' Acknowledgments

Both authors would like to thank agent, Carole Jelen, of Waterside
Productions; and awesome project editor, Nicole Sholly, for her intelligent
guidance, brilliant organization, incisive editing and, above all, tremendous
wit and generous sense of humor. Thank you, Nicole!

About the Authors

Joe Hutsko is the author of *Green Gadgets For Dummies, Macs All-in-One For Dummies,* 2nd Edition, and *The Deal: A Novel of Silicon Valley.* For more than two decades, he has written about computers, gadgets, video games, trends, and high-tech movers and shakers for numerous publications and Web sites, including *The New York Times, Macworld, PC World, Fortune, Newsweek, Popular Science, TV Guide, The Washington Post, Wired,* GameSpot. com, MSNBC, and Salon.com. Before becoming a writer, Joe worked at Apple from 1984 to 1988. You can find links to Joe's stories on his Web site, JOEyGADGET.com.

Drew Davidson purchased his first film camera at a garage sale (an 8mm Kodak Brownie) and has since enjoyed all types of home and professional filmmaking. That first purchase opened the door to the wide world of film-making: from editing to camera work, from stop motion animation to documentary *cinéma vérité,* from complex computer-controlled motion control cameras to cameras duct taped to his mountain bike on his many mountain biking forays around the world. As a professional editor and cameraman, some of Drew's credits include *Nightmare Before Christmas, James and the Giant Peach,* and MTV's *Celebrity Deathmatch.* Clients he's worked with include GameSpot.com, Time Inc., The American Museum of Natural History in New York, The New York Historical Society, the Intrepid Air and Space Museum, and the National Building Museum in Washington, D.C. His video work is represented by Getty Images, and his full body of work can be viewed at www.drewmovie.com.

Publisher's Acknowledgments

We're proud of this book; please send us your comments at http://dummies.custhelp.com. For other comments, please contact our Customer Care Department within the U.S. at 877-762-2974, outside the U.S. at 317-572-3993, or fax 317-572-4002.

Some of the people who helped bring this book to market include the following:

Acquisitions, Editorial

Project Editor: Nicole Sholly

Acquisitions Editor: Amy Fandrei

Senior Copy Editor: Teresa Artman

Technical Editor: Claudia Snell

Editorial Manager: Kevin Kirschner

Editorial Assistant: Amanda Graham

Senior Editorial Assistant: Cherie Case

Cartoons: Rich Tennant
(www.the5thwave.com)

Composition Services

Project Coordinators: Katherine Crocker, Patrick Redmond

Layout and Graphics: Samantha K. Cherolis, Joyce Haughey, Kelly Kijovsky

Proofreaders: Susan Hobbs, Lauren Mandelbaum

Indexer: Sherry Massey

Publishing and Editorial for Technology Dummies

Richard Swadley, Vice President and Executive Group Publisher

Andy Cummings, Vice President and Publisher

Mary Bednarek, Executive Acquisitions Director

Mary C. Corder, Editorial Director

Publishing for Consumer Dummies

Diane Graves Steele, Vice President and Publisher

Composition Services

Debbie Stailey, Director of Composition Services

Contents at a Glance

Table of Contents

Part IV: Editing and Sharing Movies with Mac and Windows Programs 147

Introduction

*Y*our Flip is probably the easiest-to-use camcorder in the world. Just point, shoot, and copy to your computer. A few clicks later, friends, family, and even strangers around the world can view your creations on Facebook, MySpace, YouTube, and other sharing Web sites. Burning your movie to a DVD so that others can watch it on TV or their computer is nearly as quick and easy as the online sharing options. So why, you might wonder, would anyone need a whole book for such an easy-to-use gadget? Let me count the ways. . . .

About Flip Video For Dummies

Options, baby, options. Sure you can shoot and upload your video in a few clicks. By editing your video and adding titles, credits, special effects, and a music soundtrack, however, you can make your movie more interesting to others. You'll see how to do that in this book. Want to capture individual snapshots from your videos and then string those pictures together to create photo slideshows? It's in here. Wondering how to upgrade your Flip's internal software *(firmware)* and desktop FlipShare program so you benefit from the latest and greatest features? It's in here.

And while you're mastering those things, you'll also pick up tips and tricks for capturing and editing your videos, thanks to the expert advice the filmmaker-half of the author duo's contribution to this book, which will help you get the very most from your Flip camcorder.

Here are some of the things you can do with this book:

- Learn about the features unique to each of the current Flip camera models.
- Find out how to properly connect (and disconnect) your Flip to (and from) your computer.
- Import your videos to your computer, share your videos online, or burn your videos to DVDs that you can give to others.
- Turn your simple video clips into fuller, richer mini-movies, complete with titles, rolling credits, and music soundtracks.
- Install free updates to ensure that your Flip camera and the FlipShare program give you the latest and greatest features.
- Learn simple expert tips to help you take your best shots — and edit those shots so they're interesting to your views.

Foolish Assumptions

In writing this book, we made a few assumptions about you, dear reader. To make sure we're on the same page, I assume that

- ✒ You know how to turn your computer on and locate and run programs.

- ✒ You can navigate your computer to store (and later find) files.

- ✒ You have a favorite Web browser and are familiar enough with navigating the Web to download a file, such as a program update installer file, and can then open that file.

- ✒ You appreciate the speed at which technology-based products — such as the Flip camera — change, with newer, sleeker, better, faster models replacing previous versions in as little as a few months.

Conventions Used in This Book

To help you navigate this book, we use a few style conventions:

- ✒ Emphasized terms or words are *italicized* (and defined).

- ✒ Web site addresses, or URLs, are shown in a special monofont typeface, like this: `www.joeygadget.com`.

- ✒ Numbered steps that you need to follow and characters you need to type are set in **bold**.

What You Don't Have to Read

You don't have to read anything that doesn't pertain to what you're interested in. In fact, you can even skip a chapter entirely. We hope you don't, though, because we believe that reading every chapter can make your overall reading experience more efficient and (dare I say it?) enjoyable.

As for sidebars you encounter throughout this book, feel free to ignore them because they contain, for the most part, tangential thoughts, miniature essays, or other bits of information you don't need to know to do the things we show you in the book.

How This Book Is Organized

Flip Video For Dummies is split into five parts. You don't have to read it sequentially, and you don't even have to read all the sections in any particular chapter. You can use the Table of Contents and the index to find the information you need and quickly get your answer. Here is what you'll find in each part.

Part 1: Getting to Know Your Flip

This part is all about getting comfortable with your pocket-sized camcorder — or learning about one you're thinking of buying if you don't already own a Flip. You can read about the latest Flip camera models, how to adjust your Flip's settings, and how to upgrade FlipShare. Troubleshooting information is also contained in this part.

Part 11: Putting Your Flip to Work

Using your Flip involves two activities: Shooting videos and transferring the videos you shoot to your computer. In this part, you'll dive right in and start recording videos with your Flip while picking up tips to help you capture the best shots possible. Here's where you find out how to transfer the videos you shoot to your Mac or Windows PC.

Part 111: Creating and Sharing Movies with FlipShare

Sure, you can share your video clips with others exactly as they appear, but your intended audience will find your videos way more interesting if you trim out boring parts and add movie-like elements like a title, a music soundtrack, and even closing credits that crawl up the screen when your viewers come to The End. Taking center stage in this part is the FlipShare program, which you use to create Magic Movies and Full Length movies and send your movies (and snapshots!) as e-mail messages and greeting cards. You also see how to burn your movies to DVD and upload movies to Facebook, MySpace, and YouTube.

Part 1V: Editing and Sharing Movies with Mac and Windows Programs

Editing your clips using your Mac or Windows computer's free video-editing program (iMovie or Windows Live Movie Maker) is how you turn your more serious moviemaking dreams into realities. In this part, you'll perform movie magic by turning your video clips into fuller, richer movies that boast the look and feel of movies you see at the Cineplex.

Part V: The Part of Tens

If you're looking to stabilize your Flip (out of the box, it lacks *image stabilization*) or take your editing to the cutting edge, the Part of Tens has the information you need. Here, you'll find lists of shooting tips and editing tips.

Icons Used in This Book

The icons you encounter throughout *Flip Video For Dummies* are tiny road signs to attract or steer your attention to particularly useful information — or, in rare instances, potential trouble.

The Tip icon points out useful information that can help you be more efficient or direct you to something helpful that you might not know about.

When you spot this icon, it steers your attention to something that's interesting or useful; either way, you'll want to read it. And remember it.

When you see the Warning icon, you know to proceed with caution in regard to a topic, an issue, or a series of steps that it's cozying up next to.

Where to Go from Here

If you recently purchased a Flip camera or you're thinking about purchasing one, Part I is definitely the best place to begin using this book. Parts II and III have the nitty-gritty details for shooting footage with your Flip as well as creating a masterpiece with FlipShare. But if you've been there and done all that and you're ready to get more serious about this movie-making business, head straight to Part IV and jump in to video editing with Windows Live Movie Maker or iMovie. At any time, feel free to turn to the Part of Tens section to pick up expert tips that aim to improve your video shooting and editing skills, and to find great add-ons to help you enhance your Flip experience in more ways than one (actually ten, but who's counting?).

Part I
Getting to Know Your Flip

In this part . . .

A few years ago, shooting your own videos involved wrangling bulky camcorders and juggling cumbersome videotape cassettes — not to mention extra batteries you had to carry to keep your camcorder juiced throughout the day. Thanks to the Flip, those days are gone (at least for us everyday folks who just want to have fun shooting and editing videos).

This part introduces you to the Flip phenomena that has millions of consumers literally flipping over Flip cameras. You start out with a big-picture view of what it means to Flip; then you zoom in for a closer look at Flip models. You also get the 411 on adjusting your Flip's settings, as well as upgrading your Flip and FlipShare software so they can be all that they can be, thanks to regular free updates that you can download and install.

Touring Flip Models and Features

In This Chapter

▶ Considering the big Flippin' picture

▶ Getting acquainted with current Flip features and specs

▶ Taking a closer look at the SlideHD

▶ Designing your own custom SlideHD or MinoHD

▶ Installing FlipShare on your Mac or Windows PC

Got a new Flip (or an older model) and want to find out what it can do so you can put it to good use? Or perhaps you're thinking about buying a new Flip, but you're not sure which model to choose?

Either way, you've come to the right place to get up to speed about what you can do with the Flip camcorder you already own — or the one you're thinking about purchasing.

From getting your head around the bigger picture of what Flips are all about, to wrapping your hand around individual models and figuring out which buttons do what and what features you can use, this chapter marks the best place to begin your journey into the world of Flip camcorders.

Flipping Over Flip Video

Here a Flip, there a Flip, everywhere a flippin' Flip. Or that's how it seemed to me when my editor asked whether I wanted to write this book. When I said yes, I was suddenly seeing Flip camcorders everywhere. From the local news replaying winter storm footage captured by ordinary Joes to *American Idol* contestants hamming it up on those excursions they take between episodes, everywhere I looked, people were Flipping.

So what makes the Flip so ubiquitous (and the reigning #1 bestselling no-brainer camcorder brand on Amazon.com for more than a year, as I write this)? That's simple: simplicity. Apple's iPod has enjoyed a longtime reputation as one of the world's easiest-to-use gadgets ever (and it is), but the Flip camcorders are even easier to use.

Never before has shooting and making movies been so easy. Point, shoot, save, edit (or don't bother), and share. Just like that, you're making movies.

Thanks to the Flip's small size and super-easy controls, carrying a Flip on your person and spontaneously capturing videos wherever and whenever you want becomes second nature. Don't like what you captured? No big deal; just delete it and try again.

I could go on and on about why Flip camcorders are so attractive and popular to ordinary people, in a way that their predecessors — videotape-based video cameras — never were. I could also list the ways that Flips are a bigger hit with more of us average Joe-types than the higher-end "prosumer" camcorders that capture video at quality high enough to make movies that play in theaters and film festivals. But why waste precious space and time going over what was and what isn't. The fact is that you're holding this book, and that's evidence enough that you're more interested in focusing your energy on doing the Flip thang. Time to get Flippin'!

Familiarizing Yourself with the Flip Way

Turning something that starts as an idea into a reality — be it sculpting a heart-shaped modeling clay teacup, or writing a book about Flip video cameras — typically begins with getting familiar with the tools or implements you can use that are best suited to your task at hand. The next step is discovering how you can use those tools and implements to construct and produce a tangible creation to share with others.

When it comes to creating and sharing movies with your Flip camcorder and your computer — the *Flip Way,* if you will — your tools and the ways you can use them include

- **Directing and shooting:** Your Flip camera aimed at someone or something that interests you is all you need to start capturing video footage that you can eventually turn into a movie and share with others. What, when, where, why, and how you capture video footage with your Flip is up to you. Want to make a movie of your puppy's first tussle with a tennis ball? Go for it.

- **Managing and editing:** Your Mac or Windows computer and the FlipShare program that comes preloaded on your Flip camera provide the basic tools you use to manage and edit videos you capture and then

copy to your computer. Using video-editing programs that offer greater flexibility and more features than FlipShare (like iMovie [Mac] and Windows Live Movie Maker) allows you to enrich your movie with special touches, such as transition effects between shots or rolling credits at the end of your movie that crawl by just like the ones you've seen on the big screen.

✏ **Producing and sharing:** Shooting and editing a movie that plays to an audience of one — that'd be you — has its rewards, but the fun really begins when you share your Flip movies with friends, families, co-workers, and even strangers. Producing your movie and then sharing it with others quickly and easily is, for many Flip owners, the ultimate reward in this journey known as the Flip Way. You can share the movie as a DVD that you can hand to someone to play on her DVD player or computer; or send your movie as a birthday e-mail greeting card; or upload your movie using the free Flip Channel feature on the Web; or post your movie to one of the other popular Web-based venues, such as Facebook, Twitter, YouTube, and MySpace.

Flipping through Flip Models

When I mention the Flip line of camcorders, I'm referring to the models available as I write this book. Those models, and the length of recording time each offers, include the following:

SlideHD	240 minutes
MinoHD (two models)	60 minutes
	120 minutes
UltraHD	120 minutes
Ultra	120 minutes

I refer to these models throughout this book, explaining obvious and not-so-obvious stuff on a need-to-know basis: factoids like how the letters *HD* on some models stand for high-definition (or hi-def), and how most fully charged Flip models (except the SlideHD) will never run out of battery juice before you run out of shooting space on the Flip's built-in memory because the camcorder's battery life lasts longer (from 2 to 4.5 estimated hours) than the actual length of time you can capture live video footage.

Now and then I also talk about earlier Flip models, including one you might own. To ensure we're on the same proverbial page, I give you a fuller run-down of specs and features in the next section so you can determine what your current Flip model can or cannot do, and so you can weigh the pluses and minuses of those models against the current models in case you're considering buying a used or new Flip camcorder.

Key specifications and features

Each Flip model is built with particular features and specifications. Some models have many of these features in common, and other models might not have some of these features.

Here are the features you'll find on Flip models as of this writing:

- ✔ A **video camera and microphone** for recording video and audio that are saved in video files on your Flip camera's built-in memory.

- ✔ An **LCD display** that acts as a

 • *Live viewfinder* to show you what you're capturing when you press the Record button so you can properly frame what you're shooting.

 • *Playback display* so you can watch videos recorded and saved on your Flip, or existing video files copied from your computer to your Flip.

- ✔ **Control buttons** for turning your Flip on and off, recording video, controlling video you watch on the Flip's display, zooming in and out, increasing and decreasing playback volume, and deleting video files you don't want to save.

 In the case of the SlideHD, these "buttons" aren't actual physical buttons you push, but rather simulated buttons that appear on the 3-inch touchscreen when the screen is closed. The buttons disappear when you slide up the screen to view videos you recorded and saved with your SlideHD.

- ✔ A **USB connector** that "flips" out at the press of a latch, so you can plug the connector into your Mac or Windows computer to copy files between your Flip and your PC. The USB connector also charges the Flip when plugged into a computer or an optional AC charger adapter.

- ✔ Preloaded **FlipShare installation software** for Windows and Mac computers, so you can install the FlipShare program on almost any computer you plug your Flip into.

Understanding Flip model technical specifications and how they benefit (or if they're absent, don't benefit) your Flip experience can help you determine what your current Flip can do, or what a new Flip you're thinking about buying can do.

Like with most high-tech gadgets (except when discussing weight), higher numbers typically translate to higher performance and capacity (which in turn translate to higher prices). When it comes to Flip models, higher technical specification numbers translate to higher-quality video recordings and more storage space for saving videos. These technical specifications and other features for current models include

- ✔ **Memory capacity** and estimated number of minutes of video you can record and save (4GB, 8GB, or 16GB of memory to capture 60, 120, and 240 minutes of video, respectively)

- ✔ **Camera resolution,** which is the level/quality of the video footage: standard-definition (SD) 640 x 480 pixels (px) on the Ultra, and HD 1280 x 720 px on all other models

- ✔ **Display screen diagonal size and resolution,** for viewing live video that you're recording or watching video that you've recorded and saved

 Display screens range in size from 1.5 inches and 176 x 132 px to 3 inches and 400 x 240 px.

- ✔ **Microphone type** (stereo versus mono)

- ✔ **Built-in speaker** (stereo speakers on SlideHD only)

- ✔ **Headphone jack** (SlideHD only)

- ✔ **Battery capacity and type** (2-hour internal battery for SlideHD, Mino, and MinoHD models versus a 2.5–4.5-hour, replaceable, rechargeable battery pack for Ultra and UltraHD models)

- ✔ **Video-out port** (HDMI or composite type)

- ✔ **Tripod mount**

- ✔ **Other video-related specs** that I don't detail at length:

 - Video sensor type
 - Light sensor type
 - Video performance processor
 - Frame rate (30 frames per second for all models)
 - Bit rate
 - Video format (H.264 video compression, AAC audio compression, and MP4 file format for all models)
 - White balance/exposure (automatic white balance and black level calibration; automatic exposure control with dynamic exposure compensation for all models)
 - Lens type
 - Aperture
 - Zoom (smooth multistep 2x digital for all models)

Reviewing the latest Flip models

Models come and go like the seasons, and the best way to find out which models are in and which are out is to visit the Flip Web site (www. flipvideo.com).

The Ultra and Ultra HD as well as the two MinoHD models distinguish them-selves from one another (and from the SlideHD) in these ways:

- **MinoHD models:** The smallest of Flip's camcorder models, the MinoHD slips easily into your pocket and features an almost completely smooth, button-less electrostatic surface with smooth "buttons" that respond to your touch much like a notebook computer touchpad (except for the big red Record button in the middle, which is a good ol'-fashioned push-button). The MinoHD's rechargeable battery is sealed inside, which means you can't carry a spare or two for extra battery life when you're out and about, nor can you replace the battery yourself when it even-tually wears out. For that job, you must send the camera to Flip for a replacement (for a price, of course). The 1-hour model has a 1.5-inch screen, and the 2-hour model has a 2-inch screen and is a few hairs thicker than the 1-hour model.

- **Ultra and Ultra HD:** The Ultra is the only SD model, which means it captures video at a lower resolution in a 4:3 format, whereas the UltraHD and other Flip models capture 16:9 widescreen-format HD video. The Ultra comes with two standard AA batteries, and you can buy an optional AA rechargeable battery pack that comes as standard equipment with the UltraHD. The Ultra and UltraHD are the bulkiest Flip models, have 2-inch screens, can record up to 2 hours of video, and have physical buttons instead of the button-less electrostatic buttons found on the MinoHD models, or the totally smooth touchscreen surface found on the SlideHD.

The most exciting new features in the world of Flip can be found on the new SlideHD model:

- The world's first "slider" camcorder comes with a slide-up 3-inch touch-screen that displays virtual buttons on the screen, and slides up to reveal a slider bar for browsing through videos with your fingertip.

- Tap the touchscreen to choose the video you want to watch.

- Hear recorded audio via built-in stereo speakers (albeit tiny ones) or by plugging headphones into the SlideHD's headphone jack.

- You can record up to four hours of video — the longest recording time for any Flip model.

- A Space Saver feature lets you shrink the file size of videos you copy into FlipShare, and then copy back up to 12 hours worth of those Space Saver-compressed videos to your SlideHD.

The standout features that separate the SlideHD from the rest of the Flip pack — a wide-format touchscreen, headphone jack, Space Saver — are features that I'm guessing we'll see on most if not every future Flip model. Hopefully, future models will come with longer-lasting batteries and lower prices as the number of new and innovative features go up!

Designing your own MinoHD or SlideHD

You can buy a Flip camera from a number of retail stores and online retailers. If you're thinking about buying a MinoHD or SlideHD, you can choose a custom case design from a huge gallery of designs available on the Flip Video Store Web site (http://store.theflip.com) for either of those two models.

You can also create a custom design by using the Pattern Generator feature, or you can upload an image of your own, such as a favorite photograph, or your favorite book jacket artwork (as shown in Figure 1-1).

The Flip Video Store offers a huge selection of predesigned sports, celebrity, and designer themes you can choose to customize your SlideHD or MinoHD. If you're in a giving mood, you can choose one of many Flip for Good themes, and a portion of your purchase price is donated to a nonprofit charity. Flip for Good theme choices include LIVESTRONG and Stand up to Cancer,

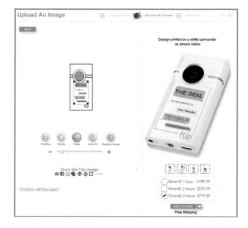

Figure 1-1: Apply the image of your choice to your Flip's exterior.

Feeding America and the World Food Programme, Polar Bears International, The Truth Fund, and a slew of other charitable causes, as shown in Figure 1-2.

Here are the basic steps you take to create your very own, custom SlideHD or MinoHD case design at no extra cost:

1. **Go to http://store.theflip.com and click the SlideHD or MinoHD model you want. Then click the Select button to choose that camera.**

2. **Click one of the custom case design options (Design Gallery, Use Your Own Image, Use the Pattern Generator).**

3. **Follow the prompts to choose a design, or upload your own image, or use the pattern generator to create a new design, depending on your choice in Step 2.**

4. **Click the Add to Cart button and then continue to the checkout process to purchase your custom-designed Flip camera.**

5. **Wait 2 to 7 business days for your new Flip to arrive (depending on your shipping service choice), and then resume reading this book — or continue reading, anyway, so you can get familiar with all the ways you'll use your Flip.**

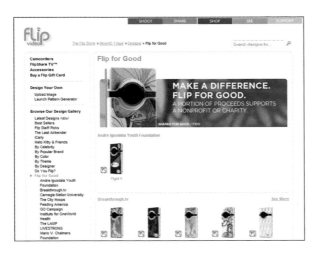

Figure 1-2: Choose a Flip for Good theme to decorate your Flip.

Your customized design is printed using an industrial-strength coating and curing process that protects your Flip's special finish from humidity, sun exposure, and the wear associated with handling your camera. Although your Flip's custom finish won't peel or fade, it can show scratches if you expose your Flip to scratchy surfaces (or bear claws — the animal kind, and not the hairstyle).

Installing FlipShare

When you plug your Flip camera into your computer for the first time, your Flip's preloaded FlipShare installer program automatically launches itself and prompts you to install the FlipShare program. A few clicks later, and *voilà!*, you've installed FlipShare on your computer.

Wait a minute: It just occurred to me that I might be telling you something you already know. As in, *Hello?! Been there, done that! Earth to Mr. Author!? There are movies to be made!* Okay, it's more than a little bit likely you might have already installed the FlipShare program on your computer. If so, my sincere apologies for slowing your creative flow. By all means, feel free to skip this FlipShare installation business if you've already been there, done that.

If you haven't already installed FlipShare (or if you have, but you want the complete lowdown on the ways and means by which you can acquire, run, and update the FlipShare installer program), please continue reading.

Wondering whether the FlipShare installer program preloaded on your Flip is the latest and greatest version known to man, woman, and child? Have no fear: When you run FlipShare, it automatically checks for updates. If a newer

version is available, a prompt appears, asking whether you'd like to update your FlipShare program to the latest version, as shown in Figure 1-3.

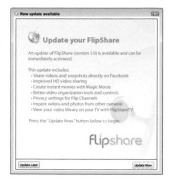

You can also download the latest version of the FlipShare program from the company's Web site whenever you want. For your Mac or Windows computer, go to www.theflip.com/support and then skip ahead to Step 3 in the following set of steps. To read more about staying up to date with the latest FlipShare program updates, check out Chapter 3.

Figure 1-3: FlipShare automatically checks for updates when you run it.

Lucky for me, FlipShare looks, feels, and functions the same way whether you're running the Mac or Windows version of the program, which translates to fewer step-by-step instructions for me to write. (And lucky for you, you won't have to endure any of that fruitless Macs-versus-PC mine's-better-than-yours rhetoric that gets lobbed back and forth between loyalist on either side of the divide.)

Sure, there are a few subtle differences between the Mac and Windows versions of FlipShare — for instance, whether you access the Preferences menu by choosing File⇨Preferences (Mac) or Edit⇨Preferences (Windows). Teensy variances aside, you can use the FlipShare program's multitude of features regardless of which version you run. That means you'll rarely see separate sets of steps for one version or the other. When pointing out those differences, I indicate as much by wrapping the platform of interest with parenthesis, like so: (Windows) and (Mac). This way, you see immediately whether you need to carry out a particular step (or steps) based on the platform you use or whether you can skip ahead to the next step that matches your version of the FlipShare program.

To run the FlipShare installer program that's preloaded on your Flip camcorder, follow these steps:

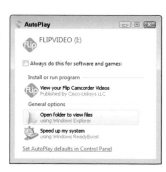

1. **Plug your Flip camcorder into one of your computer's unused USB ports.**

 If you're using a Windows computer, the AutoPlay dialog box appears, as shown in Figure 1-4. If you're using a Mac, a Finder window appears.

 If you don't see the Windows AutoPlay dialog, your computer's AutoPlay options probably aren't set the way they should be

Figure 1-4: The AutoPlay dialog appears when you plug in your Flip to a PC.

to follow along with the steps in this book. To reset your Windows AutoPlay settings,

 a. Go to Start⇨Control Panel⇨AutoPlay.

 b. Scroll to the bottom of the AutoPlay Control Panel window.

 c. Click the Reset All Defaults button.

 2. **Click Open Folder to View Files (Windows) or skip to the next step if you're using a Mac.**

 3. **Double-click the Setup FlipShare icon (Windows; proceed to Step 4) or the Start FlipShare installer icon (Mac; then skip to Step 5).**

The User Account Control dialog box appears (Windows).

 4. **Click the Continue button.**

The FlipShare splash screen appears, and then the User License Agreement dialog box appears.

 5. **Click the I Agree button to accept the FlipShare User License Agreement.**

The Setting up FlipShare progress gauge appears at the bottom of the FlipShare splash screen while the installation program progresses, as shown in Figure 1-5.

When the installation is complete, a message appears, informing you that you must reboot your computer (Windows) to complete the installation. Mac users can continue to Step 7.

 6. **Click the Exit button (Windows) to close the dialog box.**

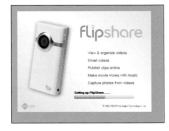

Figure 1-5: FlipShare installation in action.

 7. **If you're prompted to restart your computer to complete the installation, quit any other programs you're running, and then restart your computer.**

Note: If you recorded video with your Flip even before you installed FlipShare, FlipShare may automatically launch itself after you restart your computer. In Chapter 5, I show you how to choose what action you want your computer to automatically carry out — such as launch FlipShare — whenever you plug in your Flip.

No matter which method (preloaded or downloaded) you choose or which version of the FlipShare installer program you run (Mac or Windows), the desired result stays the same: getting this business of installing the FlipShare program to your computer's hard drive out of the way, so you can now focus on more creative endeavors — like making movies!

Adjusting Flip Settings

In This Chapter

▶ Accessing Flip settings options

▶ Choosing your language, and setting the date and time

▶ Turning on the Flip recording light and sound tones

▶ Activating the Flip Delete Lock option

*M*aking electronic devices work exactly how you want them to work can be a tedious and aggravating task. You might have to sort through many menus and fiddle with many settings — and even then, you might not achieve the results you want. To adjust the settings on simpler high-tech gizmos — like your Flip camcorder — is an easy task, though. In a matter of seconds, you can access and change the Flip's settings and then be on your merry way to record video or take a run on the beach (or both).

In this chapter, I describe the Flip camcorder settings options and show you how to access and adjust them. I also show you how to turn on (or off) a setting to help prevent you from accidentally deleting videos you capture.

Getting Acquainted with Flip Settings

Your Flip camcorder has only a handful of settings that you can change when you access the settings setup feature — simply press and hold the Record button when you turn on your Flip. These settings include

➤ **Set Language:** Choose the language Flip uses to present textual information on the display.

➤ **Set Date:** Set the month, day, and year so that videos you record and copy to your computer are automatically organized into folders with names matching the dates when you captures those videos.

✏ **Set Time:** Set the time so that videos you shoot and copy to your computer are labeled with the time that you shot those videos.

✏ **Tones:** Toggle on if you want to hear a sound when you turn your Flip on, off, or press any of its buttons, or toggle the Tones setting off if you don't want to hear a single peep (er, beep) from your Flip at all.

✏ **Recording Light:** Toggle on if you want a red light hidden beneath the front grill to appear. This lets subjects know when you're recording them. Toggle the Recording Light setting off if you're playing spy and you don't want to draw attention to the fact that you're shooting on the sly. "Smile! You're on *Candid Camera*!"

✏ **Save Settings:** Save changes you made to any of the preceding settings so your Flip remembers those settings.

Flip offers a Delete Lock option that can help prevent you from deleting videos you captured by requiring you to verify that you actually want to trash the video. This is a great option, but you won't find it with the other settings that I discuss in the next section. I talk about turning the Delete Lock option on or off in the section "Activating the Flip Delete Lock Feature" near the end of this chapter.

Making Flip Options Suit Your Taste

Your Flip's settings options automatically appear when you turn on your Flip the first time. After that, to access your Flip's settings options, simply press and hold the Record button when you turn on your Flip. The first settings screen that you see is Set Language, as shown on the right in Figure 2-1. Flip settings options screens are arranged like a stack of flash cards, one after another, in the following order: Set Language, Set Date, Set Time, Tones, Recording Light, and Save Settings.

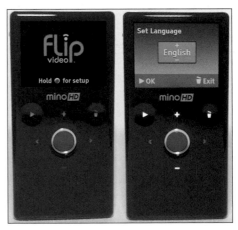

Figure 2-1: Press and hold Record at startup to access Flip settings options.

If you're the proud owner of a Flip SlideHD camera, adjusting settings on your camcorder doesn't require you to jump through every hoop like the other models, thanks to the SlideHD's touchscreen display. To adjust your SlideHD's settings, slide open the widescreen display, press the Menu button at the far right of the slide strip, and then press Settings to display the Settings pane. Adjust your SlideHD's every setting option to your heart's delight.

So even if you want to change only one settings option — such as the time of day, when daylight saving time rolls around, for instance — you still have to step through those first two settings screens to reach the Set Time screen. The good news is that you'll never have to cruise through more than five settings options screens to adjust and save (or skip changing) your Flip's settings before you're able to get right back to the business of shooting your first blockbuster.

To change your Flip's settings options, follow these steps:

1. **If your Flip is on, press the Power button to turn off your Flip.**

2. **Press and hold the Record button. Then press the Power button and continue to hold the Record button.**

 The Flip Video startup screen appears for a moment, followed by the Set Language screen (refer to Figure 2-1).

3. **Press the Up (+) or Down (–) button to scroll through a list of language choice options to find the one you want. Then press Play to choose that language.**

 Alternatively, if you'd like to accept the default language and move on to the next setting, press Play.

 At any screen, you can press the Exit button to exit the settings. The Save Settings screen appears, and you can choose to save any changes (by pressing Play) or ignoring any changes (by pressing Cancel).

 Press Play, and the Set Date screen appears.

4. **Adjust the date to match today's date by pressing the following buttons:**

 - Left (<) and Right (>) to move the green highlight to the month, day, and year fields

 - Up (+) and Down (–) to change the values in the green highlighted field, such as the day field.

5. **Press Play to move to the Set Time screen.**

6. **Press the Up, Down, Left, and Right buttons as described in the previous step to move the green highlight and adjust the hour, minute, and AM or PM values to match the current time, and then press Play.**

 The Tones screen appears. (Tones are the sounds your Flip camera makes when you turn it on or off, start or stop recording, or press buttons to change settings options, just as you are right now.)

7. **Press the Left or Right button to choose On or Off (see Figure 2-2), and then press Play.**

 The Recording Light screen appears. (The recording light gives others a visual cue that you're capturing their every move on video. If you don't want to make others self-conscious — or you don't want others to even know you're shooting them — you can turn off the recording light.)

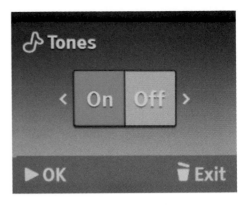

Figure 2-2: Choose to turn tones off or on.

8. **Press the Left or Right to choose On or Off (see Figure 2-3), and then press Play.**

 The Save Settings screen appears.

9. **Press Save to save any setting options you changed, or press Cancel to ignore any changes you made but don't want to keep.**

 If you choose to save your settings, a Settings Saved screen appears for a moment, and then the live camera view appears. You're ready to start recording new videos, or watching videos you already recorded and saved on your Flip.

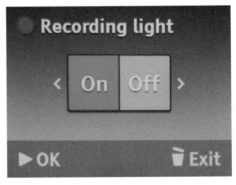

Figure 2-3: Turn the recording light on if you want to give people a cue that you're recording them.

Here's the drill if you later access settings to make changes. If the date (or any settings option screen) is already set how you want, press Play to keep that setting and advance to the next setting options screen. When you press Delete to exit the settings, the Save Settings screen appears (as usual), and you can save (Save) or ignore (Cancel) any changes you've made.

Activating the Flip Delete Lock Feature

One of your Flip's buttons is the Delete button. As its tiny trash can label suggests, pressing the Delete button is how you erase a video file (or files) from your Flip's memory.

You typically delete a video file from your Flip because the shot was a dud and you don't want (or can't stand) to watch the video file anymore, or because you already transferred a copy of the video file to your computer and you want to make room on your Flip's memory storage to capture new video footage by deleting the video file (or files).

As a person who uses a computer, I'm betting you've probably dragged a picture, document, song, or video file to your computer's desktop recycle bin that you didn't really want to get rid of. The next time you wanted to open the file and it wasn't where you expected to find it, you took a big breath, double-clicked the recycle bin, and — hallelujah! — there it was, a mere mouse click away from potential oblivion.

Your Flip doesn't have a recycle bin to root around in to retrieve video files you deleted by accident or on purpose. However, pressing the Delete button does prompt your Flip to ask whether you're sure you want to delete the currently displayed video file (or all the video files stored on your Flip), as shown in Figure 2-4.

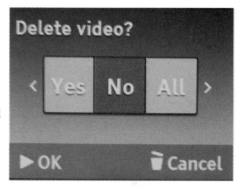

A very considerate feature indeed. But there's a second, even more-thoughtful setting you can turn on that packs a sort of one-two are-you-sure-you're-really-really-sure? protection-against-accidental-erasure called the Delete Lock feature.

Figure 2-4: An ounce of prevention can prevent accidental deletions.

Unlike your Flip's date, time, and other settings that you change in the settings options screens described in the previous pages, the Delete Lock setting is one you might never stumble upon unless someone tells you about it (insert small bow here).

Simply put, the Delete Lock feature forces you to unlock the Delete button before you can press it again to delete the file you want to delete. The extra second it takes you to unlock the Delete button causes you to think twice before you press the Delete button again, minimizing your chances of deleting a file you didn't really want to get rid of (and minimizing the likelihood of you cursing or hurling your beloved little camcorder against the wall if it had made deleting files quicker and easier).

And now, without further adieu (drumroll, please), by completing the following steps with your powered-on Flip in your hand and your thumb at the ready, you can activate your Flip's Delete Lock feature — which, not so incidentally, may potentially wind up protecting you (and those closest to you from acts of digital destruction or bodily harm to the Flip and/or anyone unfortunate enough to be on the receiving end if the gadget goes flying).

1. **Press and hold the Delete button until the `Delete Locked` message shown on the left in Figure 2-5 appears.**

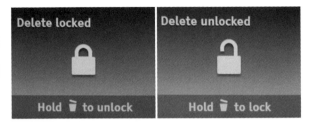

Figure 2-5: You can toggle Delete Lock.

A moment later, the live camera view reappears.

When you press the Delete button to delete a video file you're viewing, the `Delete Locked` message appears, preventing you from actually deleting the file (or files) until you unlock the Delete Lock feature.

2. **Press and hold Delete until the `Delete Unlocked` message appears (shown on the right in Figure 2-5).**

A moment later, the live camera view reappears.

When you press the Delete button to delete a file you're viewing, the `Delete Video?` screen appears (refer to Figure 2-4). Press the Left or Right buttons to choose Yes, No, or All, and then press Play to make your choice. You can also press the Delete button again to cancel your choices and return the display to the live camera view.

In Chapter 4, I show you how to delete individual videos — or every video on your Flip camcorder in one fell swoop. Before you delete videos on your Flip, make sure you've copied any videos you want to save to your computer first — which is exactly what I show you how to do in Chapter 5.

3

Maintaining, Upgrading, and Troubleshooting Your Flip

In This Chapter

▶ Upgrading your Flip's firmware and FlipShare

▶ Tackling Flip camera troubles

▶ Plugging in to better power and battery practices

▶ Solving FlipShare program problems

▶ Understanding online sharing sticklers

▶ Erasing your Flip and restoring setup files

*W*hat good is a book all about a high-tech gadget if there isn't at least one mainly technical chapter to satisfy the inner geek in most of us? If finding solutions to remedy when not-so-great things happen to otherwise well-behaved gadgets like your Flip and the FlipShare program you run on your computer, you've come to the right place.

In this chapter, you find the no-frills rundown on updating your Flip camera's internal, hard-wired software (or *firmware*) and making sure that the FlipShare program you run on your Mac or PC is the very latest version available. (FlipShare provides the basic tools you use to manage and edit videos that you capture and then copy to your computer.) And stay tuned for explanations and answers for many common questions when your Flip or the FlipShare program isn't working the way it's supposed to, as well as a few tips about rechargeable batteries and disposable battery options.

So pack your shirt pocket with your pen holder, secure that broken bow to your eyeglasses with a few good turns of Scotch tape, grab your Jolt Cola, and let's get techie.

Updating Your Flip Video and FlipShare Software

When you run the FlipShare program, it automatically checks for updates. If a newer version is available, a prompt appears, asking whether you'd like to update your FlipShare program to the latest version, as shown in Figure 3-1. Postpone upgrading by clicking Upgrade Later; update immediately by clicking Update Now.

Click your way through the successive prompts to update your FlipShare program — and if prompted, your Flip camera's internal hard-wired software as well. Or you can also download the latest version of the FlipShare installer program from the company's Web site whenever you want. To download the latest version of the FlipShare installer program for your Mac or Windows computer, visit www.theflip.com/support.

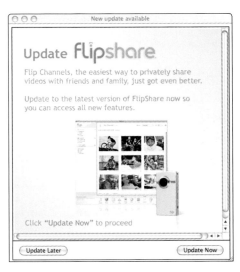

Figure 3-1: FlipShare software will prompt you to upgrade.

Responding to an Unresponsive Flip Camera

Some camera issues you might encounter aren't really problems at all but are just how some Flip features work. You see, certain features of the Flip camera are (like an angst-ridden teen vampire) misunderstood. To help you understand the difference between the two, this section discusses misunderstood features and real problems separately.

Manhandling misunderstood Flip features

You might encounter features that you hadn't realized your camera has or that you don't understand completely: "misunderstood Flip features," if you will. Although you might think of them as technical difficulties, they aren't problems per se. And when you become familiar with them, you'll see that they aren't even that difficult — just the normal functions of the camera. Here are the types of things I'm talking about:

✔ **The camera stops recording after one hour of continuous recording.** Flip cameras have a continuous recording limit of one hour, after which the camera stops recording, and you must press the Record button to continue recording up to another continuous hour of video.

So if you plan to set-it-and-forget-it, keep in mind you'll need to come back in an hour to press Record again to continue capturing your video.

✔ **The camera keeps turning itself off.** If your Flip is on and you're not watching a video or pressing any of your Flip's buttons, your Flip will shut itself off after 90–120 seconds of inactivity to save battery juice — which is a good thing, right?

✔ **A Camera Full message appears, or you have fewer recorded minutes available than you expected.** The exact number of minutes of video your Flip can capture may vary from the amount advertised, based on what you capture. For instance, capturing video with lots of fast-moving action and changes in lighting uses more of your Flip's internal memory, whereas capturing less action-packed, evenly lit videos uses less storage space.

As they say in the car business, your mileage may vary, but probably only by a few miles — er, minutes — as far as the actual number of minutes of video your Flip can capture and save. To free space on your Flip so you can capture more videos, delete any videos you don't want using your camera's delete feature. Or copy your videos to your computer and then choose the option to delete the videos from your Flip.

Tackling typical Flip troubles

This section covers a list of common hiccups with the Flip camera, and it provides the solutions so you don't have to do any heavy lifting.

Won't turn on/off

The Power button can seem finicky if you don't understand how it responds to your touch, which can also make it seem like the button isn't working when you want to turn your Flip off or on. Here's the deal:

✔ **On:** Press and let go of the Power button to turn on your Flip (assuming, of course, that the batteries are fresh or recharged).

✔ **Off:** Press and hold the Power button to turn off your Flip.

If your Flip doesn't turn on or off how it's supposed to, remove the batteries or rechargeable battery pack (if your Flip model allows you to open the back and access the battery) and then reinsert the battery. Then press the Power button to turn on your Flip. If your rechargeable Flip doesn't seem to hold a charge, check out the upcoming section, "Power and Battery Issues."

Resetting a frozen Flip camera

If your Flip is on and won't respond when you press any buttons or when you press and hold the Power button for a few seconds, press and hold the Power button for 10 seconds to restart your Flip.

Resetting your Flip SlideHD or Mino using the reset button

If pressing and holding the Power button for 10 seconds doesn't reset your Flip SlideHD or Mino, insert the tip of a straightened paper clip or a pin into the reset hole inside the camera's tripod mount, and press and hold the reset button for 5 seconds.

Won't record video when connected to TV

If pressing the Record button has no effect when you connect your Flip to your TV to watch saved videos on your Flip, disconnect your Flip from the cable connecting your camera to your TV if you want to capture new video.

Device removal warning when your Mac wakes from sleep mode

If your Mac goes into sleep mode while your Flip camera is still plugged in, the power supplied to your camera from your Mac's USB port might suspend. If that happens, you might see a device removal warning message (shown in Figure 3-2) when you wake up your Mac. To deal with this, unplug your Flip from your Mac's USB port, wait a few seconds, and then plug your Flip back into your Mac's USB port.

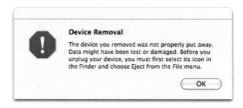

Figure 3-2: Unplug your Flip if you see this message.

Regaining full recording capacity

If you deleted some or all of your videos from your Flip camera, yet the available recording time seems too short despite the space you freed up, you can regain full recording capacity by following these steps:

1. **Plug your Flip camera into your computer.**

 (Optional) If you have any video or other files saved on your Flip that you want to save to your computer, copy the files to your computer's hard drive using FlipShare (or one of the other methods described in Chapter 5) before you continue, and then quit FlipShare.

2. **Open a new Windows Explorer (Windows) or Finder (Mac) window and double-click your Flip camera's icon. Then navigate to and open the folder where your Flip saves video files you record, as shown in Figure 3-3.**

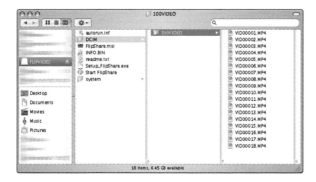

Figure 3-3: Find the video files on your Flip camera and delete them.

3. **Delete all the files contained in the folder and then empty the Recycle Bin (Windows) or Trash bin (Mac) to permanently delete the files from your Flip camera.**

 (Optional) If you saved any video files outside the 100VIDEO folder (which is the default), delete those other files, too.

4. **Safely eject and then unplug your Flip from your computer (see Chapter 5).**

5. **Press and hold the Power button to turn on your Flip, and then check the Time Left amount that appears at the bottom of the screen.**

 If the time displayed is equal or close to the prescribed recording time for your Flip model, you're ready to start capturing new videos. If the Time Left amount is not equal or nearly equal to the prescribed recording time for your Flip camera model, continue to the next step.

6. **Power your camcorder on and off eight times.**

Power and Battery Issues

Going beyond the basics of turning your Flip camera on and off as described in the previous section, your Flip might exhibit symptoms associated with power and battery matters. The most common battery-related problem is your Flip's rechargeable battery isn't charging. The following list shows the main reasons why your Flip's rechargeable battery might not be charging.

- ✔ **Your battery pack isn't properly inserted in the battery compartment (Ultra models only; the other Flip models come with built-in, non–user-replaceable rechargeable batteries).** Remove the battery compartment door and check to make sure the Flip Video logo on the battery pack is visible and facing right-side up.

- ✔ **The metal contacts are bent or obstructed, preventing the battery pack from making a firm connection with the contacts (Ultra models only).** Inspect the battery pack to ensure a snug fit between battery compartment and battery pack connection points.

- ✔ **Your computer switches to sleep mode when after a certain amount of inactivity time when your Flip is plugged in to one of your computer's USB ports.** Adjust your computer's energy saver settings so that your computer stays on long enough to charge your camera before it goes to sleep.

You can adjust your computer's power settings options to turn off your computer's display after a few minutes of inactivity to burn less energy while the computer stays on to recharge your Flip. On a Windows computer, choose Start⇨Control Panel⇨Power Options. On a Mac, choose ⌘⇨System Preferences⇨Energy Saver. Or better yet, consider buying an optional AC recharger to recharge your Flip instead of using your computer to charge your camera, if that's the only reason you're keeping your computer on for a few hours while you're not using it for anything else. (Read where to buy an AC recharger in Chapter 14.)

And here is a list of the top ten facts pertaining to Flip battery issues:

- ✔ **Flashing battery symbol:** When you see this symbol on the display screen, your battery power is too low and needs to be recharged. If you don't recharge, the camcorder will eventually turn itself off as the battery diminishes.

- ✔ **Time to fully charge:** Fully charging your Flip's rechargeable battery by plugging it into your computer's USB port can takes from 3–6 hours. Fully charging your Flip by using an optional power adapter can take roughly 2–3.5 hours.

Recharging your Flip camera by plugging it into your computer's USB port can take longer if you're running the FlipShare program, or another program that may be accessing your Flip camera, such as iMovie on the Mac, or Windows Live Movie Maker on a Windows PC. To speed up recharge time, quit FlipShare if you aren't working with it.

- ✔ **Unplugging after charging:** Although you can leave your Flip plugged in to your computer after a full charge, unplugging your camera after it's fully charged can help lengthen the lifespan of your Flip's rechargeable battery.

- ✔ **Partial battery discharge:** Flip models that come with rechargeable batteries use lithium ion–type batteries, which means you can partially

recharge your Flip's batteries anytime without the full charge or discharge cycle that older nickel-based batteries required to last long and provide maximum performance.

✔ When your Flip's battery is fully charged, you can expect the following battery life:

- *Mino, MinoHD, or SlideHD models:* Up to 2 hours

- *UltraHD model:* Up to 2.5 hours

- *Ultra model:* Up to 4.5 hours (when using the optional AA rechargeable battery pack, sold separately)

✔ **Standby time:** Standby time for fully charged rechargeable battery Flip models is generally up to three months before the camera's battery begins to discharge. However, it's not unusual to find the rechargeable battery completely depleted after three months of non-usage because of gradual (and normal) dissipation over time.

✔ **Charging symbol:** When recharging your Flip Ultra HD or Ultra (with optional rechargeable battery pack), the flashing battery charging symbol appears on your camera's screen. If you're using standard, nonrechargeable AA batteries with your Ultra HD or Ultra camera, the word Connected appears on the camera's screen.

✔ **Auto shutdown:** To conserve battery life, your Flip camera automatically shuts off after 90–120 seconds of inactivity, depending on your particular model.

✔ **Charging device temperature:** Your Flip might feel warm or hot to the touch when it's recharging, and the screen might periodically display the message It's getting hot. Charging paused. Your Flip does this automatically as a safety measure, pausing to allow the rechargeable battery to cool before it resumes charging. However, if you see the message Charging paused. Check battery pack, unplug your Flip from your computer or power charger and contact Flip technical support for assistance (phone: 1-888-222-6689; Web site: www.theflip. com/support).

Here are three battery-related tips to help you maximize your Flip experience:

✔ **Safe travels:** You can safely charge your Flip overseas by plugging it into the USB 2.0 port on any computer with those ports, or by plugging it into a worldwide charger that offers a USB 2.0 port interface option.

✔ **Charge time:** Depending on how often you use and recharge your Flip's rechargeable battery, the length of time the battery lasts after a full charge diminishes over time. Rechargeable batteries have a limited number of charge cycles and will eventually need to be replaced. Cisco states that your Flip's rechargeable battery has a lifespan of 500 charges.

 ✔ **Replacing your Flip's built-in rechargeable battery:** Cisco requires you to contact Flip Video support when it's time to replace your Flip's rechargeable battery. If your Flip is still within its 90-day warranty period, the company will replace defective rechargeable batteries. Otherwise, you must pay for your Flip's replacement rechargeable battery.

Resolving Common FlipShare-Related Problems

Sometimes FlipShare doesn't work the way you expect it to, but you need to know how to make the program for you. That's why I wrote this section. Here are some common FlipShare problems that you might encounter, as well as solutions you can try to resolve those problems.

Color Scheme changed to Windows Basic

When you run FlipShare, you might see the message The Color Scheme has changed to Windows 7 [or Vista] Basic. FlipShare takes it upon itself to change your Windows Vista or Windows 7 appearance settings when your Windows appearance settings are set to offer maximum visual beauty, which can drag down your system's performance — and that can make videos you watch using FlipShare appear to stutter rather than play smoothly.

Allowing FlipShare to automatically adjust your Windows appearance settings whenever you run it makes the program work faster and smoother, especially on slower, older computers, or lower-powered computers like netbooks.

To choose whether FlipShare automatically changes your Window's appearance settings, launch FlipShare and choose Edit➪Preferences➪Advanced. Then mark or clear the check boxes there to adjust the video performance-related settings how you want.

Your netbook screen cuts off FlipShare

The FlipShare program requires a minimal screen resolution of 1024 x 768, which means that most netbooks with a resolution of 1024 x 600 can't display the entire FlipShare program main window on their too-small screens. Some netbooks do offer a feature to magnify their screens to mimic a resolution of 1024 x 768, but the onscreen result is skewed and incorrect. One option is to connect your netbook to an external display that offers a resolution of 1024 x 768 or greater.

FlipShare preferences

To view and adjust FlipShare's preferences settings, choose Edit⇨Preferences (Windows) or FlipShare⇨Preferences (Mac) to display the FlipShare Preferences window shown in Figure 3-4. The FlipShare Preferences window contains some or all of the tabs described in this section. Simply click a tab to change the settings options displayed on it.

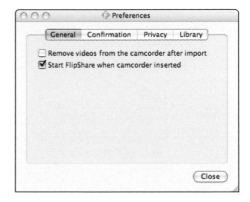

Figure 3-4: FlipShare Preferences menu on a Mac.

General tab

Find these settings on the General tab:

✏ **Start FlipShare When Camcorder Inserted:** Clear this option if you don't want FlipShare to automatically run when you plug your Flip camera into one of your computer's USB ports.

✏ **Ask Me About Saving Preferences Each Time:** Select this option if you want FlipShare to prompt you with the following choices whenever you copy video files from your Flip to your computer's hard drive.

- *Automatically Save Videos from the Camcorder:* Copies video files from your Flip to your computer's hard drive whenever you choose the Save to Computer option

- *Remove Videos from Camcorder After Saving:* Automatically deletes video files from your Flip after copying them to your computer, thus freeing up memory space on your Flip so you can shoot and save more videos

SlideHD tab (SlideHD only)

This tab appears in the Preferences window only when FlipShare identifies your camera as the SlideHD model. If you use more than one SlideHD with FlipShare on your computer, you can set the following preference options for each camera.

In the When Saving Videos to My SlideHD Camcorder section:

✏ **Use Space Saver (Use Less Memory):** Saves videos you copy from FlipShare to your SlideHD camera using the Space Saver format, which compresses the video file to a smaller size so you can store more videos on your SlideHD that you want to watch, but displays those videos at a lower quality resolution than the Original Size option

✔ **Use Original Size (Best Quality on Any Screen):** Saves videos you copy from FlipShare to your SlideHD without decreasing the file size or resolution quality

✔ **Let Me Choose the Format for Each Video:** Displays a dialog prompting you to choose Space Saver or Original Size whenever you copy a video from FlipShare to your SlideHD

Confirmation tab

In the Show a Dialog Before section, you can opt to display a confirmation dialog before carrying out any of the following actions so you can think twice before carrying out one or more of those actions:

- Saving Videos from the Camcorder
- Saving Video to the Camcorder
- Playing a Video in Full Screen Mode
- Deleting Items from Shortcuts

Privacy tab

In the Clear All Login Information section, you can opt to delete any saved login information (username and password) you typed in when you use the Facebook, MySpace, and YouTube online sharing options:

✔ **Clear Now:** Click the button (shown in Figure 3-5) to wipe out your login username and password information.

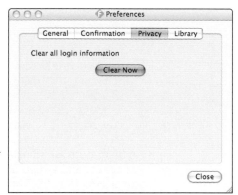

Advanced tab (Windows only)

On this tab, you can enable or disable Windows XP or Windows 7/ Windows Vista visual enhancement settings that can affect how smoothly FlipShare plays videos you watch when using the program. Clearing either check box (based on which Windows operating system you use) can improve how smoothly videos play in FlipShare on slower or

Figure 3-5: Use FlipShare Preferences menu to clear all login information.

lower-powered systems. If you have a super-fast Windows PC, you won't notice much or any difference if the options are unchecked.

✔ Use Windows XP's Standard Rendering Engine

✔ Use Windows Vista/Windows 7 Basic Color Scheme

Note: The Advanced tab appears only on the Windows Preferences window, and not on the Mac Preferences window.

Library tab

Here, you can find information about the size and location of your FlipShare Library, which is the folder containing all your FlipShare video and picture clips and any other files necessary to keep track of your FlipShare Library. You can also move the location of the Library. See Figure 3-6.

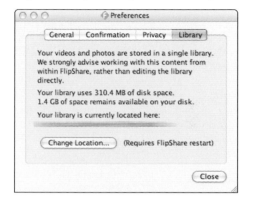

- **Change Location:** Click this button to choose a different location on your computer's hard drive than the one displayed above the button to store your FlipShare Library folder.

Choosing an external hard drive instead of your computer's built-in hard drive is one way to provide more storage space for copying and working with the many files in your FlipShare Library.

Figure 3-6: Find info about the size and location of your Flip videos.

Managing your FlipShare Library folder

Video files you copy from your Flip camera to your computer are stored in the FlipShare Library folder on your computer's hard drive. Video files are generally large in size, and (go figure) they take up a lot of space.

To find out how much space videos gobble up on your computer's hard drive, refer to the following general estimates:

- A 30-minute standard-definition (SD) video uses approximately 1GB of space, and a high-definition (HD) video of the same length uses approximately 2GB of hard drive space.

- A 120-minute SD video uses approximately 4GB of space, and an HD video of the same length uses approximately 8GB of hard drive space.

At some point, your hard drive might become so full it runs out of space for storing any more video files. To see how much hard drive space your FlipShare Library folder uses (and how much space remains on your hard drive for storing more files), open the FlipShare Preferences pane and click the Library tab.

If your hard drive is running low on remaining storage space, you can delete video files from your FlipShare folder by running FlipShare and then deleting the files you no longer want.

Deleting videos files from your Flip and computer

Videos saved on your Flip camera stay there until you delete them using the Delete button on your Flip, or you delete them from your camera using the FlipShare program. After they're deleted from both your camcorder and your computer, your videos are permanently erased and cannot be retrieved. If you delete a video from your FlipShare Library that you didn't mean to delete and if the video is still stored on your Flip camera, you can copy the video back to your computer (and vice versa).

To delete video files from your computer, go to your FlipShare Library folder on your computer and select the files that you want to delete. Right-click (⌘-click on a Mac) and choose either Delete (Windows) or Move to Trash (Mac, as shown in Figure 3-7).

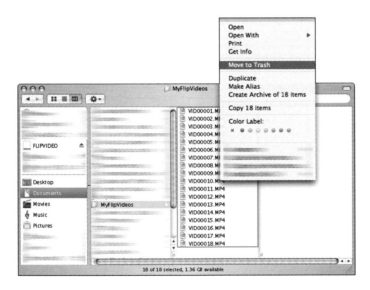

Figure 3-7: Deleting video files from your computer.

To delete videos from your camera, use the menu shown in Figure 3-8.

Moving the Library

Another option is to move your FlipShare Library to an external hard drive, with lots of available space on it for storing your existing FlipShare Library and plenty of room left over to store new video files.

Before you move your FlipShare Library to an external hard drive, monitor the Progress box in the lower-left corner to make sure FlipShare has completed any tasks that were in progress, such as copying video files from your Flip camera to your computer's hard drive or updating your Flip camera's software.

After you look at the Progress box and make sure that FlipShare isn't performing any tasks, follow these steps:

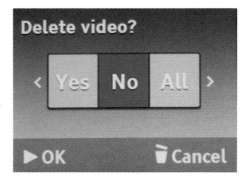

Figure 3-8: Deleting videos from your Flip.

1. **Choose Edit⇨Preferences (Windows) or FlipShare⇨Preferences (Mac) to open the FlipShare Preferences window.**

2. **Click the Library tab to display the Library Preferences pane.**

3. **Click the Change Library button to open the Browse for Folder button.**

4. **Locate the external drive where you want to relocate your FlipShare Library and then click OK (Windows) or Choose (Mac, as shown in Figure 3-9) to select the drive.**

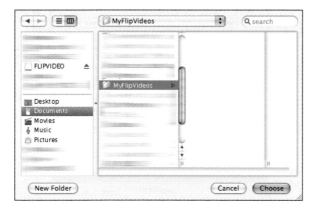

Figure 3-9: Choose a different location for your Library.

A progress dialog box appears and displays the status while FlipShare moves the contents of the FlipShare Library folder on your computer's hard drive to the external hard drive you selected.

Note: While FlipShare is moving the files, you won't be able to do any other tasks until FlipShare finishes moving the Library folder.

A message appears when FlipShare has finished relocating the FlipShare Library.

5. **Click the Close FlipShare button to close the dialog box and restart FlipShare.**

Online sharing issues

Sharing videos online through FlipShare is a snap. You simply choose Share⇨ Online and then choose your site (MySpace, YouTube, and so on; see Figure 3-10). Easy, right? Yes, but that doesn't mean you might not encounter a few common issues, such as these:

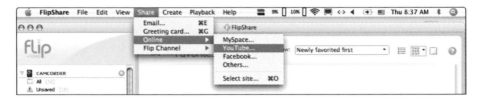

Figure 3-10: FlipShare makes sharing your videos with friends and family a snap!

- ✔ **E-mailed pictures and greeting cards appear as videos:** Pictures you share using the E-mail or Greeting Card sharing options appear as 10-second videos when your recipient views the e-mail or greeting card. Pictures played on a DVD you create play as 3-second videos when you watch the DVD. Weird, yeah, but that's how they appear.

- ✔ **The size limit of shared videos:** Videos that you share in e-mails, greeting cards, and Flip Channels are limited to 450MB or less in size, and you won't be able to upload anything larger than that size no matter how hard you kick, scream, or bite the wire connecting your computer to your broadband modem (or the air, if your connection is of the wireless variety).

- ✔ **Flip Channels that don't appear when you install FlipShare on a new computer:** Unfortunately, the Flip Channels you create on one computer don't show up in the FlipShare program you install on a new or different computer. Your only choice is to re-create your Flip Channels on your new or other computer.

- ✔ **Facebook videos time limitation:** Facebook wants to know as much as it can about you, and unless you fully complete the required fields in your account profile setup when you sign up for Facebook, videos that you upload are limited to 2 minutes of playtime even if your video is longer. Solution? Fill in the personal information and history data that Facebook wants on record, and then that oh-so-claustrophobic, 2-minute video length limit is history. Friend me?

Part II
Putting Your Flip to Work

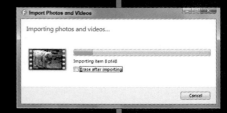

In this part . . .

Recording videos with your Flip camera is where the rubber meets the road. In this part, you see how to shoot video with your Flip, and you'll pick up some simple but effective tips that aim to help you capture the best-looking videos you can. You'll also learn about the ways you can delete videos that you don't want to keep so that you have room to capture more videos with your Flip — both on your Flip directly, or by deleting videos using the FlipShare program you run on your Mac or Windows PC.

Besides using FlipShare to copy videos from your Flip to your computer, you'll also discover other ways you can copy your videos from your camera to your computer, including just dragging and dropping your files the same way you do with other files on your computer's hard drive or any external storage device you might use.

Recording and Viewing Videos

*R*ecording videos with your Flip camera is as easy as pressing the big red Record button in the middle to start recording, and then pressing it again to stop. Watching videos that you record on your Flip is merely a matter of pressing the Play button to begin watching, and then pressing it again to pause. Don't like what you see? Press the Delete button to delete the video you're watching.

Doesn't get much easier than this. So why, you might wonder, an entire chapter dedicated to recording and viewing videos with your Flip? There's more than one way to answer that question. Like, did you know that if you hold the Play button on most Flip models, you can watch all your videos one after the other? Or that the video you're watching won't disappear if you accidentally press the Record button while you're watching your video?

In this chapter, I show you the obvious stuff, like how to record and watch videos with your Flip camera as well as how to delete videos you don't want to keep so you can free up space to capture more videos. I also give you tips that can help you capture the best-looking (and sounding) videos you can, and I show you how you can connect your Flip camera to a television so you can play your videos to a crowd of many instead of trying to crowd everyone around your Flip's tiny screen.

Getting in Touch with Your Flip's Buttons

Using your Flip camera to capture, view, and delete videos is pretty straightforward, thanks to easy-to-understand buttons which are probably instantly familiar to you. Besides the obvious-seeming primary things the Flip buttons do, most of the buttons provide a second purpose, depending on what you're doing and how you press the buttons. For instance, tapping the Play/Pause button begins playing or pausing a selected video, but pressing and holding the Play/Pause button for a few seconds activates the Play All feature, which plays every video saved on your Flip, one after another.

The following list describes all your Flip's buttons. Time to go get acquainted with what each button does:

- **Power:** Press to turn on your camcorder. Press and hold for a few seconds to turn off your camera.

- **Record:** Press to start or stop recording video.

- **Play/Pause:** Press to play a selected video. Press and hold to play all the videos saved on your Flip. Press while watching a video to pause the video.

- **Up** (+) and **Down** (–): When recording video, press Up to zoom in or press Down to zoom out. While watching a video, press Up or Down to increase or decrease the playback volume, respectively.

- **Delete:** Press to display the delete screen to delete a single video or all videos saved on your Flip camera. Press and hold to activate or deactivate the Delete Lock feature.

- **Left** and **Right:** Press Left to go backward to a previous saved video, and press Right to skip to the next saved video. (Pressing and holding either button quickly advances you forward or backward through all your saved videos.) When watching a video, press and hold Left or Right to rewind or fast forward, respectively; let go to resume watching your video.

If you upgraded to the Flip SlideHD from an earlier Flip model, your SlideHD buttons work like your older Flip camera's buttons — except, of course, that your Slide's buttons aren't actual physical buttons but rather "virtual buttons" that appear on your SlideHD's gorgeous 3-inch widescreen display. Your Slide also boasts the following additional controls and features not found in the other Flip models, including the following:

- **Widescreen:** When slid closed, the screen displays basic control buttons and a viewfinder screen. When slid open, it displays videos in widescreen mode and reveals the Slide Strip.

- **Slide Strip:** Slide your fingertip left or right to browse through videos saved on your Flip.

✓ **Menu:** Located to the right of the Slide Strip; tap to display the menu screen, which displays the following choices:

- *All Video:* Opens the default Camcorder Videos folder and displays the first video saved in that folder

- *Flip Channels:* Displays the first of any videos you share with others using the Flip Channels feature, which you set up using the FlipShare program on your Mac or Windows PC

- *Shortcuts:* Displays Favorites, Movies, and Photos that you drag and drop into those same-named folders using the FlipShare program on your Mac or Windows PC

Recording Videos

Recording video with your Flip camera is as easy as 1-2-3 (and 4), as I show you in the following steps. Before you record video, check your Flip's status display indicators to ensure that your camera is fully charged and that it has enough remaining recording time to capture the video you want to shoot. To check your Flip's battery charge level (or the remaining capacity if you're using disposable AA batteries with your Flip Ultra or UltraHD), press the Power button to turn on your Flip. On the display, as shown in Figure 4-1, note the following displays:

✓ **Ready:** In the top-left corner; indicates your Flip is ready to record video.

✓ **Battery:** In the lower-right corner; indicates your battery's charge level. If the battery icon is flashing, your batteries are too low and need to be recharged (or replaced if you're using disposable batteries with your Flip Ultra or UltraHD).

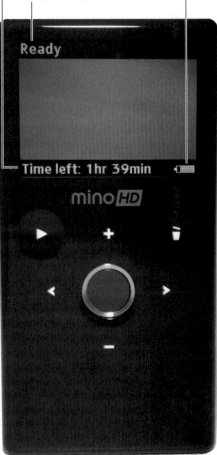

Look here to check your battery.

Recording time is shown here.

The Flip is ready to record.

Figure 4-1: The Flip will tell you how much time you have left on your batteries and how much video you can shoot.

✔ **Time Left:** In the lower-left corner; indicates how much remaining recording time is available for capturing and saving video.

The basics of shooting video

To record video, follow these steps:

1. **Press the Power button on the Flip to turn on your camera (if it isn't already on) and then point your camera's lens at whatever it is you want to shoot.**

 Use the display to frame your shot so you're sure to capture what you want to shoot.

2. **Press the red Record button to start recording.**

 You don't need to hold the Record button while recording.

 The red light on the front of your camera turns on to indicate that you are recording, and the time shown in red on the display increases to show the elapsed time for your recording as you continue to capture your video, as shown in Figure 4-2.

Figure 4-2: While recording, the Flip tells you how much you have recorded.

3. **(Optional) Press the Plus button to zoom in and the Minus button to zoom out.**

 The Zoom indicator appears when you use the Plus or Minus buttons and shows the zoom level as you zoom in or out, as shown in Figure 4-3.

 Your Flip remembers your zoom level setting after you stop recording and then start recording video again. To turn off the zoom feature, press the Minus button until the zoom level reaches the bottom of the Zoom indicator. Your Flip "forgets" the zoom level when you turn off your camera.

4. **Press the Record button again to stop recording.**

The Zoom indicator

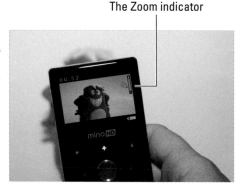

Figure 4-3 See whether you are zooming and how far.

While you're recording video with your Flip camera, remember that

- ✔ **Videos that you record are stored indefinitely.** The videos stay on your camera until you delete them, even if your camera's batteries completely run out. Your recorded videos will still be there when you recharge or replace your camera's batteries.

- ✔ **Your Flip camera can't record a new video over an existing video.** This means that you don't have to worry about accidentally recording new video over a video you captured and saved.

- ✔ **The `Camcorder Full` message appears on the display when there is no more remaining recording time to continue recording videos.** To make more recording time available, you can either delete some or all of the videos you captured but don't want to keep, or connect your camera to your computer and copy some or all of your captured videos to your computer's hard disk and then delete those videos from your camera to make room on your Flip to capture more videos.

- ✔ **Your Flip camera has a continuous recording limit of 1 hour.** After an hour, the camera stops recording and returns to Ready mode with no warning message or alert sound. To resume recording, you must press the Record button again to start recording a new video. The exception is the MinoHD model, which has a maximum recording capacity of 1 hour.

- ✔ **Your Flip won't record video when you connect it to your computer or your TV.** Your Flip records video only when it isn't connected to your computer or TV; when it's connected to either of those, your Flip basically turns into a memory storage device (computer) for shuttling files back and forth, or a video presenter (TV) for showing off your videos on the big screen. I write about this at the end of this chapter.

Taking your best shots

Your Flip's no-brainer design means you don't have to worry about adjusting settings like exposure or focus. You simply point and shoot, and your Flip handles the rest, whereas fuller-featured camcorders let you fiddle with a few or a bunch of settings to your heart's content.

Put another way, you're powerless over adjusting your Flip's way of seeing things. Even so, here are a few basic considerations to know about so that you can adjust how you shoot to ensure the videos you capture look (and sound) as great as they can even if you can't control every which way your Flip automatically adjusts things like light, sound levels, and focus.

Stabilization

Unlike most camcorders, your Flip has no *image stabilization* feature, which helps to minimize any shakes, rattles, or rolls you experience when you're recording video with those other camcorders. To minimize shakiness in the

videos you capture, try steadying your Flip camera by holding it with two hands and tucking your elbows in to your body. You can also try bracing yourself against any available object or part of the environment, such as a wall, a fence, the roof of your car, or that wonderfully heavy cooler you dragged to the park or beach.

Lighting

Basic lighting rules for still photography apply to shooting video. Make sure that your subject is properly lit: That is, the sun is to your back if you're shooting outdoors, or you turn lights on or off, or open or close curtains to achieve the best lighting level possible with the environment you're working in. Your Flip's auto-exposure feature tries to balance what you shoot by averaging all of the factors pouring into the lens. In other words, aiming at a brightly lit subject darkens any surroundings, while aiming at a darkly lit subject lightens any surroundings.

Sound

Your Flip's built-in microphone records any live sound you hear while you capture your video. Birds tweet-tweeting. Ocean waves crashing. Your Aunt Edna asking whether your camera's turned on and are you recording her right now? (**Note:** You cannot mute or adjust the built-in mic's recording volume level.) Some unwanted sounds you can control by avoiding or managing those sounds (quiet please, dear Auntie Ed'), but others you cannot control (sirens streaming past your otherwise idyllic picnic in the park). The closer you get to your subject, the better the sound. (**Hint:** If you're at a wedding, sit in the front row, or near a speaker.)

A reassuring thing to keep in mind about sound is that you can have greater control over it after you copy it to your computer and open it with FlipShare or your preferred video editing program. With FlipShare, you can add a music track to your video and then choose an option to play your selected track louder than the sound that was recorded with your video (or visa versa).

With Windows Live Movie Maker or iTunes for the Mac, you can also record your own voice to narrate parts of your video, and you can make the volume of those narrated parts louder than the sounds captured in your video for those parts.

Viewing Videos

Watching videos you record (or copy to your Flip from your computer) is as simple as pressing the Play/Pause button. While you're watching a video, you do things like adjust the volume level, fast forward or rewind through the video, or skip backward to a previous video or forward to the next saved

video. Accomplishing these basic things works pretty much the same way no matter which Flip camera model you own.

Because the Flip SlideHD boasts additional features not found on the other Flip models, I give the SlideHD some extra ink at the end of this section.

Watching and controlling videos

Watching and controlling a video (or all your saved videos one after another), and browsing through your videos to find one you want to watch, is merely a matter of pressing your Flip's control buttons.

 Although the title of this section refers to videos, your Flip camera treats any pictures copied from your computer to your camera as if those pictures were actually videos. When you view a picture, your Flip "plays" the picture by displaying it onscreen for 3 seconds.

When you watch a video, or browse through your videos to find one you want to watch, your Flip's screen changes to display information about the video you're watching, or the videos you browse through, depending on whether you're watching or browsing your videos.

To watch and control a video, press your Flip's buttons as follows:

- ✔ **Play/Pause:** Press to play a selected video, or press and hold to play all the videos saved on your Flip. Press while watching a video to pause the video.

- ✔ **Up** and **Down:** Press Up or Down to increase or decrease the playback volume.

- ✔ **Left** and **Right:** Press Left to go backward to a previous video, or press Right to skip ahead to the next saved video. Press and hold Left or Right to rewind or fast-forward through a video you're watching; then let go to resume watching your video.

The information displayed on your Flip's screen when you watch a video appears when you first start watching your video, or when you pause your video, then disappears a few moments after your video begins playing.

The information that appears during playback includes

- ✔ **Remaining time:** Counts down the time remaining for the currently playing video.

- ✔ **Progress bar:** Displays a progress bar and a moving position indicator that tracks the location you're watching in the overall video.

✓ **Volume level:** Shows the volume level and an indicator that moves up or down when you press the Up or Down buttons to increase or decrease the playback volume.

✓ **Battery:** Indicates your battery's charge level in the lower-right corner. If the battery icon is flashing, your batteries are too low and need to be recharged (or replaced if you're using disposable batteries with your Flip Ultra or UltraHD).

To browse through your videos to find a video you want to watch, press your Flip's buttons as follows:

✓ **Play/Pause:** Press while watching a video to pause the video.

✓ **Up** and **Down:** Press Up or Down to increase or decrease the playback volume, respectively.

✓ **Left** and **Right:** Press Left to go backward to the previous video, or press Right to skip forward to the next saved video. (Pressing and holding either button quickly advances backward or forward through all your saved videos.) Press and hold Left or Right to rewind or fast-forward through a video you're watching; then let go to resume watching your video.

The information you see on your Flip's screen when you browse through your saved videos, as shown in Figure 4-4, includes

✓ **Time length:** Displays the length, in minutes and seconds, of the displayed video.

✓ **Video number:** Displays the number of the displayed video (for instance, Video 6 of 11).

✓ **Battery:** Indicates your battery's charge level in the lower-right corner. If the battery icon is flashing, your batteries are too low and need to be recharged (or replaced if you're using disposable batteries with your Flip Ultra or UltraHD).

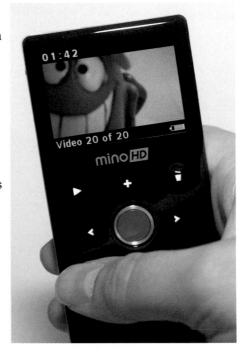

If you press the Record button while you're watching a video (by mistake or on purpose), your Flip stops playing the video but doesn't begin recording a new video until you press the Record button again.

Figure 4-4: Browse through your saved videos to see what you recorded.

Watching videos on your TV

If your Flip camera comes with a video cable, you can use that cable to connect your camera to your TV. If your Flip doesn't come with a video cable, you might already own the right video cable, or you can buy the video cable online or from your local consumer electronics retailer.

The kind of cable you use to connect your Flip to your TV varies from model to model. (The cable either comes with your Flip, or you buy it separately.) The Flip MinoHD (1-hour) and Ultra (2-hour) models have a composite video-out port, and each camera comes with a composite video cable that has red and white (audio) and yellow (video) RCA-type connectors that plug into your TV's matching RCA input ports. All the other Flip HD models have HDMI Type C mini-connector ports, and most high-def TVs (HDTVs) have larger HDMI Type A ports. The HDMI connector on an HD television is typically a standard original size, larger Type A connector ports. You can buy the special HDMI cable with a mini port on one end and a standard port on the other end from the Flip Store, or from another online retailer or consumer electronics store like Amazon.com, TigerDirect.com, Best Buy, RadioShack, or another store that sells home entertainment cables and gear.

To watch videos on your TV or HDTV, follow these steps:

1. **Make sure that your Flip camera and TV are both off.**

2. **Plug the small end of your connector cable into your Flip's video-out port, and connect the other end of the cable to your TV one of these two ways (depending on the type of cable you're using):**
 - *HDMI:* Plug the HDMI connector into your TV's HDMI port. (Most HDTVs have two or more HDMI ports.)
 - *Component:* Plug the red and white (audio) and yellow (video) RCA-type connectors into their respective RCA-type ports

3. **Turn on your TV and your Flip camera.**

4. **If you don't already see your Flip's video playback screen displayed on your TV, change your TV's video input setting by pressing your TV or your TV's remote control Input or Video or Source button and select the input choice that matches the TV connection ports you plugged into in Step 2.**

 You might need to select your TV's Source or Setup option to choose the correct input choice.

 Your TV displays your Flip's video playback screen.

5. **Use your Flip's buttons (or the SlideHD's touchscreen) to play and control the video you want to watch.**

6. **When you're done watching your videos on your TV, press the Power button to turn off your Flip camera, and then disconnect the cable from your camera and TV.**

7. **Change your TV's input setting back to what it was before you connected your Flip camera (see Step 4).**

You won't be able to record when the TV connection is activated because the camcorder display screen will turn off. To delete any videos, play back the videos on your TV and delete them using the camcorder buttons.

Deleting Videos

If you record a particular video you don't want to save, you can delete the video to erase the video file from your Flip's memory. You can also delete all saved videos from your Flip camera in one fell swoop. To delete a selected video or every video saved on your Flip, you use the Delete button.

Videos you delete from your Flip that you don't copy to your computer's hard drive are *not* recoverable. If you're on the fence about deleting a certain video file (or files), consider connecting your Flip to your computer and copying your saved video files to your computer's hard drive. Then go ahead and delete those original files from your Flip camera so you can shoot more videos.

To help prevent you from accidentally deleting video files from your Flip that you don't want to delete, your Flip features the Delete Lock setting. When turned on, the Delete Lock feature prompts you to unlock the Delete button before you can press it again to delete a video file from your Flip. By tossing in this extra step to unlock the Delete button before you can delete a file, you are more likely to think twice before you delete a file you really want to get rid of.

The Delete Lock feature is a feature you toggle. That means if Delete Lock is already turned on, you can toggle it off; if it's off, you can toggle it on. To toggle the Delete Lock feature, follow these steps.

1. **Press and hold the Delete button and keep holding the button as one or the other of these two things appears:**

 • *If Delete Lock was turned off,* the Delete Video? screen appears for a moment, followed by the Delete Locked screen.

 • *If Delete Lock was turned on,* the Delete Locked screen appears for a moment, followed by the Delete Unlocked screen, as shown in Figure 4-5.

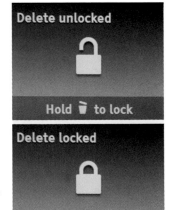

Figure 4-5: The Delete Locked feature will save you from accidentally deleting videos.

A few moments later, the live camera view reappears.

2. Release the Delete button.

To delete a video file (or all your video files), follow these steps:

1. With your Flip camera on and the Ready screen displayed, press the Left and Right buttons to browse through your videos to find the one you want to delete.

If you want to delete all of your videos, proceed to the next step.

2. Press the Delete button.

Note: If the Deleted Lock screen appears, press and hold the Delete button until the Delete Unlocked screen appears, and then press the Delete button again after your selected video reappears onscreen.

The Delete Video? screen appears and displays three options (Yes, No and All).

3. Press the Left or Right buttons to select the option you want:

- *Yes:* You're sure you want to delete the video file.

- *No:* You were only kidding, and you don't want to delete the file.

- *All:* You're dead-set on deleting every video file saved on your camera.

4. Press the Play button to confirm your choice (or press the Delete button if you changed your mind and you don't want to delete your file or files).

The Deleting Video message appears for a moment, and then your Flip returns to the live camera view screen.

If you hesitate for more than five seconds during any of the preceding steps, your Flip assumes that you're not really sure about your decision, and it closes the Delete Video? screen, flashes a Not Deleted message for a moment to show there are no hard feelings, and then returns to the live camera view screen.

Tapping into Unique SlideHD Features

If your Flip camera is a SlideHD model, you can do all the things described in the previous section and then some, thanks to the SlideHD's dual-purposed 3-inch widescreen.

To use your SlideHD's special features, slide open the widescreen to activate Widescreen mode and then play around with the following special features:

- **Simple settings:** Press the Menu icon on the right side of the slide strip and then press Settings to adjust your SlideHD's date and time settings.

- **Speedy navigation:** Press the slide strip to browse videos, and then press

 - *Camera* to browse all videos saved on your camera

 - *Flip Channels* to view videos you're sharing using Flip Channels

 - *Favorites* to display any items you marked as Favorites

- **Browsing and viewing videos and folders:** You can do the following:

 - Slide your fingertip left or right on the slide strip to browse through thumbnails of your videos.

 - Tap the top corners of the screen to scroll up or down through your folders.

 - Press the video thumbnail or the slide strip to play the video.

 - Press and hold your fingertip on the screen during playback to display the onscreen viewing controls.

 - Press the video or slide strip to return to the thumbnail video selection view.

- **Choosing favorites and deleting videos:** Press and hold a video thumbnail to display the Delete and Favorite icons, and then press either Favorite or Delete.

5

Transferring Video to Your Computer

*Y*our Flip camera makes it easy to shoot video on the fly, pretty much whenever and wherever you want. Your Flip's display also makes it easy to play your recorded videos for anyone who wants to watch them, thanks to easy playback controls like Play and Pause, Fast Forward, and Rewind — and for those really awful videos you'd rather not show others, Delete. But crowding your friends and family around the Flip's teensy tiny screen isn't nearly as enjoyable as watching your videos on a bigger screen, whether a computer screen or a TV screen that plays your movies from a DVD you burn.

For the greatest viewing pleasure, you want to edit your videos to cull the parts you don't want and then mix and match the other parts you do want to tell some kind of story. And you start by first copying video files you record and save on your Flip to your Windows or Mac computer.

That's what this chapter is all about: copying your video files to your computer so you can edit those files into movies. (I show you how to edit in other chapters.) In this chapter, you can also read about a few simple but important do's and don'ts keep in mind when you plug your Flip into your computer, and when you unplug your Flip from your computer. Lastly, I remind you that for all of its gee-whiz video camcorder coolness, your Flip can also act as a handy portable backup drive for shuttling documents, pictures, and other files to and from one computer to another computer.

Practicing Safe Flip Plugging

Before I tell you about connecting your Flip to your computer, I first need to send a little tough love your way, gentle reader. Ready or not, here it comes: Unplugging your Flip from your computer *without first choosing a command that tells your computer you want to eject your Flip* (known as *safely removing*) can cause damage to your Flip camcorder and/or the loss of any video files or other information you have saved on your Flip.

I don't tell you this to scare you but to get you into the habit of thinking twice before unplugging your Flip without properly ejecting your Flip first, which I tell you how to do a little later in this chapter. Okay; the scare-you-smart business is out of the way.

When you shoot video with your Flip, your Flip is first and foremost a video camcorder. When you want to copy recorded video files to your PC or Mac's hard drive so you can do interesting things with those videos, your Flip is — as far as your computer is concerned — just another disk drive with information on it, as shown in Figure 5-1.

Whether you use FlipShare, iMovie, Windows Photo Gallery, or another program to copy your video files to your computer, your computer doesn't care. Your computer doesn't even care if you drag and drop video files from your Flip's folder to a folder on your computer's hard drive. Your computer will forever think of your Flip as yet another disk drive.

Figure 5-1: To your computer, your Flip is just another disk drive.

Your Flip is incredibly easy to use, but it's incredibly easy to abuse if you're not careful. Besides the obvious stuff (like not dropping your Flip off a rooftop or down a drainage ditch), the following sections detail three critical but simple ways you can protect your Flip from damage.

Turn off your Flip before plugging it into a computer

Before plugging your Flip into your computer, turn off your Flip. Just press and hold the power button until your Flip screen goes dark. If you're recording

or watching a video, your Flip will automatically stop either of those activities before it powers-off. Of course, you can manually stop either of those activities before you power-off your Flip.

If you find yourself having to use excessive force to plug your Flip into your computer's USB port or into the business end of a USB cable, consider contacting the support department at Cisco (the Flip manufacturer) about possibly repairing or exchanging your Flip. I had trouble plugging a Flip Mino into the USB ports on all three of my notebook computers, and it wasn't until I did it many times that it seemed easier to plug into those computers. On the Flip support site (theflip.com/support), Article ID 229 ("Difficulty in connecting MinoHD second generation USB arm to computer") might very well prove that in all likelihood, you are not a forceful person, and your Flip may be the one to blame if plugging it in requires more than a little force.

Connect your Flip with an optional USB cable

In case it isn't already obvious to you, your Flip gets its name from the built-in USB connector that flips out when you press the USB connector release button. The good thing about a built-in USB connector means that you never have to remember to pack or search for a USB cable when want to connect your Flip to your computer to copy video files. What's not so great about the flip-out USB connector is how it puts your Flip in harm's way when your Flip is poking out the side or back of your computer, as shown in Figure 5-2.

Figure 5-2: Connected to a computer, your Flip is just begging for a knock upside its pretty (vulnerable) head.

With nothing to support your Flip as it hangs midair, your camera's USB connector and your computer's USB port are vulnerable to breakage if you (or your ever-inquisitive Jack Russell terrier) accidentally bump into your Flip.

One way to minimize your Flip's exposure to the world of hard knocks is to place a soft but supportive object, such as a thick wad of $100 bills or your wallet (even if it's empty), between your Flip and the tabletop. Another option is to plug your Flip USB connector into an optional USB cable that you plug into your computer.

Properly eject your Flip from your computer

Your computer thinks of your Flip simply as a disk drive, so it's important to treat your Flip with the same consideration you grant any external disk drive you might plug into your computer. In other words, properly connecting and ejecting your Flip can help ensure you don't damage your Flip's internal memory or corrupt any video files and other files stored on your Flip.

Before you unplug your Flip from your computer, you must first eject it — sometimes referred to as *disconnecting* or *dismounting* your Flip (or most any other plugged-in storage device). Throughout this chapter, I use the term *eject*.

The two most common ways of ejecting your Flip from your computer before you unplug your Flip are the following:

- **If you're already running FlipShare:** Click the Eject Camcorder button in the Navigation pane of the FlipShare main window, as shown in Figure 5-3. (Read about FlipShare in Chapter 6.)

- **If you're not running FlipShare:** Eject your Flip from your computer by using the process that I outline in the following steps, based on whether you connect your Flip to a Windows PC or a Mac.

Figure 5-3: Eject first; then unplug.

Ejecting your Flip from a Mac

To safely eject your Flip from a Mac so you can then unplug your Flip, follow these steps:

1. **Quit any programs you're running that may be accessing any files on your Flip camera (such as iMovie, iPhoto, or Final Cut Pro).**

2. **Drag and drop the FLIPVIDEO icon on the Desktop to the Trash icon on the Dock, as shown in Figure 5-4.**

 Alternatively, you can Control-click the FLIPVIDEO icon and choose Eject FLIPVIDEO from the pop-up menu that appears.

 Your Flip camera icon disappears from the Desktop.

3. **Unplug your Flip camera from your Mac and be on your merry way.**

Figure 5-4: Drag the Flip camera icon to the Trash to eject your Flip.

Charging your Flip

If your Flip is a model with a rechargeable battery, your Flip's battery recharges whenever your Flip is plugged in and your computer is turned on. Some computers even have a feature that lets you charge external USB gadgets when the computer is off. Toshiba's line of Mini netbooks has a Sleep-and-Charge feature, which lets you recharge your Flip or other plugged-in rechargeable gadgets even when the netbook is turned off.

Of course, you can charge your Flip the old-fashioned way, via a power adapter that plugs into a wall outlet. Out of the box, your Flip doesn't come with its own power adapter for charging your camera, but you can buy one especially made for your Flip from the Flip Store Web site (`http://store.the flip.com`).

Ejecting your Flip from Windows

To safely eject your Flip from your Windows PC so you can then unplug your Flip, follow these steps:

1. **Exit any programs you're running that may be accessing the files on your Flip, such as Windows Live Movie Maker or FlipShare.**

2. **Press Win+E to open the Windows Explorer window.**

 Your Flip camera appears as an icon in the Windows Explorer window.

3. **Right-click your Flip camera's icon and then choose Safely Remove (Windows Vista) or Eject (Windows 7) from the contextual menu that appears.**

 A notification message dialog box appears to let you know you may now safely unplug your Flip from your PC, so feel free to do just that.

Deciding What Your Computer Does When You Plug In Your Flip

When you connect your Flip camera to a computer, you can dictate that your computer automatically loads a program of your choosing to copy video files from your Flip to your computer. Chances are that your computer already launches FlipShare whenever you plug in your Flip camera.

Or maybe your computer *was* launching FlipShare, but for whatever reason, it no longer launches FlipShare when you plug in your Flip. No worries. Whether you want your computer to run FlipShare or another program whenever you plug in your Flip — or not launch FlipShare or any program at all — adjusting your computer's settings to do just that is easy.

Choosing whether FlipShare runs when you plug in your Flip

To start or stop FlipShare from automatically launching when you plug in your Flip camera, follow these steps:

1. **Launch the FlipShare program if it isn't already running.**

2. **Click the Edit menu and choose Preferences (Windows) or click the FlipShare menu and choose Preferences (Mac).**

 The FlipShare preferences window for your particular operating system appears, as shown in Figure 5-5 (Mac).

3. **As appropriate, mark or clear the Start FlipShare When Camcorder Inserted check box.**

4. **To continue using FlipShare to copy videos to your computer, go to the "Using FlipShare" section, later in this chapter; otherwise, quit FlipShare.**

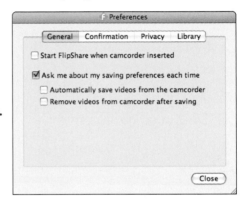

Figure 5-5: Set FlipShare starting preferences here (Mac).

Selecting a Windows AutoPlay option

From the AutoPlay control panel, you can choose what you want your computer to do when you plug in your Flip. For instance, you can select the AutoPlay option that tells your computer to copy any video files from your Flip camera to a certain folder on your PC and then delete those files after Windows copies them. Or you can choose an option that opens Windows Live Photo Gallery and imports any video files from your Flip using that program to organize your video files into folders on your Windows PC. (Note that the following figures are from Windows 7, although the steps work the same for both Vista and 7.)

To choose what program your Windows computer runs when you plug in your Flip (or to choose not to run any program at all), follow these steps:

1. **Plug in your Flip camera.**

 After a few moments, the AutoPlay window shown in Figure 5-6 appears.

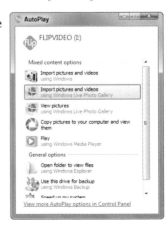

Figure 5-6: The Windows AutoPlay window.

If Windows doesn't display the AutoPlay window, do this:

a. *Choose Start⇨Control Panel and double-click the AutoPlay icon.*

The AutoPlay Control Panel window opens.

b. *Click the Reset All Defaults button, click the Save button, and then close the AutoPlay Control Panel window.*

You have to scroll down to see the Reset All Defaults button.

c. *Safely eject your Flip, unplug your Flip, wait a moment, and then proceed to Step 2.*

The "Properly eject your Flip from your computer" section, earlier in this chapter, has details on safe disconnection.

2. **Click one of the choices to instruct Windows to perform that action whenever you plug in your Flip camera.**

Windows will carry out your choice, such as launch whatever program you choose or open a Windows Explorer window to show you the folders and files stored on your Flip camera. If you chose nothing, um, nothing will happen.

If you select Windows Live Photo Gallery in Step 2, go to the "Using Windows Live Photo Gallery" section to learn how to do just that.

Selecting your Mac's default program

If you need to transfer digital images from a camera to your Mac on a regular basis, you can define a default program to use for retrieving these images by following these steps:

1. **Double-click the Image Capture icon in the Applications folder.**

The Image Capture window appears.

2. **Plug your Flip into one of your Mac's available USB ports.**

Your Flip camera will appear under the Devices group in the left pane.

You can also define a default application by running iPhoto and choosing iPhoto⇨Preferences.

3. **Click the Connecting This [*Your Flip Name Here*] pop-up menu in the bottom-left corner and then choose iPhoto or Image Capture, as shown in Figure 5-7.**

(Optional) You can choose another program listed on the pop-up menu; or, click Other to choose a program in your Mac's Applications folder that isn't listed in the pop-up menu, such as iMovie, so that it can automatically run when you connect your camera to your Mac.

4. **Choose the following options if you want to:**

 • *Share Camera (or whatever your Flip is named):* Allow others on your Mac's network to view and import pictures from your connected Flip.

 • *Delete After Import:* Copy your videos from your Flip to your Mac's hard drive and then delete the videos from your Flip and free memory on the device so you can take more pictures.

 • *Location:* Click the pop-up menu to the left of the Import button to choose where you want Image Capture to save your imported videos.

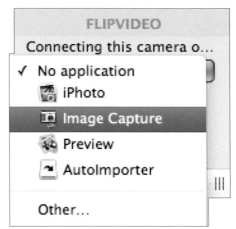

Figure 5-7: Choose the program you want your Mac to run when you plug in your Flip.

Getting Video Files from Your Flip to Your Computer

When it comes to transferring files from your Flip camera to your computer, you have several options. I detail six methods here. What you use will depend on what type of operating system you use (Windows or Mac) as well as what happens when you plug your Flip into your computer. (For more about that, see the preceding sections.)

Using Windows Live Photo Gallery

In Chapter 11, I write about downloading and using the free Microsoft Windows Live Movie Maker video editing and production program. Movie Maker is part of the free Microsoft Windows Live suite of programs, which also includes Windows Live Photo Gallery, which you can download at http://photos.live.com.

To copy video files from your Flip camera to your PC via Windows Live Photo Gallery, follow these steps:

1. **Launch Windows Live Photo Gallery.**

 The Sign In to Windows Live dialog box appears, as shown in Figure 5-8.

2. **Enter your Windows Live user name and password (if you have them) and click Sign In.**

 Click Cancel if you don't have a Windows Live username or password, or you don't want to sign in right now.

 The Windows Live Photo Gallery window appears, as shown in Figure 5-9.

Figure 5-8: Click Cancel to bypass the sign-in process.

Figure 5-9: The Windows Live Photo Gallery main window.

A dialog box might appear asking whether you want Windows Live Photo Gallery to open picture files instead of whatever other program is assigned to open picture files. If you want to do this, click Yes; otherwise, click No. You can also select the Don't Show Me This Again for These File Types check box if you don't want Windows Live Photo Gallery to prompt you with this dialog box every time you run the program.

3. **Plug in your Flip camera.**

What happens next might vary:

- If the AutoPlay dialog box appears with options you can choose (refer to Figure 5-9), click Import Pictures and Videos using Windows Live Photo Gallery. Proceed to Step 6.

- If the FlipShare program launches and displays the video files stored on your Flip in the workspace window, choose File⇨Exit to quit FlipShare. Proceed to Step 4.

- If another photo or video program that you previously selected to open when you plug in your Flip prompts you to import your video files, click Cancel. Proceed to Step 4.

4. **Choose File⇨Import from Camera or Scanner.**

The first Import Photos and Videos dialog box appears, showing your Flip camera and any other media devices you have plugged in to your computer, as shown in Figure 5-10.

5. **Select the FLIPVIDEO icon and then click the Import button.**

The second Import Photos and Videos dialog box appears for only a moment as Windows Live Photo Gallery searches your Flip to see whether it contains any video files. The third Import Photos and Videos dialog box appears.

Figure 5-10: The initial Import Photos and Videos dialog box.

6. **Make choices in the third Import Photos and Videos dialog box:**

- *Review, Organize, and Group Items to Import (the default selection):* Leave this radio button selected to choose what files to import.

- *Import All New Items Now:* If you select this radio button, you can enter a name for your files in the Enter a Name field.

- *Add Tags:* Click this link to add descriptive text, such as "spring" or "doggies" or "river," separated by commas for each tag, to your video files. Windows Live Photo Gallery will attach the tag names to your video files so you can easily sort and find the files based on those tags. When done, click Import.

More Options: Click this link to display the Options/Import Options dialog box, as shown in Figure 5-11. Use the drop-down menus to change options and/or select or clear the check boxes in the Other Options section to turn those options on or off. After you make all your choices, click OK, and you're taken back to the Import Photos and Videos dialog box.

Figure 5-11: The Options/Import Options dialog.

7. **Click Next.**

The fourth Import Photos and Video dialog appears and displays one or more video files stored on your Flip camera.

8. **Make choices in the fourth Import Photos and Video dialog before proceeding:**

- *Select All:* Select this check box to copy all video files.

 Leave this check box clear if you *don't* want to copy every video file stored on your Flip camera to your hard disk (even ones you might have already copied). Instead, select the check box to the left of each video that you do want to copy from your Flip to your computer.

- *Expand All:* Click this link (the lower-left corner) to display how all your video files will be grouped after Windows Live Photo Gallery imports the files.

- *Adjust Groups:* Use this slider (lower-right corner) to adjust the length of time Windows Live Photo Gallery uses to determine how it organizes your video files. Dragging all the way to the left separates and organizes your video files into half-hour groups; somewhere in the middle change the length of time between groups; all the way to the right puts all your video files into a single group.

- *More Options:* Click this link (lower-left corner) to display the Options/Import Options dialog box (refer to Figure 5-11). Make your choices and then click OK.

9. **Click Import.**

The fifth Import Photos and Video dialog appears, displaying a progress bar as Windows Live Photo Gallery imports your video files to your computer.

10. **(Optional) Select the Erase After Importing check box.**

Windows Live Photo Gallery deletes your video files from your Flip camera after it finishes copying the files to your computer's hard drive.

When Windows Live Photo Gallery finishes importing your video files, a message inviting you to view your new photos appears (even though you imported videos), as shown in Figure 5-12.

Figure 5-12: Windows Live Photo Gallery invites you to view your new photos, er, videos.

Using Image Capture

If you defined Image Capture as the default program to run when you plug your Flip into to your Mac, follow these steps:

1. **Plug your Flip into an available USB port on your Mac.**

The Image Capture program automatically launches (if it isn't already running) and displays videos you recorded and saved on your Flip camera.

Note: If you didn't choose Image Capture as your default program, you can still use it to import your videos by double-clicking the Image Capture icon in the Applications menu to launch the program.

2. **(Optional) Before importing your videos, you can click the icons below the right pane of the Image Capture window.**

 • *Switch between List view and Icon view.*

 • *Rotate a selected video left.*

 • *Rotate a selected video right.*

• *Delete a selected video.*

• *Choose the location where* you *want Image Capture to save your imported video (click the pop-up menu).*

3. **(Optional) Click and drag the slider in the bottom-right corner of the Image Capture window to increase (left) or decrease (right) the size of your picture icons.**

4. **Select a picture that you want to transfer and click Import, or click Import All to retrieve all video stored on your Flip.**

 To select multiple images, hold down the ⌘ key and click each video you want to import.

 Image Capture marks each video with a check mark after it copies each one to the location selected in the pop-up menu to the left of the Import button, as shown in Figure 5-13.

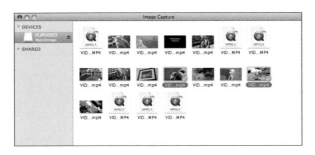

Figure 5-13: Check marks indicate the video files Image Capture copied to your Mac.

5. **Choose Image Capture➪Quit Image Capture.**

If you didn't select the Delete After Import check box, you have to manually erase the pictures from your Flip after you import them to your Mac so your Flip has more space to store new videos you record and save.

Using iPhoto

If you defined iPhoto as the default program to run when you connect your Flip to your Mac, follow these steps:

1. **Plug your Flip into an available USB port on your Mac.**

 iPhoto automatically launches (if it isn't already running) and displays videos you recorded and saved on your Flip camera, as shown in Figure 5-14.

Figure 5-14: The iPhoto window displays videos stored on your Flip.

Note: If you didn't choose iPhoto as your default program, you can still use it to import your videos by double-clicking the iPhoto icon in the Applications menu to launch iPhoto.

2. **(Optional) Before importing your videos, you can adjust or choose the following options in the lower area of the iPhoto window:**

 • *Event Name:* Click the text field and type a name for the batch of videos you're importing, such as My Wedding Day, or Summer Vacation. This adds a tag to the file for indexing/searching purposes.

 • *Description:* Click the text field and type a description that can include details of the batch of videos you're importing, such as the names, places, and things captured in your pictures.

 • *Autosplit Events After Importing:* Select this check box to make iPhoto automatically create separate event folders for videos you're importing based on the date you snapped the photos.

 • *Hide Photos Already Imported:* Select this check box to make iPhoto ignore (therefore, not display) any videos you chose not to delete from your camera after previously importing those videos.

3. **(Optional) Click and drag the slider in the bottom-right corner of the iPhoto window to increase (left) or decrease (right) the size of your video icons.**

4. **Click a videos that you want to transfer and then click Import Selected.**

 If you click Import All, iPhoto retrieves all videos stored on your Flip.

 To select multiple videos, hold down the ⌘ key and click each video you want to import.

When iPhoto finishes importing your videos, a dialog appears asking whether you want to keep or delete the videos from your Flip.

5. **To delete the videos from your Flip, click the Delete Photos button. Otherwise, click the Keep Photos button to leave the videos on your Flip.**

6. **Choose iPhoto⇨Quit iPhoto to exit iPhoto.**

Using iMovie

In Chapter 10, I show you how to use iMovie to edit video files you captured with your Flip camcorder. If you plan to use iMovie as your main video editing program, the easiest way to copy your video files to your Mac's hard drive is to launch iMovie and choose File⇨Import from Camera and use the Import dialog to copy your videos.

Using FlipShare

To copy recorded video files from your Flip camera to your computer's hard drive using FlipShare, follow these steps:

1. **Launch FlipShare to open the FlipShare main window.**

2. **Plug your Flip camera into a USB port on your computer.**

 The Camcorder section of the Navigation pane automatically expands and displays the All and Unsaved folders. An exclamation icon appears next to the Unsaved folder icon, indicating that some or all of the video files saved on your Flip camera have not been saved to your computer's hard drive.

 The number next to the All folder displays the total number of videos stored on your Flip camera. The number next to Unsaved folder indicates how many video files stored on your Flip camera have not been copied to your computer's hard drive.

 If there are no unsaved video files on your Flip camera, you've already copied all the video files to your computer's hard drive.

3. **Click either the All or Unsaved folder in the Navigation pane to display the contents of the chosen folder in the workspace.**

4. **Select the video files you want to copy one of the following ways:**

 • Click the Select All button or the Select Unsaved button (lower-left corner of the Workspace).

 • Click an individual video file or select multiple video files by holding the Control/⌘ key and then clicking each movie you want to select.

5. **Click the Save to Computer button on the Action bar. (You can also choose File⇨Save to Computer, or press Ctrl+S/⌘+S.)**

The Save Videos to Computer dialog box appears.

6. **Click Yes or No.**

A second Save Videos to Computer dialog box appears, as shown in Figure 5-15.

Note: The Save Videos to Computer dialog doesn't appear if you selected the Don't Ask Me Again check box (refer to Figure 5-15) described in the next step. Skip to Step 8 if you don't see the Save Videos to Computer dialog.

Figure 5-15: Choose save options here.

- If you want FlipShare to erase the video (or videos) from your Flip camera after it copies the file (or files) to your computer, select the Remove Videos From Camcorder After Saving check box.

- If you want FlipShare to just go ahead and copy your video file (or files) to your computer without bothering you with the Save Videos to Computer dialog whenever you copy files to your computer, select the Don't Ask Me Again check box.

7. **Click Yes to copy your video files to your computer or click No if you don't want to.**

8. **The Progress box displays the FlipShare Is Working message, along with a progress bar.**

When FlipShare is done copying the video files to your computer, it displays a completion message.

Using the drag-and-drop method

I mention at the start of this chapter that your computer treats your Flip camera like any ol' external storage drive. As such, you can simply drag and drop video files from your Flip to your computer to copy those files just like you would using any other external storage drive.

Whether you use a Windows PC or a Mac, the folder where your Flip stores videos you capture and save in the same folder is always *<Your Flip Camera>/* DCIM/100VIDEO.

Clicking a video file in Windows Explorer or a Mac Finder window displays more information about that video file, such as the size of the file and the date when you captured the video file.

To browse, select, and copy video files from your Flip to your computer's hard drive, follow these steps:

1. **Choose one of the following:**

 • *Windows:* Press Win+E to open a new Windows Explorer window.

 • *Mac:* Click the Finder icon on the Dock or press ⌘+Shift+C to open a new Finder window.

2. **Click the icon for your Flip camera in the left column of the Windows Explorer or Finder window and then navigate to the 1000VIDEO folder.**

 Video files stored on your Flip camera appear in the Windows Explorer or Finder window.

3. **Click and hold down on the icon for a video file you want to copy to your computer; then drag the icon to your computer's desktop and release the mouse button.**

 You can also drag to another folder in the left column where you want to copy the selected video file, as shown in Figure 5-16 (Windows).

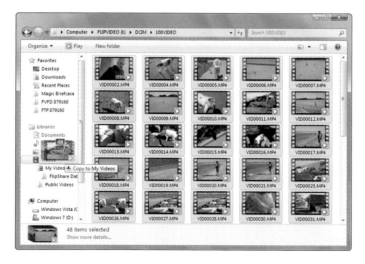

Figure 5-16: Drag and drop files from your Flip to your computer's hard drive.

To select every video file icon, press Ctrl+A (Windows) or ⌘+A (Mac). To select some but not all video file icons, press and hold Ctrl (Windows) or ⌘ (Windows) and click each file you want to copy; then click and hold one of your selected icons and drag to your desktop or another folder to copy those files to your computer's hard drive.

Your computer copies your selected file or files to your computer's hard drive.

4. **To delete one, some, or all of the video files from your Flip camera, select the files you want to delete and then do the following, as appropriate:**

 • *Windows:* Drag and drop the files to the Recycle Bin. Right-click the Recycle Bin and choose Empty Recycle Bin from the contextual menu that appears.

 • *Mac:* Drag and drop the file or files to the Trash icon on the Dock; then choose Finder⇨Empty Trash.

 Your computer erases the video files from your Flip camera.

You can also copy video files from your Flip camera to your Mac's hard drive via the Finder. In the Finder, select the files on your Flip that you want to copy, and then drag and drop those files to a folder on your Mac's hard drive.

Part III

Creating and Sharing Movies with FlipShare

In this part . . .

Maybe every video you shoot is a study in movie-moment perfection. If so, hats off to you. For most people, though, many of your videos include stretches of footage that you don't want to include in your final video for whatever reason (usually because you don't want to bore your viewer or embarrass someone you captured on video doing something that he would rather not share with the rest of the world). Trimming your videos to cut out those parts before you share them with others or sharing your individual clips or pulling them together into a movie or photo slideshow using FlipShare is the territory you venture into in this part.

From making Magic Movies or Full Length movies complete with titles and credits and music scores, to uploading those movies to sharing Web sites or sending links to them in greeting card or e-mail messages, to burning your movies to DVDs, those things and more are what's in store for you in this part.

6

Getting Familiar with FlipShare

In This Chapter

▶ Touring the FlipShare interface

▶ Importing, viewing, and managing video files

*F*lipShare is a multifaceted program that does a bunch of things, and the best way to learn about what those things are is to spend some up close and personal face-time with the FlipShare program. The great thing about FlipShare is that it's so easy to use, you might find yourself spending only a little time getting up to speed before you're off and running on your own, copying your video files, editing those files into movies, and sharing your movies with friends and family using FlipShare's handy sharing features.

With FlipShare (check out Chapter 1 for installation details), you can

- ✓ **Import your videos** from your Flip and organize those videos using different folders.

- ✓ **Play those videos** or ones still stored on your Flip camera that you haven't copied to your computer yet (when it's plugged into your computer).

- ✓ **Grab individual pictures** from videos as snapshot files.

- ✓ **Share your videos** by creating DVDs, sending the videos in e-mails or greeting cards, or uploading them to your very own (and free!) Flip Channel that others can go to on their Web browsers to watch your creations.

FlipShare also acts as your one-stop video editing shop (albeit a supremely simplified one at that) for trimming your videos the way you want, and adding titles, credits, and even accompanying music. FlipShare also makes it easy to upload your movies to popular social networking and sharing Web sites such as YouTube, Facebook, and MySpace.

Touring the FlipShare Interface

Throughout this book, I make the assumption that you know how to launch your Mac or Windows PC's FlipShare program. By default, FlipShare *should* run automatically whenever you plug in your Flip camcorder, but if not, check out Chapter 3 to find out how to adjust what your computer does whenever you plug your Flip into your computer. You can also run FlipShare by double-clicking the FlipShare program icon. The most obvious places to look for the FlipShare program icon on your computer include

✓ **Mac:** Your Mac's Applications folder is where you find the FlipShare program icon. Double-click the icon to launch the FlipShare program. You can also drag the FlipShare icon to your Mac's Dock to launch FlipShare with a single click of the mouse whenever you want to run the program.

✓ **Windows:** The Windows desktop is where you'll find the FlipShare application icon. If you deleted the icon from your desktop, choose Start➪All Programs and look for the FlipShare icon. You can also drag the FlipShare icon to the Windows Start menu to quickly launch FlipShare whenever you want.

If you're running FlipShare on a Windows computer and the pop-up message shown in Figure 6-1 appears, check out Chapter 3 to find out why the color scheme has been changed to Windows Vista Basic. In Chapter 3, you can also read how to change the setting that can stop this distracting (but informative) message from appearing every time you run FlipShare.

Figure 6-1: Running FlipShare might automatically change Windows' visual settings.

The FlipShare main window

When you run the FlipShare program, the FlipShare main window appears, as shown in Figure 6-2. The main window consists of the following four sections (from left to right):

✓ **Navigation pane:** The left column provides one-click access to

• *Folders* containing videos and pictures you copied to your computer's hard drive

- *Videos* saved on your Flip camera (when it's plugged in) that you haven't yet copied to your computer's hard drive (or ones you leave on your camera or copied to it so you can play them on your Flip's display whenever you want)

- *Videos* that you uploaded to your personal and shared Flip Channels (Sent Flip Channels), and videos in Flip Channels that other FlipShare users invite you to view (Received Flip Channels)

- *Links* you can click that launch your Web browser and take you to Flip-related Web sites

✓ **Progress box:** The lower-left space beneath the Navigation pane is where you track progress while you do certain things, such as how far FlipShare has progressed when you're copying videos from your Flip camera to your computer's hard drive.

Navigation pane Progress box Workspace Action bar

Figure 6-2: The main FlipShare window is the sum of its four separate parts.

✓ **Workspace:** The large, central area of the main window displays the contents of whatever folder or item you selected in the Navigation pane, such as videos stored on your Flip or movies you edited. You can click on these items here.

✓ **Action bar:** This row of buttons beneath the Workspace holds actions that do certain things with an item (or items) that you selected in the Workspace, like saving a video to your computer, or e-mailing a picture.

In the following sections, I describe a little more fully what each of the FlipShare main window's four sections do, how they relate to one another, and how you can use them.

Although I cover FlipShare's main window sections one at a time, you typically use them in a mix-and-match way to do things with your video files, such as clicking between sections or dragging things from one section to another section.

Navigation pane

The Navigation pane contains six sections to help you organize and view your videos, movies, and photos; organize and play movies you've uploaded to your Flip Channel; and access Flip-related Web sites.

✔ **Camcorder:** If your camera isn't plugged in, this section title is grayed out and the triangle to left of the Camcorder icon is collapsed. When you plug in your Flip camera, the triangle automatically expands to display two folders: All and Unsaved. Click the All or the Unsaved folder to display thumbnails of that folder's video files in the Workspace; then click a thumbnail in the Workspace to do things with that video, such as play the video or copy or delete the video.

Flip SlideHD users may see additional folders in the Camcorder Navigation pane section that they created on their SlideHD camcorder or added in FlipShare.

Videos saved on your Flip camera that you have not copied to your computer's hard drive are flagged with a yellow ! (exclamation point) icon, as shown in Figure 6-3. The All folder displays videos you might have already copied to your computer and videos that you have not yet copied to your computer. The Unsaved folder shows only those video files stored on your Flip camera that you have not copied to your computer.

Figure 6-3: ! marks video files not saved to your computer.

✔ **Shortcuts:** Click any of these three shortcut choices to display the following contents in the Workspace:

• *Favorites* you created by dragging or dropping a video, photo, or other Navigation pane item (except Camcorder or Resources items) into the Favorites folder

• *Movies* you created and saved on your computer's hard drive or uploaded to your Flip Channel

- *Photos* you created by selecting one or more individual frames from your videos, which FlipShare converted into a separate picture file (or files), as shown in Figure 6-4

Figure 6-4: The Photos shortcut provides one-click access to your picture files.

✔ **Computer:** These folders contain videos you copy from your Flip camera and save to your computer's hard drive. When you copy video files from your Flip camera to your computer's hard drive, FlipShare automatically creates (and names) folders based on the month and year when you recorded the video files. Clicking the Add Folder icon to the right of the Computer section title creates a new Untitled folder that you can rename by typing in the name you want and then pressing Enter/Return.

✔ **Sent Flip Channels:** These folders contain videos you share with individuals (one person's e-mail address) or groups of people (two or more e-mail addresses). Individuals or group members are automatically notified by e-mail whenever you drag a movie into a Flip Channel folder. (I write more about setting up your Flip Channels and sharing your movies using Flip Channels in Chapter 9.)

✔ **Received Flip Channels:** The folders contain videos that other FlipShare users have invited you to view. The items that appear in these folders are based on the e-mail address where you received invitations from other FlipShare users to view the items.

✔ **Resources:** Click these links that turn the Workspace into a Web browser that displays that particular Resource link (Flip Store, Support, and Registration).

Showing and hiding folder contents

The triangle icon to the left of each Navigation pane section indicates whether that section's contents are hidden (pointing right) or displayed (pointing down). Things you can do with the triangle icon include

- ✔ Clicking the triangle to expand (show) or collapse (hide) the contents of that section's contents, such as folders or shortcuts, as shown in Figure 6-5

- ✔ Clicking a folder (or other item) beneath an expanded section title to display that folder's contents (or related information) in the Workspace

Figure 6-5: Collapsed (left) and expanded (right) folders in the Navigation pane.

Movie or video? What's the diff?

Only video files that FlipShare recognizes as actual movies appear in the Movies Shortcuts folder in the Navigation pane, whereas movies and videos both appear in folders in the Computer folder. What's the difference? A *movie file* is a video file (or combination of video files you combine together) that becomes a movie file when you use the FlipShare Create Movie feature, tweaking that video file (or files) by trimming your footage and cutting out parts you don't want, adding a title and credit, and adding an optional music sound track. FlipShare does its movie magic and combines all your edits and choices, and then creates a new video file that it recognizes as a movie because it contains all the things you added to it to make it a movie. Comparatively, a video file is just that: raw video footage you captured but haven't enriched with movie-like features. Even if you trim away a section of footage from a video file, FlipShare still thinks of that file as a video file and not a movie file.

You can click a folder to select that folder and display its contents, rename or delete the folder, or drag and drop the folder to move or copy it to another folder.

Deleting and renaming folders in the Navigation pane

Deleting and renaming folders in the Navigation pane is a snap.

✏ **Delete a folder.**

 a. Click the trash can icon to the right of the selected folder to display the delete warning message dialog box.

 b. Click the Permanently Delete button.

 Change your mind? Click Cancel.

 You can also right-click/Control-click a folder and then choose Delete from the menu that appears.

✏ **Rename a folder.**

 a. Double-click the folder name, or right-click/Control-click the folder and choose Rename from the menu that appears.

 b. Type in your new name and then press Enter/Return.

Progress box

From the Progress box, you can track the progress of certain tasks FlipShare is working on, such as uploading a movie to your Flip Channel, or copying one or more videos from your Flip camera to your computer's hard drive.

Personally, I think the Progress box is too tiny and unobtrusive for its own good. For example, because the progress bar and status text are so teensy, it's easy to start copying videos from your Flip camera to your computer, turn your attention to something else for a minute, and then unplug your Flip without noticing whether the Progress box indicated you were finished doing what you started before you looked away.

To avoid potential loss of videos you're copying between your Flip and your computer, try to make it a habit to take a gander at the Progress box before you unplug your Flip camera. For a fuller explanation of why keeping an eye on the Progress box and other Flip and computer connection considerations matter, check out Chapter 5.

If an active task that's underway can be cancelled, a teeny-weeny Cancel button appears alongside the progress bar — yes, it's that flea-sized "X" you can barely see in Figure 6-6.

Click the X to cancel an action.

Figure 6-6: An X appears next to tasks you can cancel if you change your mind.

Some tasks (such as copying a single, three-second video file) can take only a few seconds to complete. Other tasks, like uploading a movie to your MySpace Web site page, can take many minutes to complete. Uploading a 42-second movie to my MySpace page took about 2 minutes to complete. Rough estimate: 1 minute of movie time equals 2 minutes and 9 seconds of uploading time based on my computer and broadband connection's combined speed. Your mileage may vary, of course.

Workspace

Although the Action bar (which I get to in a moment) *sounds* like the place you want to go to if you're looking for, well, action, the *real* action takes place in the Workspace section of the main window (refer to Figure 6-2). The Workspace is where you can click thumbnails of your video files to

- **View video files** stored on your Flip camera and your computer's hard drive.
- **Play video files** on your screen.
- **Trim away sections of your video files** to remove unwanted shots that you don't want to see when you play the video files. (*Unwanted* equals too silly or poorly captured. Can you say "outtakes"?)
- **Delete, copy, or move your video files** to other folders.
- **Share a selected video file** using one of FlipShare's sharing options.

✏ **Click an Action bar icon.**

- Share a video file or use that video file to create a movie or DVD copy of the video file.

- Create a snapshot by selecting individual frames from the video file and saving those frames as individual picture files.

✏ **Log into and manage video files** stored in your Flip Channels folder.

✏ **Access and use Flip-oriented, Web-based resources** the same way you use your favorite Web browser.

The Workspace display sorting and layout buttons, selection buttons, and volume control slider disappear when you click the Resources section in the Navigation pane. Clicking the Resource section transforms the Workspace into a simple Web browser window.

You can work with the Resource sections' Flip-related Web pages you see in the Workspace's Web browser window the same way you use your favorite Web browser program. However, you can't use the Web browser window to go to other Web sites, such as www.dummies.com or joeygadget.com.

Sorting and displaying your video thumbnails

The FlipShare Workspace provides a few simple controls — as described in the following list — for displaying and working with your video thumbnail files:

✏ **Sort order:** Click the Show drop-down menu and select one of the choices to sort your video files in that particular order, as shown in Figure 6-7.

Note: The drop-down menu choices change based on which Navigation pane section you're viewing.

✏ **Workspace layout display:** Click one of the three Workspace layout display buttons in the upper-right corner above the Workspace to display your thumbnails as a single list of thumbnails, a series of rows and columns, or a single list of large videos that fill up the entire workspace area.

Note: Click and hold the middle layout display button to display a drop-down menu, and then choose one of the thumbnail size options to display the size and number of thumbnails that appear in the Workspace.

✏ **Select:** Click one of the Select buttons in the lower-left corner beneath the Workspace to quickly select All thumbnails displayed in the Workspace or None of them.

Note: You can also right-click/Control-click in the white space between video thumbnails and then choose Select All or Select None from the menu that appears to do those things.

Workspace layout display

Sort order

Select buttons

Volume

Figure 6-7: Choose how you want to sort your files in the Workspace display.

✔ **Volume:** Click the volume control slider in the lower-right corner beneath the Workspace and then drag left or right to decrease or increase (respectively) the playback volume of videos you play in the Workspace. You can also control the volume using the following keyboard shortcuts:

- Alt+↑/Option+↑: Increases volume
- Alt+↓/Option+↓: Decreases volume
- Ctrl+Alt+↓/⌘+Option+↓: Mutes sound

Watching and controlling your videos

You can play and control your videos in an any of the three Workspace display views using the control buttons shown in Figure 6-8.

To play and control your videos

✔ **Start watching your video.** Click the Play button. The Play button turns into a Pause button when your video starts to play. Click Pause to pause playback.

✓ **Rewind or fast forward to another location in the video.** Click and drag the progress bar slider beneath the video. You can also click the space on either side of the progress bar slider to jump directly to that location in the video.

✓ **Trim.** Click the Trim button to the right of the time-length indicator to open the Trim Tool window (row and column, and full-size Workspace layout views only), as shown in Figure 6-9. I tell you more about how to use this tool in Chapter 7.

Pause Progress bar slider Trim

Figure 6-8: Play, pause, fast forward, or rewind videos here.

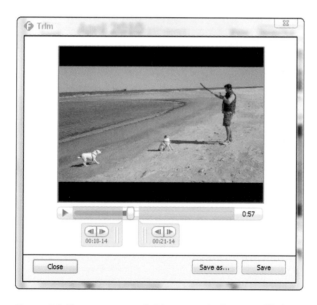

Figure 6-9: Remove parts of videos you don't want with the Trim Tool window.

Watching your videos in full-screen mode

You can watch your videos in full-screen mode to see them in the maximum size possible. To watch your videos in full-screen mode

1. **Right-click/Control-click a video thumbnail and choose Play Full Screen from the menu that appears.**

 You can also just click the Play Full Screen button in the Action bar at the bottom of the FlipShare main window; I talk more about the Action bar in the next section.

 The Play Full Screen window appears with a list of keyboard shortcuts you can use to control playback when you watch your video in full-screen mode, including

 - Spacebar: Pauses and plays your video

 - Right arrow (→): Fast-forwards 20 seconds

 - Left arrow (←): Rewinds 20 seconds

 - Esc(ape) or mouse click: Closes the full-screen window mode and returns to the FlipShare main window

2. **Click OK to watch your video in full-screen mode, or click Cancel if you don't want to watch your video in full-screen mode.**

3. **(Optional) Select the Don't Show This Again check box if you don't want FlipShare to display the Keyboard Shortcuts reminder window every time you watch a video in full-screen mode.**

 Your video fills your entire screen and begins playing.

 The full-screen mode closes and returns to the FlipShare main window when your video reaches the end.

Action bar

The Action bar lives at the bottom of the FlipShare main screen, as shown in Figure 6-10. This is where you'll find a smattering of big fat buttons that you can click to perform certain tasks with video files you select and other content you select in the Workspace area.

Figure 6-10: Click Action bar icons to do things with files you select in the Workspace.

The first two action bar buttons (Save to Camcorder and Play Full Screen) do their respective things with a selected video or picture with a mere click of the mouse. Click any of the remaining Action bar buttons, grouped under the guises of Share and Create, to initiate tasks that require two or more steps to complete.

Here's what each Action bar button does:

✔ **Save to Computer/Save to Camcorder:** Copy video and/or snapshot files to or from your computer or camcorder, depending on which section of the Navigation pane you select. When you click the Camcorder Navigation pane section title, this first Action bar button is named Save to Computer. When you click any of the other Navigation pane section titles, this first Action bar button is named Saved to Camcorder.

✔ **Play Full Screen:** Play selected video (or videos) or display selected snapshot (or snapshots, as a slideshow) in full-screen mode.

✔ **Email:** Open the Share by E-mail window with text fields where you type e-mail addresses of recipients with whom you want to share selected video or snapshots.

✔ **Flip Channel:** Open the Share by Flip Channel window, with its text field to type in e-mail addresses of recipients you want to invite to your Flip Channel so that they can play or view selected videos or snapshots.

✔ **Greeting Card:** Open the Share Greeting Card window to display themed greeting card choices (holidays, thank you, and so on). Then you type in e-mail addresses of recipients you want to share selected videos or snapshots with.

✔ **Online:** Open the Share Online window to display online sharing choices (Facebook, MySpace, YouTube, and Other Web Sites). Then you type in online account user and password information to connect with that service so that you can share selected videos or snapshots.

✔ **Movie:** Open the Create Movie window to begin the multi-step Magic Movie or Full Length movie creation process.

✔ **Snapshot:** Open the Create Snapshots window to select individual frames from selected video to create one or more snapshot picture files from those frames you select.

Because the Action bar buttons grouped in the Share and Create sections initiate tasks that require several steps to complete, I revisit those Action bar buttons in upcoming sections that show you how to perform each button's related task.

Organizing Videos, Snapshots, and Folders

The more video files you record with your Flip camcorder and copy to your computer, the more stuff you have to sort through and work with in FlipShare. Before you know it, you may be up to your arms in video files that you've imported and snapshots and movies that you've created from those video files.

Fortunately, FlipShare does a pretty great job of automatically organizing your files so that you can easily find, work with, or view videos without a lot of clicking around.

Naming, renaming, moving, copying and deleting files, creating new folders or deleting ones you no longer want, and making the most of the Favorites Navigation pane feature are what I describe in the following sections.

If, like me, you prefer keyboard shortcuts over mouse maneuvers, feel free to invoke those ol' favorites — Ctrl+C/⌘+C (Copy) and Ctrl+V/⌘+V (Paste) — instead of clicking the Edit menu to choose those commands.

Playing with Favorites

The Favorites folder in the Shortcuts section of the Navigation pane provides quick, one-click access to video, movie, and snapshot files you frequently view or work with. A file marked as Favorites is identified by a gold star above the upper-left corner of the file's thumbnail, as shown in Figure 6-11.

Click the Favorites folder anytime you want to display all your favorite files in the Workspace.

To add a video, snapshot, or movie file to the Favorites folder:

☆ Video 30 0:00:19-23 04/29/10

Figure 6-11: Favorite files are recognized by their star-star status.

- ✔ Click the grayed-out star icon above the upper-left corner of a file's thumbnail to turn the star to gold.
- ✔ Click and drag a file (or files) to the Favorites folder and then release the mouse to add that file (or those files) to the Favorites folder.

Creating and renaming folders

Although FlipShare thoughtfully creates and names folders based on the months you recorded videos when you copy those video files from your Flip camera to your computer, you might want to create additional folders. For instance, maybe you want to create a folder called My New Life, in which you copy video files from other folders no matter what month they were created.

To create a new folder, follow these steps:

1. **Choose File⇨New Folder.**

 You could also press Ctrl+N/⌘+N or click the New Folder icon to the right of the Computer section title in the Navigation pane.

 A new folder named Untitled Folder appears beneath any existing folders, and the folder is automatically highlighted.

2. **Type a name for your new folder and then press Enter/Return.**

 Your new folder is ready to serve.

To rename a folder you create, double-click the folder to select it, type a new name, and then press Enter/Return to save the folder with your new name.

Naming and renaming files

One of your Flip camera's great virtues is that you need to press the camera's red Record button only to start or stop recording videos with your camera. Unlike computers, which typically prompt you to give files a name when you save them, your Flip does the job without distracting you from your shooting by bugging you with questions about what you want to name your video files. Naming or renaming video files you copy to your computer makes it easier to remember what those files contain when it comes time to edit the files into movies that you want to share with others. You might want to also name or rename individual picture files you create from your video files using FlipShare's Create Snapshot feature.

To name or rename a video file or snapshot file

1. **Click the filename field next to the star icon.**

 The file's name field is selected and highlighted.

2. **Type a new name for your file, and then press Enter/Return to save your new filename.**

Copying files

Video files you record with your Flip camera and then copy to your computer are automatically saved in folders in the Computer section of the Navigation pane. FlipShare automatically creates and labels new folders based on the month when you captured the video that you're copying to your computer. If you're copying new video files that you captured during a month for which FlipShare already created a folder, those files are added to the existing folder.

You can create a new, duplicate file of an existing file by using the Copy command.

To create a new video, movie, or snapshot file of an existing file, follow these steps:

1. **Click the file you want to copy in the Workspace to select the file.**

 To select multiple files, hold the Ctrl/⌘ key and then click each file you want to select.

2. **Choose Edit➪Copy or press Ctrl+C/⌘+C to copy the selected file.**

3. **Click the folder in the Computer section of the Navigation pane that you want to copy the file to, or skip to the next step if you want to copy the file (or files) to the current folder containing your selected file.**

 The contents of the selected folder appear in the Workspace.

4. **Choose Edit➪Paste (press Ctrl+V/⌘+V).**

 The newly created file appears in the Workspace with the same name as the original file followed by a number in parenthesis, as shown in Figure 6-12.

Figure 6-12: Files you copy are renamed with a number at the end of the filename.

Moving files

Moving files from one folder to another should be as easy as dragging and dropping those files from the one to the other, right? Well, it is that easy — sort of — as long as the files you're moving to another folder are in the same section of the Navigation pane. However, if you copy a file from one section of the Navigation pane to another section — a file from a folder in the Computer section to a folder in the Flip Channels section, for instance — FlipShare *copies* that file instead of just moving the file (or files).

To make sense of whether a file is actually moved or a copy of the file is created and placed in a folder you drag a file to, keep these points in mind when you drag and drop:

⋙ Dragging a file from one folder to another folder in the same Navigation pane section moves that file.

⋙ Dragging a file from one folder to another folder in the same Navigation pane section while holding down the Ctrl/⌘ key makes a duplicate of that file.

Deleting files and folders

Deleting files you don't want to keep can help decrease overall clutter when you're using FlipShare. Cleaning house this way also frees up space on your computer's hard drive so that you have more room available for saving new video files you capture and copy from your Flip camera.

To delete a video, snapshot, or movie file, follow these steps:

1. **Click a folder in the Navigation pane to display that folder's contents in the Workspace. Then click the file you want to delete to select that file.**

 You can also choose Edit⇨Select All to choose every file in a selected folder, or you can select a specific group of files by holding the Ctrl/⌘ key and then clicking each file you want to delete.

2. **Choose Edit⇨Delete or press the Delete key (the trash can icon).**

 A warning message appears, asking whether you're sure you want to delete the file (or files).

3. **Click Permanently Delete to delete your selected file (or files) or click Cancel if you were only fooling and don't really want to delete your selection.**

 Your selected file (or files) disappears from the FlipShare Workspace (and from the storage space it occupied on your computer's hard drive until you gave it the digital heave-ho).

You can delete certain folders in the Navigation pane — and in the same fell swoop, delete any files stored in those folders. Folders you can delete (and all the goods inside those folders) include

⋙ Folders that FlipShare automatically creates in the Computer section when you copy video files from your Flip camera to your computer's hard disk

> ✔ Folders FlipShare automatically creates in the Computer section that you renamed
>
> ✔ New folders you created in the Computer section
>
> ✔ Folders you created in the Flip Channels section

To delete a folder (and any files stored in that folder), follow these steps:

1. **Click a folder you want to delete and then click the trash can icon to the right of that folder.**

 You can also choose File➪Delete Folder(s) or press the Delete key.

 A warning message appears, asking whether you're sure you want to delete the selected folder and all the files inside that folder.

2. **Click Permanently Delete to delete your selected folder and the files contained therein, or click Cancel if you were only fooling and don't really want to delete your selection.**

 Your folder vanishes from the FlipShare Navigation pane (and file number indicators to the right of FlipShare's other Navigation pane folders decrease by however many files were stored in the folder you just deleted).

Note: Although you cannot delete certain permanent folders, such as the folders in the Shortcut section, you *can* delete the files stored in those individual Shortcuts folders, as I describe in the preceding section. Ditto for the topmost My Channel folder in the Flip Channels section.

Creating Movies, Snapshots, and Photo Slideshows

The FlipShare program can act as your be-all movie-making centerpiece. With FlipShare, you can copy your saved video files from your Flip to your computer, organize those files, and use those files to make movies and capture individual picture files — and then share those movies and picture files a number of ways. And with FlipShare, you can also quickly create a movie with FlipShare's Magic Movie feature (I show you how in this chapter), which makes editing choices for you and gets the job done in just a few steps (even if it limits you to just a few options). You can also create a full-length movie (I also show you how), which is a fancy way of saying a movie you create by taking full control of every trick FlipShare has up its sleeve.

Before you share your movie and photo sensations, you'll want to edit your video clips with FlipShare's Trim feature to cut away parts of your videos you don't want to appear in your movie. You can also use FlipShare's Snapshot feature if you want to pluck individual shots from your video clips so you can use those shots as standalone pictures you can share with others, or include those shots as images right inside a movie you create. This chapter has the details on these processes as well.

In Chapter 5, I show you how to move videos from your Flip camera into the FlipShare program and also give you a guided tour of the FlipShare interface and features. I make the assumption that if you're reading this chapter you know your way around FlipShare — either by reading Chapter 5 or by fiddling with the program on your own — and you have a pretty good understanding of what features it offers and what those features do.

Creating Your First Magic Movie

A Magic Movie is magical mainly because you're leaving it up to FlipShare to edit together random segments of your clips and pictures into a final shortened movie that captures the overall essence of your clips.

Some key decisions the Magic Movie feature makes with regards to your clips when you create a Magic Movie include

- ✔ Clips are trimmed at random into smaller segments that are woven together into a shortened final movie that you save as a separate movie file.

- ✔ Clips longer than 1 minute are separated into 1-minute mini-segments, from which random segments are extracted and combined to create a trimmed segment representing the original minute-long clip.

- ✔ Clips shorter than 4 seconds are left as-is and are not trimmed.

Time to crank out your first movie in a matter of minutes (or maybe even seconds, if your movie's a really short one). To create a Magic Movie, follow these steps:

1. **Launch FlipShare to open the FlipShare main window, as shown in Figure 7-1.**

2. **Click a video clip or photo in the Workspace — one that you want to use to create your movie — to select and highlight that clip.**

 Note: Hold down the Ctrl/⌘ key to select more than one video clip or photo.

3. **Click the Movie button in the Create section of the Action bar beneath the Workspace to open the Create Movie window, as shown in Figure 7-2.**

4. **If you selected only one clip for your movie, proceed to the next step. Otherwise, feel free to drag and drop your clips to rearrange the order in which they appear.**

 You can also drag more clips or pictures from the Workspace into the Create Movie window, or remove ones you don't want by clicking the X button to the upper left of the clip (see Figure 7-2).

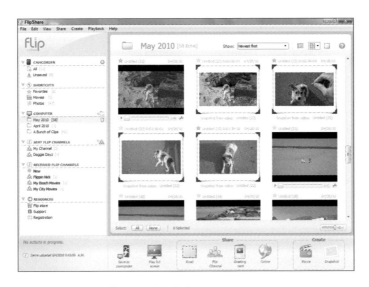

Figure 7-1: The FlipShare main window.

5. Click the Magic Movie button in the bottom-right corner.

FlipShare processes your selection and then displays a preview of your movie in the Create Movie window, as shown in Figure 7-3.

Click to watch a preview of your movie.

Figure 7-2: The Create Movie window.

Figure 7-3: A preview of your Magic Movie appears in the Create Movie window.

6. **Click the Play button to watch a preview of your movie if you want, or just click Next to display the next Create Movie window step, which involves adding titles and credits to your Magic Movie.**

 The Back button takes you back to the Create Movie screen shown in Figure 7-2, where you can rearrange your clips, delete ones you don't want, or add new ones.

7. **Select the check boxes next to any of the title and credit options to add those options to your movie; if you choose the first or second options, click in the text field of the preview thumbnail (see Figure 7-4) for those options and type in the text you want to appear.**

 Note: Any text you type in the title or credits sections is limited to only what fits in the box; you can type more text if you want, but no one will see it because it doesn't appear when you play your movie.

8. **Click Next to display the next Create Movie window, which lets you choose an audio file and options for how your chosen audio file plays in the background as your movie plays, as shown in Figure 7-5.**

9. **Select one of the following Music File choices:**

 - *No Music:* If you don't want to add a background audio file to your Magic Movie, proceed to Step 11.

 - *Use Flip Video Music:* Click the drop-down menu and choose a music track, as shown on the left in Figure 7-6; click the Play button on the Preview thumbnail

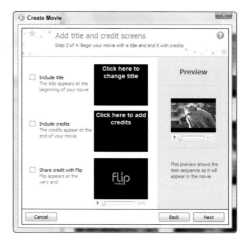

Figure 7-4: Add a title and credits to your Magic Movie.

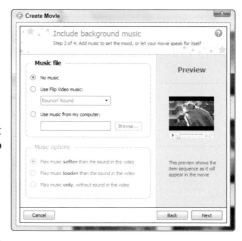

Figure 7-5: Add background music to your Magic Movie.

to the right to watch a preview of your video and hear the background music track you selected.

- *Use Music from My Computer:* Click the Browse button to open a dialog box, as shown on the right in Figure 7-6, in which you navigate to and select an audio file you want to use. Then click the Open button to select that audio file and return to the Create Movie window.

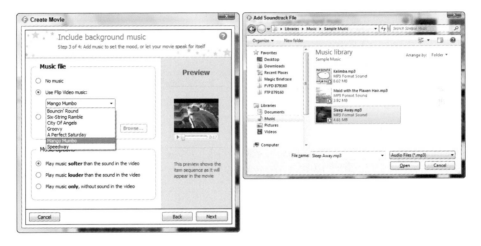

Figure 7-6: Use FlipShare's background music tracks (left) or your own (right).

10. **(Optional) Select one of the Music Options choices to include ambient sound or not:**

 - Play your selected music track *softer* or *louder* than any ambient sound that was captured with your video when you recorded your video (such as people singing "Happy Birthday," or crashing ocean waves and cawing seagulls).

 - Play *only* your background music track but none of the ambient sound you might have recorded when you captured your video.

11. **Click Next to display the next Create Movie step. In the Name field (shown in Figure 7-7), either stick with the default name provided or type a name for your movie file.**

12. **(Optional) If you want to save your file to a different location than the one displayed under To Folder, click the Change Folder button, choose your desired location, and then click Save.**

 You're taken back to the Create Movie window.

13. **Click the Create Movie button.**

The Progress box displays the `FlipShare is Working` message and a progress bar as FlipShare creates your Magic Movie, followed by a `Movie Created` message when your Magic Movie is complete.

Your new movie appears in the Workspace, as shown in Figure 7-8, ready for you to share with others, which I show you how to do later in this chapter.

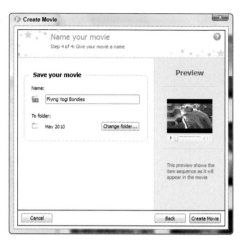

Figure 7-7: Name your movie file.

Figure 7-8: Presto! Your Magic Movie is ready to share!

More than one way to make a movie

Keep in mind that although creating a full-length movie gives you the power to create more interesting movies than movies you make using the Magic Movie feature, neither of FlipShare's movie-making methods compares with the richer, more powerful movie-making features found in the Windows and Mac video editing programs I write about in Chapters 10 and 11, respectively.

Creating a Full-Length Movie

Ready to roll up your sleeves and create a longer, more opulent and creatively complex (and hopefully more enjoyable to watch) movie using FlipShare's Full Length movie creation feature? Bravo! But before you do, I have some exciting news for you; although it might not sound so exciting when you first hear it. Here goes: Creating a full-length movie is accomplished by performing the same steps you take to create a Magic Movie.

Figure 7-9: Click the Full Length button to take control of your movie.

Wait, wait! Please remain in your seat! Before you toss your bucket of popcorn at the screen, let me clarify my statement. There is *one* tiny step in the movie-making process I describe in the preceding section that differs when you create a full-length movie. It happens in Step 5, and it's simply this: Instead of clicking the Magic Movie button (see Figure 7-9), you click the Full Length button. That's it. But, oh! what a majorly different outcome that single mouse click produces.

Opting for Full Length means that FlipShare takes a hands-off approach to editing your movie and simply packages your selected files into a final movie file that you can share. So, it's up to you to edit your video clips by trimming the parts you don't want before you select those clips to include in the final movie that FlipShare will create if you go for Full Length. You get to choose the length of and content of all the individual video clips you want to include in your full-length movie, and that's what appears in the final movie file FlipShare spits out at the end of the process (with pretty titles and credits and background music accompaniment, if those are elements you choose to also add to your movie).

So, in a nutshell, the big-picture take on creating a full-length movie really comes down to these three steps:

1. Trim video clips you want to include in your movie so that those clips contain only the footage you actually want to appear in your final movie.

2. Create snapshot picture files from your video files for any pictures you want to include in your final movie.

3. Click the Movie button on the Action bar and then follow the prompts to create your actual final movie file. (This process is similar to Steps 6–13 in the "Creating Your First Magic Movie" section.)

The following sections detail each step.

Trimming video clips

Sometimes a video clip contains a little too much extra footage that you need to trim. Fortunately, you can use FlipShare's Trim Tool window, shown in Figure 7-10, to remove unwanted sections of footage from the beginning, end, or both the beginning and end of a selected video clip.

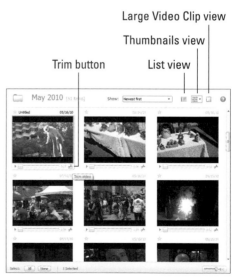

Here are the two ways you can choose the Trim command and open the Trim Tool window for a selected clip:

Figure 7-10: Cut excess footage.

✔ Choose Edit⇨Trim.

✔ Click the Trim button (the scissors icon; see Figure 7-11) in the lower-right corner of a video clip thumbnail in the Workspace when viewing your clips in either Thumbnails view or Large Video Clip view.

Don't worry that trimming a clip means the parts you clip are gone forever. Even though trimming makes it appear as if the sections of snipped footage are gone for good, those trimmed parts still exist. FlipShare simply hides and ignores the sections as if they're gone based on your trim choices. As with all things that seem to vanish when

Large Video Clip view

Thumbnails view

Trim button List view

Figure 7-11: Open the Trim window by clicking the scissors icon.

you're working on a movie project file, the original files you imported into FlipShare (stored in the folders under the Computer section of the Navigation pane) remain intact regardless of how you slice, dice, or otherwise transform the video clips you play with in the Workspace pane.

To trim a video clip, follow these steps:

1. **Click a clip in the Workspace that you want to trim to select that clip, and then choose Edit⇨Trim to open the Trim Tool window (refer to Figure 7-10).**

 The Seek slider bar beneath the video preview window changes to the Trim Tool slider bar, which has start and end point sliders at either end. The scroll bar button appears to the right of the left-side start point slider.

2. **Click and drag the Trim Tool slider and the start and end point slider buttons to frame the section of your video clip that you want to keep.**

 Figure 7-12: Note what footage to keep.

 Note: You can drag the slider that's between either of the Trim Tool sliders to quickly move around in your video to find the section you're looking for.

 The parts between the left and right sliders are what stays, and the parts on either side of the sliders are removed, as shown in Figure 7-12. That is, the section of footage between the start and end point sliders is the footage you want to keep.

3. **Save your trimmed selection either one of two ways:**

 - *Click Save.* You're done.

 - *Click Save As.* The Save Trimmed Video dialog box appears where you can enter a name (in the Video Name text box) and then choose a new location if you want to save your trimmed clip in a different folder than what's selected. Click Save when you're done to save your trimmed clip and return to the Trim Tool window.

 Note: Back in the Trim Tool window, click the Close button to close your video clip without saving your original video clip. You already saved a copy of the trimmed clip using the Save As button.

The Trim Tool window closes, and your trimmed clip appears in the Workspace.

To restore a trimmed section of video to a trimmed clip

1. **Select your trimmed video clip, and then choose Edit⇨Trim to display the Trim Tool window (refer to Figure 7-10).**

2. **Drag the start point trim slider all the way to the left and the end point trim slider all the way to the right; then click Save.**

 The Trim Tool window closes, and your restored clip appears in the Workspace.

Capturing Snapshots from video clips

Although your Flip camcorder doesn't have a feature to let you capture individual snapshots the way you can with most other camcorders (or camera-equipped smartphones, for that matter), you can extract single-frame pictures from your video files by using FlipShare's Snapshot feature.

To create a snapshot, follow these steps:

1. **Select a video clip in the Workspace, and then choose Create⇨ Snapshot to open the Create Snapshots window, as shown in Figure 7-13.**

 You can also just click the Snapshot button on the Action bar.

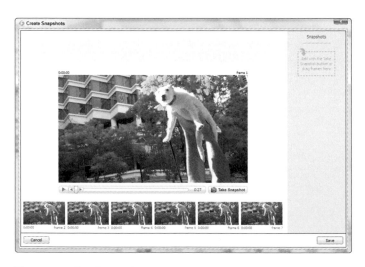

Figure 7-13: The Create Snapshots window displays frames of your video clip that you can save as snapshots.

2. **Drag the slider left or right to move through your video clip until you find the frame you want to save as a snapshot.**

 You can also:

 - Click the Play button to watch your video, and then click the Pause button to stop your video when you see a frame you want to capture as a snapshot.

 - Click any thumbnail above or below the preview window to jump directly to frames that come before (above) or after (below) the frame displayed in the preview window.

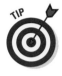

 Depending on how fast (or slow) your computer is, the thumbnail frames displayed above and below the preview window might appear very quickly (or very slowly) while you move through your video clip.

3. **If you want to save only one frame as a snapshot, proceed to Step 4; otherwise, select two or more frames to save as snapshots by clicking and dragging one of the following:**

 - The displayed frame in the preview window to the Snapshots column to the right of the preview window.

 - One of the thumbnail frames displayed above or below the preview window to the Snapshots column to the right of the preview window, as shown in Figure 7-14. (To delete a snapshot image from the Snapshots column, click the image thumbnail and press Delete.)

Figure 7-14: Drag and drop one or more thumbnail images to the right column to create a snapshot.

4. **Click the Save button in the lower-right corner to save your selected snapshot image (or images).**

 Your snapshot (or snapshots) appears in the Workspace window framed by a unique mounted-photo border, as shown in Figure 7-15, which makes them easy to differenti-ate from video clips.

Figure 7-15: Snapshot thumbnails are easy to spot.

Making the final movie file

To create your actual final movie file, just follow these steps:

1. **Trim the clips and create any snapshots you want to use in your movie, as I show you in the preceding sections.**

2. **Select the video clips and/or snapshots in the Workspace that you want to use in your movie.**

 Note: Hold down the Ctrl/⌘ key to select more than one video clip or photo.

3. **Click the Movie button in the Create section of the Action bar to open the Create Movie window.**

4. **Drag and drop your clips to rearrange their order.**

 You can also drag more clips or pictures from the Workspace into the Create Movie window, or remove ones you don't want by clicking the X button to the upper left of the clip (as shown in Figure 7-16).

Figure 7-16: Drag and remove clips.

5. **In the Create Movie window, click the Full Length button in the bottom-right corner.**

6. **Follow Steps 6–13 in the section "Creating Your First Magic Movie" to complete a Full Length movie.**

Unlike creating a Magic Movie, the progress bar that appears at the end of the process can take a lot longer to fill up when you create a full-length movie. When it's finally finished, the `Movie Created` message appears. FlipShare doesn't shorten your selected clips when you create a Full Length movie the way it automatically (and radically) trims clips when you create a Magic Movie.

Creating Photo Slideshows

When you create a Magic Movie or Full Length movie, you can add snapshots to your movie that appear on the screen for a few moments before the next video shot appears, or at the beginning or end of your movie. You can also create an entire movie made up of only snapshots and no video. A movie made of only photo snapshots without video is a *photo slideshow*.

To create a photo slideshow, follow the same steps I give you in the earlier section, "Creating Your First Magic Movie," but choose only snapshots — and no video files — that you want to include in your photo slideshow.

When you're done, your photo slideshow appears in the Movies folder of the Navigation pane, and in the Workspace window, just like any other movie you create, as shown in Figure 7-17.

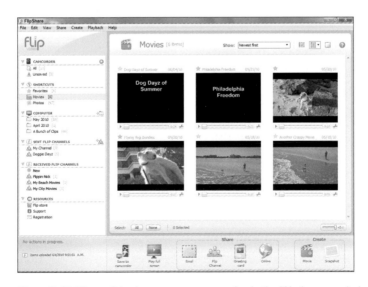

Figure 7-17: Photo slideshows appear as movies in the Workspace window.

Sharing Your Movies and Slideshows

After you edit your video clips and snapshots to create a Magic Movie or Full Length movie (or create snapshots or a photo slideshow), you'll probably want to share your handiwork to others so they can watch your movie or view your pictures or photo slideshows.

Share your creations by clicking one of the buttons on the Action bar (see Chapters 8 and 9 for details):

✔ E-mail your creation to one or more recipients.

✔ Upload your creation to your Flip Channel. Invite others to view by adding their e-mail addresses to your list of approved viewers.

✔ Frame your creation in a colorful greeting card that you e-mail to one or more recipients.

✔ Upload your creation to Facebook, MySpace, YouTube, or another sharing Web site that others can access through their Web browser.

8

Creating Video E-Mails, Greeting Cards, and DVDs

In This Chapter

▶ Sending video and picture e-mails
▶ Creating and sending greeting cards
▶ Burning movies with iDVD
▶ Burning movies with Windows DVD Maker

*Y*our Flip is great for capturing special moments like your best friend walking into the room when everyone screams, "Surprise!" Capturing and then watching videos on your Flip is entertaining, but crowding a bunch of friends around your Flip's tiny screen isn't fun. Fortunately, you can easily share your movies by sending your creations (or pictures you capture from your videos) to others as e-mails or greeting cards. You can also burn your movie and picture slideshow creations to a DVD. In this chapter, I show you how you can do all of these things using the FlipShare program — and, when it comes to burning DVDs, other programs as well.

In this chapter, I make the assumption that you know how to launch the FlipShare program; that you've already copied video files from your Flip camera to your computer; and that you know how to browse, view, organize, and work with those video files. I also assume you know how to create a movie, capture individual picture snapshots from your video clips, and create photo slideshows. If you plan to share your creations as e-mails or greeting cards, I also assume you already have an e-mail address because you'll need to enter it when you use FlipShare to send an e-mail or greeting card. And last, if you intend to burn your movies and photos to DVDs that you can distribute to friends, family members, or anyone else, I naturally assume that your computer is equipped with a DVD drive capable of pulling off this kind of disc mastery.

Sending Video and Picture E-Mails

Sharing movies and pictures you capture and create by sending an e-mail message makes it easy to reach out and touch someone with your creations no matter how near or far they are.

Although FlipShare allows you to send your videos or pictures as an e-mail message, the e-mail message that your recipient receives contains a link inviting them to view your videos or pictures through their Web browser. In other words, the e-mail itself doesn't contain the actual video or picture files.

To send a video or picture e-mail, follow these steps:

1. **Launch FlipShare (if it isn't already running).**

2. **Click a video or picture item that you want to send as an e-mail.**

3. **Click the Email icon on the Action bar (or choose Share⇨Email).**

 The Share by E-mail window, shown in Figure 8-1, appears with a thumbnail of your selected item (or items).

4. **(Optional) Add more items from the Share by E-mail window by dragging and dropping items from the Workspace window to the right column of the Share by E-mail window.**

 If you change your mind about a file or add the wrong one, just click the red X in the left corner next to items you want to delete from your e-mail.

5. **Fill in each of the text fields:**

 • *Your Name:* Use whatever name you want to appear as the sender of the e-mail. Your name is automatically filled if you've previously sent an e-mail. See Figure 8-1.

 • *Your Email:* Add your e-mail address. Your e-mail address is automatically filled in if you've previously sent an e-mail.

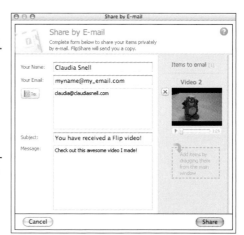

Figure 8-1: Type in your intended recipients' e-mail addresses.

- *To:* Add the e-mail address for your intended recipient. If you want to send your e-mail to more than one recipient, add each e-mail address, separated with a comma.

 (Optional) Click the To button to open an Address Book where you can choose an address (or addresses). Then click the Add To button to close the Address Book window and add your selected recipients to the To field.

- *Subject:* You can keep the text that's already filled in, or backspace over the text and type in new text that you want to appear as the Subject line for your e-mail.

- *Message:* Type any message you want your recipient to see.

6. **Click Share.**

 The Share by E-mail window closes, and a progress bar appears in the Progress box as FlipShare sends your e-mail message. An `Items Emailed` message lets you know when FlipShare successfully e-mails your message.

When you send a video or picture e-mail, FlipShare also sends a copy of your e-mail to the e-mail address you typed in for yourself. To see what your recipients will see when they open your invitation, open your message in your e-mail program. An example is shown in Figure 8-2.

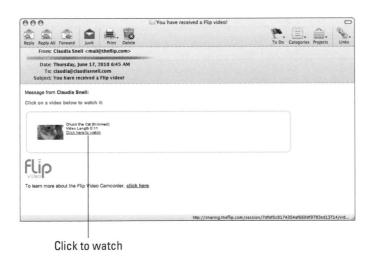

Click to watch

Figure 8-2: The e-mail message FlipShare sends you.

When you click the Click Here to Watch link, your Web browser automatically launches (if it isn't already running) and opens a Web page showing your picture or video. Click the Play button (shown in Figure 8-3) to view your creation.

Creating and Sending Video and Picture Greeting Cards

Click to play the video.

Figure 8-3: Click play to view the video or picture you e-mailed to others.

You can invite others to view your movies and pictures by sending your electronic invitation as a colorful greeting card custom tailored for a particular holiday or event. You do so by using one of FlipShare's many greeting card choices. Greeting cards that aren't tied to a particular event are also available.

To send a video or picture greeting card, open FlipShare and follow these steps:

1. **Click a video or picture item you want to send as a greeting card, as shown in Figure 8-4, and then click the Greeting Card icon on the Action bar.**

 The Select Your Card window appears (shown in Figure 8-5) and displays a scrollable list of greeting card theme choices.

2. **From the Category drop-down menu, click a theme category.**

 Categories include Love and Friendship, Thank You, or Others.

3. **Click Next.**

Figure 8-4: Click a video or picture thumbnail to select the item you want to e-mail.

The Arrange Your Items window appears, as shown in Figure 8-6, displaying a thumbnail of your selected video or picture item (or items) on the left. On the right is a preview of your greeting card that you can watch by clicking the Play button to see how your card will look.

4. **(Optional) Add, rearrange, or remove items from the Greeting Card window:**

 - *Add:* Drag and drop items from the workspace window to the left side of the Greeting Card window.

 - *Rearrange:* Drag and drop items in the left side of the Greeting Card window to rearrange the order in which the item will appear when the recipient watches the greeting card.

 - *Remove:* Click the X to the left of an item to delete that item from your greeting card.

5. **Click Next to display the Select Recipients window, as shown in Figure 8-7, and then fill in the text fields.**

 - *Your Name:* Use whatever name you want to appear as the sender of the greeting card. Your name is automatically filled if you've previously sent an e-mail.

 - *Your Email:* Enter your e-mail address. Your e-mail address is automatically filled in if you previously sent an e-mail.

 - *To:* Fill in the e-mail address for your intended recipient. If you have more than one recipient, add each e-mail address separated by a comma.

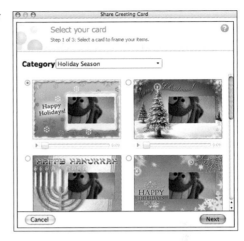

Figure 8-5: The Share Greeting Card window displays theme styles you can choose.

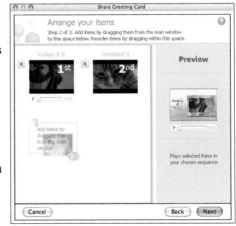

Figure 8-6: Review your selected item(s) and a preview of your card.

(Optional) Click the To button to open an Address Book where you can choose an address (or addresses). Then click the Add To button to close the Address Book window and add your selected recipients to the To field.

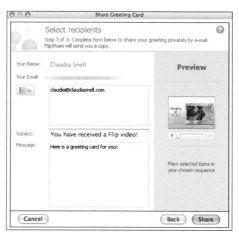

Figure 8-7: Add recipients' e-mail addresses here.

- *Subject:* You can keep the text that's already filled in, or backspace over the text and type in new text that you want to appear as the Subject line for your e-mail.

- *Message:* Type in a message you want your recipient to see. If you don't, FlipShare asks if you want to send the email with no message text.

6. **Click Share.**

The Share Greeting Card window closes, and a progress bar appears in the Progress box as FlipShare sends your e-mail message. Then you see an `Items Emailed` message, which lets you know when FlipShare successfully e-mailed your message.

When you send a video or picture e-mail, FlipShare also sends a copy of your e-mail to the e-mail address you typed in for yourself. To see what your recipients will see when they open your invitation, open your message in your e-mail program. When you click the Click Here to Watch link, your Web browser automatically launches and opens a Web page showing your picture or video. Click the Play button (shown in Figure 8-8) to view your creation.

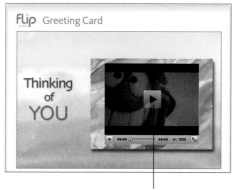

Click to pay the video.

Figure 8-8: View the video or picture greeting card you e-mailed.

Burning Movies and Pictures to DVDs

Burning a copy of your movie or photo slideshows to a DVD disc using iDVD or Windows DVD Maker enables you to create a disc you can give or send to another person, who can then enjoy your movie on their computer TV. If you ever dreamed of creating your own Hollywood-style DVDs to present your home movies or digital photographs, you've come to the right place to see how to do just that.

Using FlipShare

If you created a movie or slideshow using FlipShare's Magic Movie or Full Length feature, you can use FlipShare's Create DVD command to save your movie or slideshow as a file that's ready to burn using one of the programs I write about in the following sections of this chapter.

You can also use Create DVD to save any video or picture files you want to burn to a DVD, even if you didn't create a Magic Movie or a Full Length Movie from those video or picture files.

To save a FlipShare movie or slideshow as a file you can open with your preferred DVD-burning program, open FlipShare and then follow these steps:

1. **Select a movie (or video clip or snapshot) that you want to save as a file you can open with your DVD-burning program; then choose Create⇨DVD.**

 To select more than one item, hold down the Ctrl/Control key and then click each item you want to select.

 The Create DVD window appears, displaying a text field for naming the folder FlipShare automatically creates to store your file, as well as a thumbnail of your item (or items) in the right column.

2. **(Optional) Backspace over the text in the text field and type in a new name for the folder FlipShare creates to store your file; see Figure 8-9.**

3. **Drag and drop additional items from the workspace window to the right-hand Items for DVD column of the Create DVD window.**

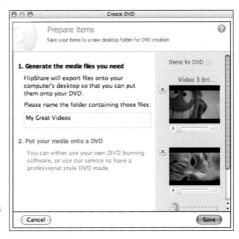

Figure 8-9: Name the folder that FlipShare creates to store your file.

Click the red X in the left corner next to items you decide you don't want to save with your file.

4. **Click Save.**

The Create DVD window displays a message confirming your file has been saved to the folder on your desktop.

Using iDVD

The iDVD program comes preinstalled with all new Macs, and also with the iLife suite of programs that you can purchase separately.

To burn DVDs using iDVD, you need a Mac with a DVD drive that can write to DVD. If your Mac's DVD drive can't write to DVD, you can purchase an external DVD drive that can burning DVDs, or you can transfer your iDVD project to another Mac to create your DVD.

To create a DVD, the iDVD welcome screen, shown in Figure 8-10, gives you these choices:

Figure 8-10: iDVD options for burning your DVD.

 ✔ **Create a New Project:** Create custom DVD menus and graphics for storing and presenting digital photographs and movies.

 ✔ **Open an Existing Project:** Open a DVD project you already created to change that project or finish it.

 ✔ **Magic iDVD:** Choose from a variety of DVD templates that you can modify for creating menus to organize the content of digital photographs and movies stored on the DVD.

 ✔ **OneStep DVD:** You can opt for this quick-and-easy way to transfer a video directly from a digital video camcorder or movie file to a DVD that, when inserted into a DVD player, begins playing immediately, with none of the menus or other fancy enhancements you can add to your DVD using the Magic iDVD and DVD project options.

I provide detailed step-by-step instructions for those fancier options, but not for the OneStep DVD option. The results for the others are so darn sweet. If you still want to burn your DVD using the OneStep DVD option, though, check out the nearby sidebar, "Burning a video straight to DVD."

Creating a DVD with the Magic iDVD option

The Magic iDVD option provides predesigned templates that you can customize to create DVD menus. To choose the Magic iDVD option, follow these steps:

1. **Click the iDVD icon on the Dock (or double-click the iDVD icon in the Applications folder).**

2. **In the iDVD welcome window that appears, click Magic iDVD.**

 The Magic iDVD window appears, as shown in Figure 8-11.

Figure 8-11: Choose the template, pictures, and video files to include on your DVD.

3. **Type a descriptive name for your DVD in the DVD Title text box.**

4. **Choose a theme, such as Vintage Vinyl or Sunflower, from the Theme browser.**

 Each theme offers a different appearance for your DVD menus. The theme names are pretty self-explanatory.

5. **In the Media pane (on the right) of the Magic iDVD window, click the Movies tab.**

 A list of movies stored in your Movies folder appears. If you don't see the movie file you want, navigate to the folder containing that movie file.

 Note: Video files you copied from your Flip to your Mac using FlipShare are stored in the Movies⇨FlipShare Data⇨Videos folder.

6. **Click and drag a movie that you want to add to your DVD onto the Drop Movies Here drop well.**

To select multiple movies, hold down the ⌘ key and click each movie you want to add to your DVD.

If you click a movie and click the Play button, you can see a thumbnail image of your movie.

7. **In the Media pane, click the Photos tab.**

A list of photos stored in iPhoto appears.

Note: You can drag and drop any picture file from anywhere on your computer's hard drive to the Drop Photos Here section of the iDVD main window.

8. **Click and drag a picture that you want to add to your DVD onto the Drop Photos Here drop well.**

To select multiple pictures, hold down the ⌘ key and click each picture you want to add to your DVD.

Each drop well represents a separate slideshow. Generally, you want to put several pictures in the same drop well to create a slideshow of multiple pictures. Underneath each drop well, iDVD lists the number of slides currently stored.

9. **In the Media pane, click the Audio tab.**

A list of audio files stored in iTunes and GarageBand appears.

10. **Click and drag an audio file that you want to play during a photo slideshow onto the Drop Photos Here drop well.**

Figure 8-12: An audio icon identifies pictures with an audio file.

Pictures that include audio appear with an audio icon over them, as shown in Figure 8-12.

Magic iDVD is smart enough to time the audio file you added to the length of your video. For example, if you add a 3-minute audio file over a slideshow (in the drop well) that contains three slides, each slide will appear for 1 minute: that is, timed until the entire audio file finishes playing. Likewise, if you add a 3-minute audio file to a slideshow of 30 slides, each slide appears for 0.1 minutes (6 seconds). So, the more slides (pictures) you add, the faster the images pop up and disappear while the audio file plays.

11. **Click the Preview button in the lower-left corner.**

An iDVD Preview window appears with a controller (which mimics a typical remote control) so you can take your DVD through its paces to make sure it works the way you want, as shown in Figure 8-13.

Figure 8-13: Preview how your DVD will look when played.

12. **Click Exit on the controller on the screen.**

 The Magic iDVD window appears again.

13. **Select one of the following:**

 • *Create Project:* Save your DVD design to modify it later.

 • *Burn:* Burns your music, pictures, and movies using your chosen DVD theme. If you choose this option, you'll need to insert a recordable DVD in your Mac and then follow the prompts to burn the DVD.

Working with iDVD projects

For maximum flexibility, you can design your own DVD menus and add graphics to give your DVD a polished, professional look. When you create your own DVD project, you can save it and edit it later.

The different parts of an iDVD project are

- **Title menu:** Displays a list of the DVD contents, such as movies or slideshows

- **Slideshows:** Displays a slideshow of digital photographs

- **Movies:** Displays a movie

- **Text:** Displays text, which is useful for providing instructions or descriptions about the DVD

- **Submenus:** Displays another menu where you can offer additional slideshows or movies

- **Opening content:** Displays a photo or movie that appears as soon as someone inserts the DVD into a DVD player

Not every iDVD project uses all the preceding parts. At the very least, though, an iDVD project needs a title menu and one slideshow or movie.

To create a DVD project, follow these steps:

1. **Launch iDVD.**

2. **In the iDVD welcome window, you can**

 • *Start a new project.* Click Create a New Project.

 Figure 8-14: Creating a new project.

 A Create Project dialog appears, as shown in Figure 8-14. If you go to this route, then you name your project and choose an aspect ratio here (see Steps 3 and 4).

 or

 • *Open an existing project that you want to edit.* Click Open an Existing Project and then edit what you want.

3. **Enter a descriptive name for your project into the Save As text box and then choose where you want to save your project from the Where pop-up menu.**

4. **For the Aspect Ratio, select either the Standard (4:3, for ordinary TV screens) or Widescreen (16:9, for widescreen TVs) radio button.**

 Even though choosing Standard optimizes your DVD project for an ordinary TV set, it will still play on a widescreen but with borders on either side to maintain the video's proper resolution. Likewise, choosing Widescreen allows a DVD project to play on an ordinary TV set although it won't look as nice as on a widescreen TV.

5. **Click Create.**

 An iDVD project window appears with the Themes browser in the right pane, as shown in Figure 8-15.

6. **Scroll through the Themes browser to find one you like.**

 As you can guess, each theme offers a different appearance for your DVD menus. Click the triangle to the left of the theme to see how it will apply to the Main, Chapters, and Extras menus of your DVD. (Clicking the arrow again compresses the selection.)

 When you click a theme, a preview of the theme appears in the iDVD window. Depending on the theme you choose, you might see Drop Zones where you can place pictures or video.

 You can even customize some themes. I describe how in the next section.

Figure 8-15: Choose a theme.

7. **Double-click the title in the iDVD Project pane and then type the title of your movie or slideshow, as shown in Figure 8-16.**

 You can choose the font type and size from the menus that appear. And this is cool: Even if you click a different theme, your title remains.

8. **Choose File➪Save.**

 Save your project every so often while you're working on your project.

 After saving your iDVD project, you can quit iDVD or continue with the next sections to add pictures to your title menus, and to add movies and slideshows to your project.

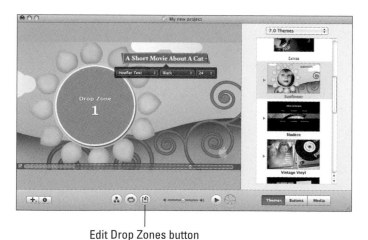

Edit Drop Zones button

Figure 8-16: Add the title of your movie or slideshow.

Adding photos to a title menu

Some themes display only a colorful graphic background, but others provide placeholders for adding your own pictures to customize the theme further. To add your own pictures, follow these steps:

1. **Open the iDVD project in which you want to add pictures.**

 Open a saved project by choosing File⇨Open or Open an Existing Project when iDVD first loads.

2. **Click the Media button in the bottom-right corner of the iDVD project window.**

 The Media pane opens, showing Audio, Photos, and Movies tabs on the right side of the iDVD window.

3. **Click the Photos button.**

 A list of photos stored in iPhoto appears, which you can add to your title menu.

 You can drag and drop any picture file from anywhere on your computer's hard drive to the Drop Photos Here section of the iDVD main window.

4. **Click the Edit Drop Zones button (the dotted square with the arrow at the bottom) to display a list of Drop Zones (refer to Figure 8-16).**

5. **Click and drag a photo to a Drop Zone and then release the mouse button.**

 Your chosen picture now appears as part of the DVD theme.

6. **Repeat Step 5 for any additional photographs you want to add to another Drop Zone.**

7. **Choose File⇨Save.**

 After saving your iDVD project, you can quit iDVD or continue working on your project.

Adding options to the title menu

After you define a theme and possibly add some photos for your title menu, you can add viewer options. The four types of options you can display on the title menu are slideshow menus, movie menus, text, and submenus.

Creating a slideshow

When a viewer selects a slideshow menu option, the DVD displays one or more digital photographs. To add a slideshow option to the title menu, you need to create a menu that allows viewers to choose your slideshow. Then you create the slideshow.

Burning a video straight to DVD

The OneStep DVD option allows you to burn a video from your FireWire-enabled video camcorder, or from a movie file on your hard drive, to a recordable DVD on your Mac. When you insert your finished DVD into a DVD player, your video starts playing immediately, with no DVD menus.

Although USB-enabled camcorders (like your Flip camera) don't work directly with OneStep DVD, you can still use video files you recorded with your Flip and copied to your computer, and choose those files when you select the files you want to use to create your OneStep DVD.

To burn a video using the OneStep DVD option, follow these steps:

1. **Launch iDVD.**

 Click the iDVD icon on the Dock, or double-click the iDVD icon in the Applications folder.

2. **Choose File⇨OneStep DVD from Movie.**

3. **Select your movie file from the dialog that appears, and then click Import.**

4. **Insert a recordable DVD in your Mac.**

 A dialog appears to let you know when the DVD has finished burning.

5. **Click Done.**

1. **Choose Project⇨Add Slideshow (or press ⌘+L).**

 A My Slideshow button appears on your title menu, as shown in Figure 8-17.

2. **Click the My Slideshow button.**

 The My Slideshow text becomes highlighted and displays Font, Style, and Font Size pop-up menus.

3. **Type descriptive text for your slideshow button.**

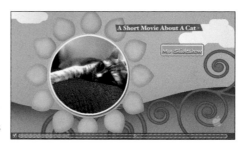

Figure 8-17: The slideshow menu option appears as a generic My Slideshow button.

4. **(Optional) Click the Font, Style, or Font Size pop-up menus to further format your text.**

5. **Double-click your slideshow button (called My Slideshow in Figure 8-17).**

 The iDVD project window displays a Drag Images Here box. Now you can start building the slideshow.

6. **Click and drag a photograph displayed in the right pane to the Drag Images Here box and then release the mouse button.**

 To select multiple pictures, hold down the ⌘ key and then click each picture you want to select. A slideshow can hold up to 99 pictures.

Your chosen pictures appear in the Slideshow window, numbered to show the order in which your pictures will appear, as shown in Figure 8-18. You can reorder your pictures by dragging and dropping a picture's icon.

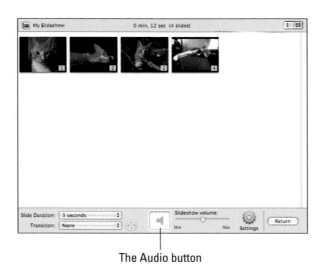

The Audio button

Figure 8-18: See the order of your images in your slideshow.

7. **(Optional) Open the Slide Duration pop-up menu and choose how long a slide stays onscreen.**

8. **(Optional) Open the Transition pop-up menu and choose a transition to display between slides, such as Dissolve or Twirl.**

9. **(Optional) Add sound by clicking the Audio button, clicking and dragging an audio file from the listing in the right pane to the left pane where file icons appear, and then releasing the mouse button.**

If you add an audio file to a slideshow, the slide duration defaults to the Fit to Audio option, which means that your pictures appear until the audio file finishes playing. However, you can override this default and set the time yourself by opening the Slide Duration pop-up menu and choosing how long you want the audio file to play (from 1–10 seconds).

10. **Click the Return button onscreen.**

Your DVD title menu appears again.

11. **Choose File⇨Save.**

You need to create a different slideshow menu option for each slideshow you want to include on your DVD.

Creating a Movie menu option

When a viewer selects a Movie menu option, the DVD plays a movie. To create a Movie menu option on the title menu, follow these steps:

1. **Choose Project⇨Add Movie.**

 An Add Movie Here button appears. This button provides a link to a movie.

2. **Click the Media button to open the Media pane and then choose Movies.**

 The movie files stored on your Mac appear.

3. **Click and drag the movie file of the movie you want on your DVD to the Add Movie Here button.**

 Your movie begins playing in the space where you put it.

4. **Choose File⇨Save.**

For a faster way to create Movie menu buttons, click and drag a movie shown in the Media pane anywhere onto your title menu and then release the mouse button to create a button that will play your chosen movie.

Creating text

Sometimes you might want to add text on a title menu to provide additional descriptions or instructions. To add text on the title menu, follow these steps:

1. **Choose Project⇨Add Text (or choose ⌘+K).**

2. **When the Click to Edit text box appears, click it.**

 Font, Style, and Font Size pop-up menus appear, as shown in Figure 8-19.

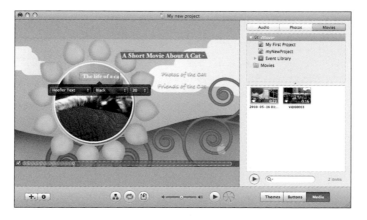

Figure 8-19: Use the pop-up menus to include text in your slideshow.

3. **Type descriptive text for your slideshow button, using the Font, Style, or Font Size pop-up menus to choose how to format your text.**

4. **Choose File⇨Save.**

Creating a submenu

If you have too many options on the title menu, the title menu can look cluttered. To fix this, you can create a submenu on your title menu and then place additional Slideshow or Movie options on this submenu. To create a submenu, follow these steps:

1. **Choose Project⇨Add Submenu.**

2. **Click the My Submenu button that appears.**

3. **Type descriptive text for your submenu button, and use the Font, Style, and Font Size pop-up menus to format your text.**

4. **Double-click the submenu button.**

 The iDVD window displays a new menu where you can add slideshows, movies, text, or even additional submenus.

5. **Choose Project⇨Add Title Menu Button.**

 Using a Title Menu button allows viewers to jump back to the title menu from your submenu. At this point, you need to add a Slideshow or Movie menu option on your submenu. Follow the steps outlined in the "Creating a slideshow" and "Creating a movie menu option" sections.

6. **(Optional) If the theme you choose has additional menu options, such as Extras or Chapters, use them for your submenu.**

 Choose the menu option you want from the Themes browser; the submenu changes to that option and keeps the titles, slideshows, or movies you added.

Moving and deleting buttons

After you create a Slideshow, Movie, Submenu, or Text button on a menu, you can move or delete it.

- ✔ **To move a button:** Click it. The text inside your button appears highlighted. Click and drag your selected button to its new location and then release the mouse button.

- ✔ **To delete a button:** Click it and then choose Edit⇨Delete. Your button disappears.

Defining opening content for your DVD

You can display a picture or a movie — the *opening content* — as soon as someone inserts your DVD into a DVD player. Opening content appears before the title menu appears and gives the audience a preview of your movie's flavor by showing the birthday girl (for example) who is the film's star. To define a picture or movie to display as the opening content, follow these steps:

1. **Choose View⇨Show Map (or click the Show the DVD Map button, which has a miniature organization chart with a box connected to two other boxes on it).**

 The Show Map command can be particularly useful when you want to see the layout of your entire iDVD project, as shown in Figure 8-20.

 The iDVD window displays a blank content box that displays the message `Drag Content Here to Automatically Play When the Disc Is Inserted.`

2. **Click the Photos or Movies tab in the Media pane to display your iPhoto pictures or the movies stored in your Movies folder.**

3. **Click and drag a picture or movie to the blank content box.**

4. **Release the mouse button.**

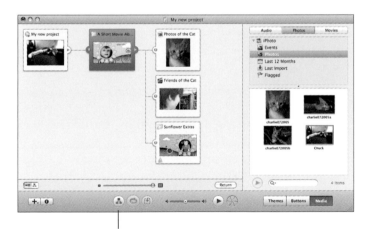

The Show the DVD Map button

Figure 8-20: The map view of your iDVD project displays the blank content box.

Burning to a DVD

When you save your iDVD project to a DVD, you create a DVD that you can give to anyone to play on any DVD player. To burn an iDVD project to a DVD, follow these steps:

1. **Insert a blank DVD into your Mac.**

2. **Choose File⇨Burn DVD.**

 iDVD prompts you to insert a recordable DVD.

3. **Pop-in your blank DVD, and then follow the prompts to burn your creation to your DVD.**

Using Windows DVD Maker

Windows DVD Maker is included with Windows Vista Home Premium and Ultimate editions, as well as with Windows 7 Home Premium, Professional, Enterprise, and Ultimate editions. If your version of Windows doesn't come with Windows DVD Maker, consider purchasing a DVD-burning program, such as Roxio's MyDVD or Roxio Creator (www.roxio.com). Or consider upgrading to Windows 7 so you not only get Windows DVD Maker, but you also wind up running the latest and greatest version of Windows to boot.

To burn DVDs using Windows DVD Maker or another DVD-burning program, you need a PC with a DVD drive that can write to DVD. If your Windows computer's DVD drive can't write to DVD, you can purchase an external DVD drive that's capable of burning DVD, or you can transfer your DVD project to another PC to create your DVD.

To burn a movie file to a DVD using Windows DVD Maker, follow these steps:

1. **Launch Windows DVD Maker by choosing Start⇨Programs⇨Windows DVD Maker.**

 The Windows DVD Maker program welcome window appears.

2. **Click Choose Photos and Videos.**

 The Add Pictures and Video to the DVD window appears, as shown in Figure 8-21.

3. **Click the Add Items button to open the Add Items to DVD dialog box, and then navigate to the folder containing your video or picture file (or files).**

 Note: Video files you previously copied from your Flip to your PC using FlipShare are stored in the My Videos⇨FlipShare Data⇨Videos folder, which you can find in your Home folder.

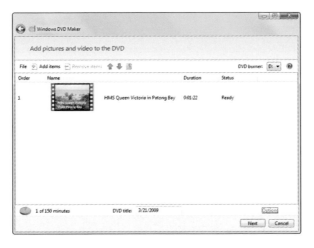

Figure 8-21: The Add Pictures and Video to the DVD window.

4. **Click the video or picture file icon you want to add to your DVD, and then click the Add button.**

 To select more than one file icon, hold down the Control key and then click each file icon you want to add to your DVD.

 Your selected file (or files) appears in the Add Pictures and Video to the DVD window.

5. **(Optional) Add, delete, or rearrange your video files or picture Slideshow folders and files in the Add Pictures and Video to the DVD window.**

 - *Add more items.* Click the Add Items button and repeat Step 4.

 - *Delete a file or Slideshow folder.* Click the file or folder to select it, and then click the Remove Items button.

 - *Rearrange the order of your items.* Click an item and then drag it up or down or click the up- or down-arrow button above the items list.

 - *View individual picture files you added.* Double-click the Slideshow folder to open and view the contents of that folder.

6. **(Optional) Double-click the date in the DVD Title text field and type a name for your DVD that's more interesting and descriptive than the boring default name already filled in for you.**

7. **(Optional) Click the Options link in the bottom-right corner to open the DVD options window, as shown in Figure 8-22, and then click any options you want to change.**

 Click the How Do I Change My DVD Settings? link to open a help window to learn more about these options.

8. **Click Next to display the Ready To Burn DVD window.**

9. **(Optional) Click and drag the scrollbar slider on the right edge of the window to browse different menu styles for your DVD. Click a style to select that style.**

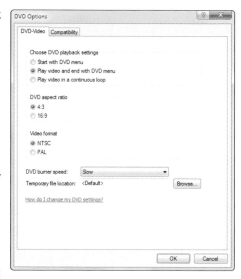

Figure 8-22: Adjust how your DVD is created.

10. **(Optional) Click the Menu Text, Customize Menu, or Slide Show buttons to adjust or customize those elements for your DVD**

 Playing around with these options is a blast because you see a preview of what any given option does without having to actually apply it unless you really want to.

11. **(Optional) Click the Preview button at any time to preview how your movie will appear when someone watches the DVD you create.**

12. **Click Burn.**

 A dialog box appears prompting you to insert a blank DVD.

13. **Insert a blank DVD into your computer's DVD drive.**

 If the Windows AutoPlay dialog box appears, click Close to close it.

 If a warning dialog box appears stating that your DVD already has content on it, click Yes if you want DVD Maker to overwrite any content on the disc with your new DVD movie, or click No if you want to eject the DVD and insert another DVD.

 A progress dialog box appears while Windows DVD Maker burns your movie file to disc, followed by another message dialog box that lets you know when your DVD is ready.

9

Uploading Your Creations
to the Web

In This Chapter

▶ Getting your movies to your Flip Channel, Facebook, MySpace, and YouTube

▶ Using other programs to upload your video and picture files

*C*rowding a bunch of friends around your Flip's tiny screen isn't
exactly the most fun way to show off videos you capture with your
Flip. Fortunately, you can use FlipShare to easily share your special video
moments or movies you've edited: Just upload your creations (or even
pictures you capture from your videos) to a number of popular Web-based
social networking sites, including Facebook, MySpace, and YouTube.
You can also upload your creations to your very own Flip
Channel, which you're automatically entitled to if you
install and run FlipShare — even if you don't own a Flip
camera! (*Shhh, let's keep that fact a secret between us!*)

In addition to sharing your content online, you can
also save a video clip, snapshot, or complete movie
or slideshow as a file that you can upload to your
own Web site or another Web site.

In this chapter, I show you how to upload your
video and photo creations to those popular social
networking services via FlipShare. I also show you
how to save your creations as a file you can upload to
other video- and picture-sharing Web sites that aren't
listed as options in FlipShare, such as Vimeo and Picasa
Web Albums.

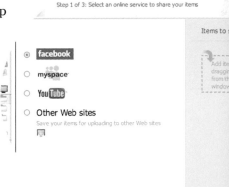

For the tasks in this chapter, I make the assumption that you know how to launch the FlipShare program; that you already copied video files from your Flip camera to your computer; and you know how to browse, view, organize, and work with those video files. If you plan to upload completed movies, snapshots, or picture slideshows, I assume you know how to create those things with FlipShare.

Using FlipShare to Upload Your Movies and Pictures

Uploading your video clips, snapshots, movies, and photo slideshows to Web-based social networking sites is a cinch, thanks to FlipShare's easy-to-use online sharing options.

A single click of the Online button on the FlipShare Action bar opens the Share Online window, as shown in Figure 9-1, which displays your options for uploading your digital creations using one of three social networking options. (I show you how use each of these options later in this chapter, in the respective section dedicated to each service.)

A fourth option — Other Web Sites (also shown in Figure 9-1) — is available so you can upload a file online: to your own Web site or to another Web site that's not listed in the Share Online window, such as Vimeo or Google Picasa. (I show you how to use this option at the end of this chapter.)

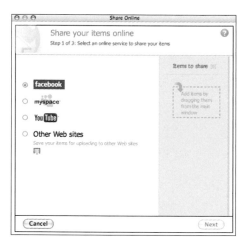

Figure 9-1: Start here for Web-based sharing possibilities.

Don't have an account to sign in to one of the social networking options FlipShare offers? Not a problem because all three are free to join. Just open your Web browser and go directly to the Web site of the particular service you want to join to sign up for that service. Or, click the Create Account button that appears when you choose any of the services in the Share Online window, and FlipShare launches your Web browser, opening the selected social networking service's home page where you can sign up for a new account.

If you don't have (or even want) an account on one or more of the social networking Web sites, you can still share your videos, pictures, movies, and

photo slideshows with friends, family members, and co-workers by using the FlipShare Flip Channel feature, as shown in Figure 9-2. I show you how to use the Flip Channel feature in the next section.

Video clips, edited movies with background music, snapshots, and photo slideshows you drag into your Flip Channel folders are shared with others whose e-mail addresses you add to a list of people you authorize to access and view the contents of those folders. You can also view Flip Channels in FlipShare that others have invited you to view by clicking the folders under the Received Flip Channels category of the navigation pane.

Figure 9-2: Sharing your creations with others via Flip Channel is merely a drag and drop away.

Using Flip Channels

In the Navigation pane are the two Flip Channel categories:

- **Sent Flip Channels:** The first folder is the My Channel folder, which is your private storage space that you can access on the Web using any Web browser, even if you don't have FlipShare installed on the computer you're using to browse your My Channel folder. You create additional folders that appear under the Sent Flip Channels category, and you share the contents of those folders by creating lists of e-mail addresses for the people you want to authorize to view the contents of your shared FlipShare folders.

- **Received Flip Channels:** These folders contain items that other FlipShare users have invited you to see. The New folder just below the Received Flip Channels heading contains the newest items that others have invited you to view. Folders automatically appear whenever another FlipShare user sends an invite to the e-mail address you use to sign in to your Flip Channels.

Sharing your creations with others is as easy as dragging and dropping videos, pictures, movie, and photo slideshows into Sent Flip Channels folders that you create. You define who can view your Sent Flip Channels folders by typing the e-mail address for each person you want to authorize to view the folder's contents. Those lucky folks then receive an e-mail inviting

them to check out whatever items you choose to share in the Sent Flip Channels folder you choose to share, as shown in Figure 9-3.

For instance, say you create a folder called Nick's Wedding that contains pictures and videos of Nick's big day, and then invite friends and family members so they can relive that beautiful day whenever they want. Then, you could create another folder called Rock Climbing Vacation and copy pictures and videos into that folder from your same-named event,

Figure 9-3: People you want to share your Flip Channels with receive an e-mail invitation.

and then share those items with your best friend who joined you for the vacation but not share the folder with the folks who attended Nick's wedding.

Activating and signing in to your Flip Channel account

Before you can access your My Channel folder or create new folders to share with others, you must first activate your Flip Channel by providing your name and the e-mail address you'll use to log in to your Flip Channel. After you supply that information, you then must verify your account by responding to an e-mail you receive to confirm you are the owner of the e-mail address you provided to use as your Flip Channel login name.

Make sure that the e-mail address you sign up with doesn't have a spam filter that auto-deletes e-mail. If the initial sign up e-mail is deleted, activating the account might be difficult.

Activating your Flip Channel account

To activate your Flip Channel sharing features, follow these steps:

1. **Launch FlipShare (if it isn't already running) and click My Channel, beneath the Sent Flip Channels item in the Navigation pane.**

 The My Channel registration window appears.

2. **Type your name and e-mail address into the appropriate fields, and then click the Create button.**

 The My Channel window displays a message instructing you to click the link in an e-mail that FlipShare sends you to confirm your identity, as shown in Figure 9-4.

Figure 9-4: FlipShare sends you a confirmation message.

3. In your e-mail program, open the Flip Channel confirmation e-mail message, as shown in Figure 9-5.

If you don't find the message in your inbox, check your Spam or Junk Mail folder in case your e-mail program or service mistakenly identified the message as spam or junk mail.

4. Click the Click Here link in the middle of the e-mail message.

Your Web browser launches (if it isn't already running)

The Click Here link

Figure 9-5: Check your e-mail for the Flip Channel confirmation message.

and opens to the Welcome to FlipShare.com Web page, as shown in Figure 9-6, which displays characters you must type in to verify your Flip Channel account.

Figure 9-6: Welcome to FlipShare.com!

5. **Click the text field and type in the characters displayed above the text field; then click Enter.**

 A confirmation message appears saying that your Flip Channel has been activated. You can close your Web browser and return to FlipShare if you want, as shown in Figure 9-7.

Figure 9-7: Congratulations! You're now the proud owner of your very own Flip Channel.

Creating a password and signing in to your Flip Channel account

After you create your Flip Channel, you need to create a password for signing in to your channel from a Web browser so you can see your content, as well as view the items in any folders other FlipShare users want to share with you that appear in the Received Flip Channels section of the Navigation pane (which I write about a little later in this chapter).

Already have a password but you can't remember it? No problem. Follow these steps to create a new password for your Flip Channel account.

To create a password for your Flip Channel account

1. **Click the My Channel folder in the Navigation pane. Then click the My Channel link near the top of the My Channel window to launch your Web browser (if it isn't already running) and open the FlipShare.com Welcome Web page (refer to Figure 9-6).**

 Or just open your Web browser yourself and go to www.flipshare.com.

2. **Click the Need a Password? link (shown in Figure 9-8) to open the Create Password page.**

3. **Type in your e-mail address and the other required fields, and then click the Enter button.**

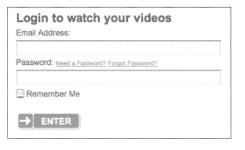

Figure 9-8: Start to create a password here.

 A confirmation message appears stating you can activate your new password by checking your e-mail and then clicking a link in an e-mail message FlipShare.com sent to the e-mail address you entered.

4. **Click OK.**

 The Login window appears with your e-mail address already filled in.

5. **Open your e-mail program (or log in to your e-mail account if you use a Web-based e-mail service) and open the FlipShare Account Update Request e-mail message.**

 If you don't find the message in your inbox, check your Spam or Junk Mail folder in case your e-mail program or service mistakenly identified the message as spam or junk mail.

6. **Click the Click Here link (see Figure 9-9) in the middle of the e-mail message.**

Your Web browser opens to the Welcome to FlipShare.com and displays a message thanking you for updating your password.

Figure 9-9: FlipShare.com e-mails you a message you must open to activate your new password.

7. **Click the Login link to open the FlipShare.com login screen, and type in your password.** *Note:* **Your e-mail address should automatically appear in the Email Address field; if not, type in your e-mail address. Then click the Enter button onscreen.**

Your FlipShare.com My Channel Web page appears, which ought to seem pretty darn familiar because it's designed to look and work just like the FlipShare program that you run on your computer.

Working with your My Flip Channel folder

Your My Flip Channel folder in the FlipShare Navigation pane acts as your private repository for storing any videos or pictures you want to access using a Web browser, which can come in handy whenever you're away from your own computer.

The My Channel folder discussed here is the one you work with in the FlipShare program running on your computer — not the My Channel folder you can access and work with on your FlipShare.com My Channel Web page. I talk about that My Channel folder a little later in this chapter.

Click the My Channel folder to view any items you stored in the folder, as shown in Figure 9-10.

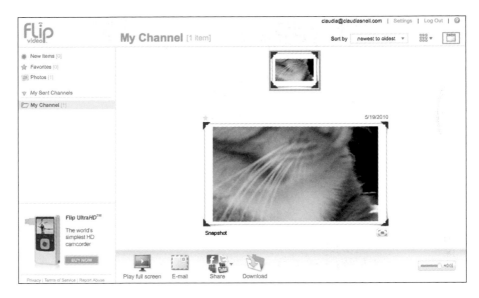

Figure 9-10: Your My Channel folder is your storage repository.

Things you can do with your My Channel folder include

✔ **Add a video or picture** to your My Channel folder by dragging and dropping a video or picture you want from the workspace window to the My Channel folder.

FlipShare uploads a *duplicate copy* of your selected item (or items) to the FlipShare.com server.

✔ **Delete an item** from your My Channel folder by clicking the item, pressing Delete, and then clicking the Permanently Delete button on the confirmation dialog box that appears.

Items that you save in your My Channel folder (or any Sent Flip Channel Folders; see the next section) are duplicates of items in your FlipShare library saved on your computer's hard drive. When you delete an item from any of your Flip Channel folders, only that duplicate file is deleted — not the original file you dragged into the Flip Channel folder when you originally uploaded the file. However, *if you delete a file from your hard drive* that you are sharing in a Flip Channel, you delete that file or the entire channel: That file (and any other files) will be gone for good.

Creating and sharing new Flip Channels folders

Items that you copy to your My Channel folder are for your eyes only. To share your creations with others, you create a new Flip Channel folder by adding the items you want to share and inviting others to access the items by supplying the e-mail address for each person you want to share the items with.

To create and share a new Flip Channel folder and invite others to see the items you want to share in your new folder, follow these steps:

1. **Click any item(s) in the workspace area that you want to share and then click the Add New Channel icon button to the right of the Sent Flip Channels folder in the Navigation pane.**

 The Share by Flip Channel window appears and displays your selected item (or items) in the right column. On the left, your name and e-mail address is already filled in (see "Activating and signing in to your Flip Channel account," earlier in this chapter), as shown in Figure 9-11.

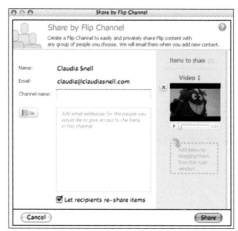

 You can also click the Flip Channel icon in the Action bar to open the Share by Flip Channel window. Then, from the drop-down Channel menu, choose Add a New Channel.

 Figure 9-11: Share by Flip Channel here.

2. **(Optional) Add or remove items from the Items to Share column in the right side of the Share by Flip Channel window:**

 - *Add:* Drag and drop items from the workspace window to add those items to your e-mail.

 - *Delete:* Click the red X in the left corner next to items you want to delete.

3. **Type a name for your new channel in the Channel Name field. Then click the To field and enter the e-mail address for the person you want to share your selected item with.**

 You can enter more than one e-mail address. Just separate each address with a comma.

You can also fill this field from addresses in your Address Book. Click the To icon button to open an Address Book window to display any e-mail addresses stored there. Select the check box next to the e-mail address (or addresses) you want to send your e-mail to and then click the Add To button. The Address Book window closes, and your selected recipients are added to the To field.

If you don't want the people you share your items with to share the items with others, clear the Let Recipients Re-share Items check box. Leaving this check box selected allows people to share your items by inviting others to view your creations.

4. Click the Share button.

The Share by Flip Channel window closes, and a progress bar appears in the Progress box as FlipShare processes your request. An Items updated message appears to let you know when FlipShare has successfully uploaded your item (or items) to your Flip Channel.

Adding and removing items and people in a shared Flip Channel

Click a Shared Channel folder in the Sent Flip Channels section of the Navigation pane to see and work with the items you've invited others to view.

Things you can do with your shared Flip Channel include

- **Add a video or picture** to your shared channel folder by dragging and dropping a video or picture you want from the workspace window to the My Channel folder. FlipShare uploads a *duplicate copy* of your selected item (or items) to the FlipShare.com server.

- **Delete an item** from your My Channel folder by clicking the item and pressing Delete. Then click the Permanently Delete button of the confirmation dialog box that appears.

- **Add or delete e-mail addresses** in the Share With field by typing new e-mail addresses or backspacing over e-mail addresses you want to remove from your list of people you share your items with.

- **Choose whom to share with** by clicking the Share With button to open the Address Book window; then clear or mark the check boxes for the e-mail address for each person you do or don't want to share with. Click the Add To button to close the Address Book window.

- **Prevent** the people with whom you share your items to share these items with others by clearing the Let Recipients Re-share Items check box. Otherwise, leave this check box enabled so that people with whom you share your items can invite others to view your creations.

Renaming or deleting a shared Flip Channel

You can rename or delete a shared Flip Channel whenever you want. Renaming a Flip Channel doesn't affect any item in the Flip Channel folder or change anything about the people you invited to view those items. Deleting a shared Flip Channel removes any items you were sharing and prevents anyone you were sharing those items with from seeing the items anymore in one fell swoop.

Instead of deleting a shared Flip Channel folder, you can just stop sharing items in the folder by removing the e-mail addresses for everyone you invited to view the channel (as described in the preceding section).

To rename or delete a shared Flip Channel folder, right-click a shared Flip Channel in the Navigation pane and choose one of the following from the contextual menu that appears:

- ✔ **Rename:** Highlights the current name; type in the new name for your shared Flip Channel, and then press Enter/Return to lock in your new name.

- ✔ **Delete:** A warning dialog box appears asking whether you're sure you want to delete your folder. Click the Permanently Delete button to delete your Flip Channel folder, and poof! Your folder disappears. (You can also click the little trash icon next to a shared folder to delete that shared folder.)

Any items you add to any of your Sent Flip Channels, including shared Channels, are duplicates of items saved in your FlipShare library on your computer's hard drive. When you delete an item from any of your Flip Channel folders, only that duplicate file is deleted, but not the original file you dragged into the Channel folder when you originally uploaded the file. However, if you delete a file from your hard drive that you're sharing in a Flip Channel, that file is gone for good — whether you delete the file only or the entire channel.

Viewing received Flip Channels

If another FlipShare user invites you to view items in a shared Flip Channel folder, you can view those shared items on the Web by clicking the link in the e-mail invitation you receive, as shown in Figure 9-12.

An easier way to view items inside shared Flip Channel folders that others invite you to view is to use the Received Flip Channels feature, which displays any folders you're invited to view in the Navigation pane, as well as the contents of those folders.

Figure 9-12: The Received Flip Channels feature displays folders with items other FlipShare users invite you to view.

To display folders you're invited to view, you must first log in to FlipShare. com using the e-mail address and password you provided when you create your FlipShare Account. (See "Activating and signing in to your FlipShare account," earlier in this chapter.)

To log in to the FlipShare Received Flip Channels feature, follow these steps:

1. **Click the Received Flip Channels folder in the Navigation pane.**

 The Received Flip Channels Log In screen appears.

2. **Type in your e-mail address (if it isn't already filled in for you), type in your password, and click the Enter button onscreen.**

 A confirmation message appears, informing you that any Flip Channels you've been invited to see appear under the Received Flip Channels section in the Navigation pane.

3. **(Optional) Click the logout button in the workspace window to log out of the Received Flip Channels feature and remove any shared folders others invited you to view.**

Deleting your Flip Channels account link in FlipShare

If you decide that you no longer want to keep your FlipShare account associated with FlipShare, you can delete the link between FlipShare and your account. When you delete this link, any shared folders that appear under the Sent Flip Channels item in the Navigation pane are also deleted.

Any items that you add to any of your Sent Flip Channels, including shared channels, are *duplicates* of items in saved in your FlipShare library on your computer's hard drive. When you delete an item from any of your Flip Channel folders, only that duplicate file is deleted, but not the original file you dragged into the channel folder when you originally uploaded the file. Deleting a file from your hard drive that you are sharing in Flip Channel deletes that file (or the entire channel) for good.

To delete the link between your FlipShare account (referred to as your *sender* account), follow these steps:

1. **Right-click the Sent Flip Channels item in the Navigation pane and choose Delete from the contextual menu that appears.**

 A warning dialog box appears, asking whether you're sure you want to delete your send account and any corresponding channels you created.

2. **Click Delete Sender.**

 Any channel folders that were displayed under the Sent Flip Channels item in the Navigation pane disappear, and the title of your My Channel folder changes to italics.

Uploading Items to Facebook, MySpace, and YouTube

Uploading your videos and pictures to one of the popular social networking Web sites is a quick and easy way to share your creations with friends, family members, and co-workers you grant permission to view those creations. (Even total strangers can see your movies if your privacy settings for your account are configured to allow the whole World Wide Web world the right to view your profile.) FlipShare makes it easy for you to upload your creations to Facebook, MySpace, and YouTube. (You can also upload to other Web sites, and I write about that later in the chapter.)

If you have an account on one or all of those services, you can upload your pictures or videos in no time. The process is as easy as one, two, three — or in other words:

1. Click the item (or items) in the workspace that you want to share, and then click the Online button at the bottom of the Action bar.

2. Choose the service you want to upload to and add any additional items or remove ones you changed your mind about.

3. Log in to your chosen service, choose any options that determine who can view your items, and then click the Share button to upload your items.

If you don't have an account on the service you want to upload to, you can sign up for an account by opening your Web browser and visiting the Web site for the service that you want to join, or you can click the Create Account button FlipShare displays when you choose one of the services to upload your creation.

Facebook

To upload items to Facebook, follow these steps:

1. **Click an item in the workspace that you want to share to select the item (or items); then click the Online button in the Action bar.**

 The Share Online window appears and displays your selected item (or items) on the right, and a list of social networking options you can choose on the right.

2. **(Optional) Add or remove items in the Share Online window by dragging and dropping items from the workspace window to the right-hand Items to Share column to add those items to your upload.**

 Click the red X in the left corner next to an item you want to delete from your upload.

3. **Select the Facebook radio button and then click Next.**

 The Upload to Facebook window appears.

 If you don't have a Facebook account, click the Create a Facebook Account button to do just that; then come back and complete these steps.

4. **Click the Login button.**

 A new Facebook Login window appears, as shown in Figure 9-13.

5. **Type your e-mail address and password into those fields; then click the Connect button.**

 The Facebook Login window disappears, and the Upload to Facebook window shows the account name you used to login to Facebook.

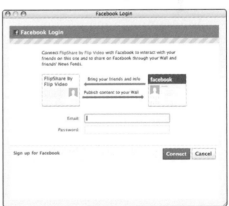

Figure 9-13: The Facebook Login window.

6. Click the Share button.

The Upload to Facebook window closes, and a progress bar appears in the Progress box as FlipShare uploads your selection, followed by the message Your items are ready! and a link you can click to launch your Web browser and open your Facebook Web page. See Figure 9-14.

Note: Your video may not immediately appear when you go to view it on your Facebook page. You might see a message indicating that your video is being processed and that it will appear when the processing is complete.

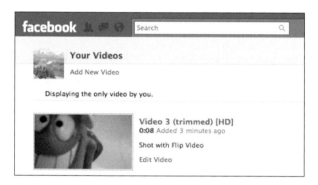

Figure 9-14: Your uploaded creation appears on your Facebook page.

MySpace

To upload items to MySpace, follow these steps:

1. Click an item in the workspace that you want to share to select the item (or items); then click the Online button on the Action bar.

The Share Online window appears and displays your selected item (or items) on the right, and a list of social networking options you can choose on the left.

2. (Optional) Add or remove items in the Share Online window by dragging and dropping items from the workspace window to the right-hand Items to Share column to add those items to your upload.

Click the red X in the left corner next to an item you want to delete to remove that item from your upload.

3. Select the MySpace radio button and then click Next.

The Upload to MySpace window appears.

If you don't have a MySpace account, click the Create a MySpace Account button to do just that; then come back and complete these steps.

4. Type your e-mail address, as shown in Figure 9-15, and then click the Login button.

Your Web browser launches (if it isn't already running) and opens the MySpace homepage.

5. Type your e-mail address and password into Log In fields on the MySpace home page; then click Log In.

The MySpace My Devices authorization Web page opens and displays your computer (and any other devices), as shown in Figure 9-16.

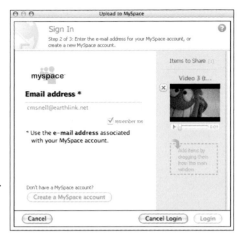

Figure 9-15: The Upload to MySpace window.

Figure 9-16: The MySpace My Devices authorization Web page.

6. Click the Authorize button.

A dialog box appears, asking whether you want to allow your computer to upload videos to your account.

7. Click OK.

The dialog box closes, and the MySpace home page reappears. At the same time (behind your Web browser window), the FlipShare Upload to MySpace window closes.

8. Click the FlipShare main window to make it the active window on your screen.

A progress bar appears in the Progress box as FlipShare uploads your selection, followed by the message Your items are ready! and a link you can click to open your MySpace video album page with your Web browser, as shown in Figure 9-17.

Figure 9-17: Your uploaded creation appears on your MySpace album page.

YouTube

To upload items to YouTube, follow these steps:

1. **Click an item in the workspace that you want to share to select the item (or items), and then click the Online button on the Action bar.**

 The Share Online window appears and displays your selected item (or items) on the right, and a list of social networking options you can choose on the left.

2. **(Optional) Add or remove items in the Share Online window by dragging and dropping items from the workspace window to the right-hand Items to Share column to add those items to your upload.**

 Clicking the red X in the left corner next to an item you want to delete to remove that item from your upload.

3. **Select the YouTube radio button and then click Next.**

 The Upload to YouTube window appears.

If you have a Gmail e-mail address and password, you can type those in as your YouTube username and password. If you don't have a Gmail account or a YouTube account and you want to create one, click the Create a YouTube Account button to do just that, and then come back to this step with your new account information.

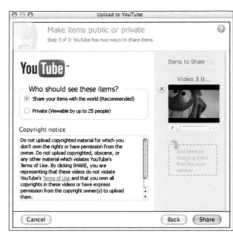

4. **Type your YouTube username and password into the Upload to YouTube sign-in window; then click Login.**

 The Make Items Public or Private window appears, as shown in Figure 9-18.

Figure 9-18: Choose whether you want to keep your creation private or show it to the entire World Wide Web.

5. **Click the choice you want and then click the Share button.**

 The Upload to YouTube window closes, and a progress bar appears in the Progress box as FlipShare uploads your selection, followed by the message `Your items are ready!` and a link you can click to launch your Web browser and open your YouTube Web page, as shown in Figure 9-19.

Figure 9-19 Your uploaded creation appears on your YouTube Web page.

Deleting Login Information from FlipShare

If you share your computer with other people and you don't want anyone but you to control what pictures and videos get uploaded to one or more of your social networking service accounts, you can choose an option to make FlipShare forget your login information.

To remove any social networking service username and password information FlipShare has saved, follow these steps:

1. **Choose Edit⇨Preferences to open the FlipShare Preferences window, and then click the Privacy tab to display the Privacy preferences pane.**

2. **Click the Clear Now button to delete any saved username and password information FlipShare saved; then click Close to close the FlipShare Preferences window.**

 Nothing happens immediately, but the next time you upload an item to one of the social networking services, FlipShare prompts you for your username and password information.

 To prevent FlipShare from saving your MySpace or YouTube username and password, clear the Remember Me check box in the Sign In window the next time you use either of those service options to upload your creations. (A Remember Me check box doesn't appear for Facebook.)

Saving Files for Uploading

If you want to upload a picture or video to another social networking service, such as Vimeo (www.vimeo.com) or Picasa (picasa.google.com), you can save your item as a file and then sign in to your preferred sharing Web site and use the Web site's uploading feature to choose the file you saved.

To save a video or picture you want to share as a file you can upload to another sharing Web site or social networking service, follow these steps:

1. **Click an item in the Workspace that you want to share to select the item (or items), and then click the Online button on the Action bar.**

 The Share Online window appears.

2. **(Optional) Add or remove items in the Share Online window by:**

- Dragging and dropping items from the Workspace window to the right-hand Items to Share column to add those items to your upload

- Clicking the red X in the left corner next to an item you want to delete to remove that item from your upload

3. **Click the Other Web Sites option and then click Next to display the Upload to Other Websites window, as shown in Figure 9-20.**

4. **Click Next to display the next window, where you can type in a name for the folder in which FlipShare will store your saved file on your desktop (or just keep the name already filled in). Then click the Go button.**

Figure 9-20: The Upload to Other Websites window.

The Upload to Other Websites window closes, and a progress bar appears in the Progress box as FlipShare saves your file, followed by the message Items saved to computer. Then the Upload to Other Websites window reappears to confirm that your file has been saved and is ready for upload.

5. **Click the Go button to close the Upload to Other Websites window, and then double-click the desktop folder FlipShare created to view your saved file.**

Part IV
Editing and Sharing Movies with Mac and Windows Programs

The 5th Wave By Rich Tennant

"I found these two in the multimedia lab using iMovie to morph faculty members into farm animals."

In this part . . .

When you're ready to graduate from making movies the FlipShare way (covered in the previous part), you're ready to pick one of the chapters in this part to turn your Mac or Windows computer (and yourself!) into a more powerful video-editing and production machine. Whether you want to control the speed at which your scenes fade from one to the next, or narrate parts of your movie with voice-over recordings or onscreen subtitles, the chapters in this part will show you how to do those things and more.

For Mac users, you'll dive into Apple's iMovie program, which comes with every new Mac (or you can purchase the latest version of iLife, which includes the newest version of iMovie and a bunch of other programs for making movies on your Mac).

If you're a Windows Vista or Windows 7 movie-maker in the making, you can find here how to access the latest version of Windows Live Movie Maker that you can download for free and install on your computer. Keep reading to see how to use that program's editing tools to make livelier movies than the ones you can make using the simple but limited FlipShare program.

Making Movies with iMovie

In This Chapter

▶ Getting familiar with how iMovie works

▶ Creating a new movie project

▶ Browsing and organizing video files

▶ Adding titles, transitions, and sound

▶ Sharing your movies

*I*f you've played with FlipShare on your Mac, you know that you can use it to quickly and easily transform videos you record with your Flip camera into movies you can share with others. (You can read all about FlipShare in Chapter 6. And for those of you on a PC, Chapter 11 has the goods on creating movies in Windows Live Movie Maker.) But if you want to make fancier movies with your Mac than the simple but less-showy movies you can make with FlipShare, let's do the iMovie thang.

With iMovie, you can turn your videos into finely polished movies that you can upload to video-sharing sites like YouTube, play on an iPhone and iPod, or just watch on your Mac. You can also transfer movies you create with iMovie to a DVD to give to Aunt Clara who doesn't have a computer but does have a DVD player hooked up to her television. Whatever your personal movie distribution preference, making movies using your Mac and iMovie is sure to elevate your movie-making skills beyond what you managed to pull off using FlipShare.

I cover iMovie '09 in this chapter. If my instructions don't match up with what you're seeing onscreen, check which version you're using.

How iMovie Works

The iMovie interface, shown in Figure 10-1, consists of an Event Library and a Project Library. The Event Library, which appears in the bottom left of the iMovie window, is where you store video files you want to slice into an eventual movie. The Preview window in the upper right lets you preview a movie you're working on anytime you want. When you work on a movie project, you choose parts of any videos stored in the Event Library and then copy these parts (known as *clips*) into the Project Library, which appears in the upper-left corner of the iMovie window. The lower-right section of the iMovie window displays different things based on what you're doing, such as adding a title or transition to your movie (which I show you how to do later in this chapter).

Project Library Preview window

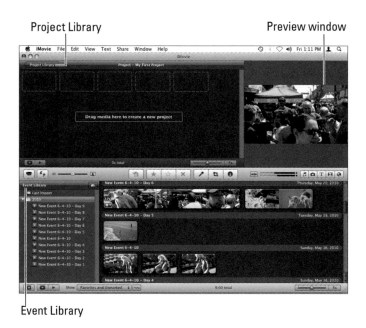

Event Library

Figure 10-1: Touring the iMovie window.

The elementary steps for using iMovie are

1. Import, store, and organize video in the Event Library.

2. Copy video footage from the Event Library to a project in the Project Library.

3. Edit your video clips in the Project pane.

4. Save your video as a digital video file for viewing on other computers; on DVD; or uploading to Web-based sharing sites, such as your personal Flip Channel, or to YouTube, or Facebook, or MySpace.

For the ultimate guide to making movies and burning them to DVDs, check out *iMovie '09 & iDVD '09 For Dummies* (Dennis R. Cohen and Michael E. Cohen, Wiley).

Importing a Video into the Event Library

The Event Library (videos you import are organized as *events*) holds all your videos, acting as your personal film vault. From here, you can choose footage from videos you recorded and saved to use in any new projects.

To store video in the Event Library, you must import a video from one of three sources:

- Your Flip camcorder (or any other video camera or video-capable source, including smartphones, webcams, and even an Apple iPod nano capable of recording and saving video files)
- A project created and saved using an earlier version of iMovie
- A digital video file stored on your hard drive, which may include video files you might have copied from your Flip camera to your computer using FlipShare

Importing from your Flip camera

When you plug your Flip camera into your Mac (or any camera or video-capture-capable gadget), your Mac carries out a certain automatic action, such as launching the FlipShare program or iMovie program, for instance, or just opening a Finder window that displays any files stored on your Flip camera. Check out Chapter 5 to see how to choose which action you want your Mac to take when you plug in your Flip camera.

To *import* (copy) a movie to your Mac's hard drive that you captured with your Flip camcorder, follow these steps:

1. **Launch iMovie.**

2. **Plug your Flip camera into one of your Mac's USB ports.**

The Import From Pure Digital Inc. Flip Video Camcorder window appears, as shown in Figure 10-2, displaying all the recorded videos saved on your Flip camera.

Note: If your Flip has a lot of saved video files stored on it, you may first see the `Generating Poster Images` message and progress bar while iMovie gathers information about the videos saved on your Flip camera.

Figure 10-2: The Import window displays video files saved on your Flip camera.

If the Import window doesn't open, choose File⇨Import from Camera, and then choose your Flip camera from the Camera pop-up menu at the bottom (if it isn't already selected).

3. **Select the clips you want to import.**

 - *To import all clips:* Click the Import All button in the lower-right corner.

 - *To selectively import clips:* Set the Automatic/Manual switch to Manual. Deselect any clips you don't want to import (or click Uncheck All and then select only the ones you want to import), and then click the Import Checked button.

 If your Flip camera is one of the HD models that records video in high-definition, the HD Import Setting window appears, as shown in Figure 10-3; otherwise, skip ahead to Step 5.

4. **Choose one of these two options, and then click the OK button:**

 - *Large - 960x540:* This option reduces the quality and file size of your video file, which means it doesn't look as nice as the Full option, but the file also doesn't take up as much space on your hard disk as that option, either.

 - *Full - Original Size:* This option imports your video file at the highest possible quality, and uses up more space on your hard drive than the Large option.

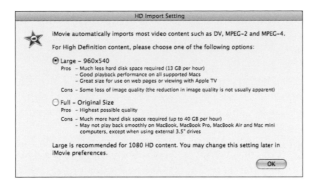

Figure 10-3: iMovie offers two video file quality and size options when you import HD videos.

The Save To dialog appears, prompting you to choose where you want to save your video files on your hard drive.

5. **Click the Save To pop-up menu and choose where you want to save your video.**

6. **Choose how to organize your video by selecting one of the following radio buttons:**

 • *Add to Existing Event:* Stores the video as part of an existing event in the Event Library. (This option is grayed out if this is the first time you're importing video files into iMovie.)

 • *Create New Event:* Stores the video as a new event in the Event Library. The default name for the Event is the date, but you can type a more descriptive name if you want. See the upcoming section, "Organizing the Event Library."

7. **Select or deselect the Split Days into New Events check box.**

Many video camcorders time-stamp any video footage you capture, so enabling this option divides a video into parts that represent all the video footage shot on a particular day.

8. **Select the Analyze for Stabilization After Import check box if you want iMovie to attempt to detect and smooth any shaky parts.**

Choosing this option can make importing your video files take a longer time than if you don't choose the option, as the option invokes an analysis process after the initial import process completes. For instance, when I imported 30 video files, it took iMovie about 15 minutes to first import the files to my Mac's hard drive, and then I stared at the Analyzing for Stabilization message window for another 50 minutes or so.

Slowdowns notwithstanding, choosing this option can be worth the longer wait. That's because, unlike most camcorders, your Flip does not have a built-in image stabilization feature that attempts to smooth out any shakiness you experience when you're recording videos with your Flip.

If you'd rather not spend time waiting right now, you can always perform the Analyze for Stabilization process later by selecting a clip (or clips) you want to analyze, and then choosing File➪Analyze for Stabilization.

9. **Click the Capture button.**

 The Save To dialog closes, and iMovie imports your video files.

 As your video files are imported, a progress bar appears beneath each video file's thumbnail image in the lower half of the import window, and a large image of the first frame of the video file appears in the upper window, as shown in Figure 10-4.

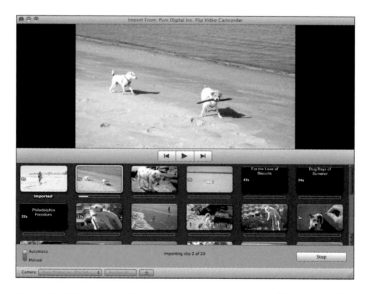

Figure 10-4: A progress bar appears under each video file thumbnail as iMovie imports your video files.

Note: If you selected the Analyze for Stabilization check box in Step 8, the Analyzing for Stabilization window appears after iMovie finishes the initial import process. It displays an estimate of how long you must wait until the process is complete.

When iMovie is finished importing your video files, the Import Complete message appears.

10. **Click OK, and then click the Done button in the lower-right corner of the Import From window.**

Your imported videos appear as thumbnail images in the lower pane (the Event pane) of the iMovie window (refer to Figure 10-1). After you import a video, your source video footage remains on your Flip camera. To free some memory, you might want to go back and erase it (which I tell you about in Chapter 5).

iMovie divides a video into separate scenes, where each scene displays the first frame of a video clip. Browse through these thumbnail images of scenes to see which scene is likely to contain the video footage you want to use.

Importing a digital video file

If you have a video file saved to your Mac's hard drive, you can easily import that video file into iMovie. To import an existing video file, follow these steps:

1. **Choose File⇨Import⇨Movies.**

An Open dialog appears. You might need to navigate to the folder where you stored the video file you want to import.

Note: Video files you imported using FlipShare are saved in the Movies⇨FlipShare Data⇨Videos folder.

2. **Select the digital video file you want to import.**

3. **Click the Save To pop-up menu and choose the location where you'd like to store your video.**

4. **Select one of the following radio buttons:**

 • *Add to Existing Event:* Stores the video as part of an existing event in the Event Library.

 • *Create New Event:* Stores the video as a new event in the iMovie Event Library.

5. **From the Optimize Video pop-up menu, choose how you want to optimize high-definition (HD) video.**

The Large option reduces the frame size of the HD video to 960 x 540 pixels, whereas the Full option displays the frame size at the complete 1920 x 1080 pixels.

6. **Select either the Copy Files or the Move Files radio button.**

 • *Copy Files:* Leaves your original file and creates a duplicate file to store in iMovie's Events folder.

 • *Move Files:* Transfers your chosen video file into iMovie's Events folder.

7. **Click the Import button.**

 Your imported movie appears as thumbnail images in the iMovie window.

Video files are notoriously large — which means they can take up lots of space on your computer's hard drive. The more video files you copy to your hard drive, the less hard drive space you have. In Chapter 5, I write about copying files to and from your hard drive, and in Chapter 3, I write about how you can move your video files to an external hard drive if you need more space for storing your video files.

Organizing the Event Library

The more videos you import and store, the more crowded the Event Library becomes — and the more challenging it becomes to find what you want. When you store a new video in the Event Library, iMovie gives you the option of creating an event folder, which identifies the date you imported the video file into iMovie.

Organizing videos in the Event Library by date can be helpful, but you might prefer to identify events with descriptive names. To rename an event, follow these steps:

1. **Double-click an event in the Event Library pane in the bottom-left corner of the iMovie window.**

 If the Event Library is not visible, choose Window⇨Show Event Library.

 Your chosen event name becomes highlighted.

2. **Type a descriptive name for your event, and then press Return to save your new name.**

Storing video in different event folders can help you remember where you stored videos you are looking for. If you want to edit video of your family vacation, just click the event folder for that day or span of days to display your video.

Event Library displays each video file as a series of thumbnail images. To define how to divide a video into multiple thumbnail images, drag the slider in the bottom-right corner of the iMovie window, as shown in Figure 10-5. Dragging the slider to the left divides your video into more thumbnail images (top); dragging the slider to the right divides your video into fewer thumbnail images (bottom). The number on the right of the slider indicates the duration of the clip from one-half second up to 30 seconds or All, which means no divisions.

Instead of forcing you to browse through your entire video to find the one part you need, iMovie lets you jump straight to a scene that contains the footage you want to use. You do this by dragging the mouse pointer over the thumbnail images of the clips. After you find the video footage to edit, copy that video footage into your project by clicking and dragging it with the mouse.

Figure 10-5: Drag the slider to show more (top) or fewer (bottom) thumbnails.

Working with Projects

The Event Library contains your raw, unedited video. The Project Library contains the copies of your video that you can modify. By default, the Project Library appears in the upper-left corner of the iMovie window. The Project Library lists your projects by title and displays a filmstrip next to each project title so that you can preview your video. To view (or hide) the Project Library, choose Window⇨Show/Hide Project Library.

Projects contain one or more video clips from movies stored in the Event Library. In the Project Library, you can rearrange, trim, and delete video clips to create your movie. Here, you can also add titles or sound effects to your edited video. If you accidentally erase or mess up a video in the Project Library, just retrieve the original footage from the Event Library and start over. You can copy and store the same video footage in two or more projects.

Creating a new iMovie project

To create a new iMovie project, follow these steps:

1. **Choose File⇨New Project.**

 The New Project dialog appears, as shown in Figure 10-6.

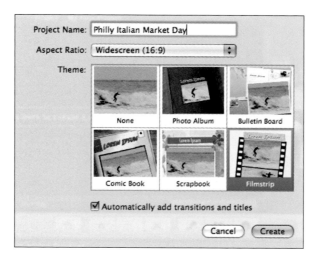

Figure 10-6: Choose a name, aspect ratio, and theme for your video project.

2. **Enter a descriptive name for your project in the Project Name text box.**

3. **Choose Standard, iPhone, or Widescreen from the Aspect Ratio pop-up menu.**

 The aspect ratio optimizes your video project for displaying on different devices.

 • *To view your video on a TV set:* Choose Standard or Widescreen.

 • *To view your video on a mobile phone or other portable gadget capable of playing videos:* Choose the smaller iPhone aspect ratio.

4. **Choose a theme.**

 • *If you want iMovie to automatically apply transitions and titles to your project:* Click one of the five theme choices.

 • *If you want to make those thematic choices yourself:* Choose None.

5. **(Optional) To automatically add a particular transition effect to your movie, select the Automatically Add Transitions and Titles check box.**

6. Click the Create button.

Your new project's name appears above the Drag Media Here to Create a New Project pane in the Project section of the iMovie window, as shown in Figure 10-7.

The stage is now set for you to begin sculpting your movie masterpiece!

Figure 10-7: Arrange your video clips in the Drag Media Here to Create a New Project pane.

Selecting video clips

Whether you want to create a new project or edit an existing one, you need to add video clips from the Event Library and place them in a project stored in the Project Library.

Before you can select a video clip to store in a project, you may want to skim through parts of your video clips so that you can find the ones you want to use in your project. To help you skim through parts of a video, iMovie displays an entire video as a series of images that appear like individual frames of a filmstrip. To find a specific part of a video, you can skim through a video. When you find the part of a video to use, just click and drag it into a project.

For now, don't worry about the order in which you import clips. I show you how to arrange them in the upcoming section, "Rearranging the order of video clips."

Skimming a video

Skimming a video lets you see the contents of a video file just by moving the mouse over the video images. To view a video by skimming, follow these steps:

1. **Move the pointer over any of the thumbnail images of a video file displayed in the Event Library section of the iMovie window.**

 A red vertical line appears over the thumbnail image, as shown in Figure 10-8.

The current image

Figure 10-8: A red vertical line shows you the position of the current image in a video file.

2. **Move the mouse left and right to watch your video in the upper-right corner of the iMovie window.**

 The faster you move the mouse, the faster the video plays. Moving the mouse to the left plays the video backward; moving the mouse to the right plays the video forward.

Selecting a video clip

After you see the part of a video you want to use, you can select the video clip by following these steps:

1. **In the Event Library, move the pointer to the beginning of the part of the video that you want to use.**

2. **Click and drag to the right.**

 A yellow rectangle appears to define the size of your clip, as shown in Figure 10-9. Drag the handles to define the exact frame to start and end your video clip.

Drag to define the clip's size

Figure 10-9: A yellow rectangle defines the size of a video clip.

3. **Release the mouse button when you're satisfied with the portion of the video that your clip contains.**

After you select a video clip, you can preview it by choosing one of the following:

✓ Move the mouse over the left selection handle until the pointer turns into a two-way pointing arrow. Then double-click to view your video clip in the Preview pane in the upper-right corner of the iMovie window.

✓ Control-click the video clip and then choose Play Selection from the menu that appears.

Placing a video clip in a project

After selecting a video clip, you can place it in a project. To place a video clip in a project, follow these steps:

1. **Click the project in the Project Library list.**

2. **Click the Edit Project button above the list.**

 Thumbnail images of any video clips already stored in the project appear.

 Note: If you haven't added any video clips to a project, you see a Drag Media Here to Create a New Project message, along with dotted rectangles (refer to Figure 10-7).

3. **Move the pointer inside the yellow rectangle of the video clip you selected.**

 The pointer turns into a hand icon.

4. **Click and drag the selected video clip to one of the dotted rectangles in the Project pane, and then release the mouse button, as shown in Figure 10-10.**

Your selected video clip appears as a thumbnail image in the Project Library section of the iMovie window.

To edit a project, click the project in the Project Library list, and then click the Edit Project button above the list. To return to the Project Library, click the Project Library button.

Figure 10-10: Drag a video clip to add it to a project.

Deleting video clips

If you decide you don't need a particular video clip you stored in a project, you can delete that clip from the project.

Deleting a video clip from a project does not delete the video clip from the Event Library.

To delete a video clip from a project, follow these steps:

1. **Click a project in the Project Library list, and then click the Edit Project button, as shown in Figure 10-11.**

 The Project pane displays all the video clips stored in the selected project.

The Edit Project button

Figure 10-11: Select a project.

2. **In the Project pane, click the video clip that you want to delete.**

3. **Choose Edit➪Delete Selection (or press Delete).**

Deleting a project

When you finish a project that you saved as a movie, or you decide you no longer want to save a project you started but don't want to finish, you can delete an entire project.

When you delete a project, you also delete any video clips stored inside that project. However, the original videos (from which you copied clips to add to the project) remain in the Event Library.

To delete a project, follow these steps:

1. **In the Project Library list, click the project you want to delete.**

2. **Choose File➪Move Project to Trash.**

If you accidentally delete a project, you can retrieve it by pressing ⌘+Z or choosing Edit➪Undo Delete Project.

Organizing the Project Library

You can divide the Project Library into different folders, where one folder might contain your family vacation video, and a second folder might contain the footage you captured of a UFO you spotted hovering over a mesa in New Mexico. To create a folder, follow these steps:

1. **In the Project pane, click the Project Library button.**

 The Project Library list appears.

2. **Choose File⇨New Folder.**

 Type the name you want for the folder in the dialog that appears.

3. **Click Create.**

 The folder appears in the Project Library.

4. **Click and drag the projects to the folder.**

Editing Video Clips in a Project

After you place one or more video clips in a project, you usually want to edit those video clips to put them in a particular order, trim unnecessary sections of the video clips that you don't want to appear in the eventual movie, and add titles and credits and audio to spice up your entire movie.

Rearranging the order of video clips

A project plays video clips in sequence, but you can always change the order of your video clips. To rearrange the order of your video clips in a project, follow these steps:

1. **Click a project in the Project Library list.**

2. **Click the Edit Project button at the top of the pane.**

 The Project pane opens.

3. **Click the video clip you want to move and hold the pointer over the clip.**

 The pointer turns into a hand icon.

4. **Click and drag the selected video clip behind another video clip.**

 Vertical lines appear to show you where your video clip will appear, as shown in Figure 10-12.

Figure 10-12: This is where your clip will appear.

5. Release the mouse button.

Your video clip appears in its new location.

Adjusting the size of a video clip

Sometimes a video clip contains a little too much extra footage that you need to trim. Other times, you might have trimmed a little too much from a video clip, and you need to add more footage. In either case, you can adjust the size of your video clip by following these steps:

1. Click a project in the Project Library list, and then click the Edit Project button.

2. Move the pointer over a video clip, and then click the lower-left corner of the clip.

A gear icon appears.

3. Click the gear icon and then choose Clip Trimmer from the pop-up menu, as shown in Figure 10-13.

A Clip Trimmer pane appears at the bottom of the window. It displays a rectangle that contains the size of your video clip, along with dimmed thumbnail images of the original video that you used to copy the video clip.

Figure 10-13: Open this pop-up menu to adjust your project.

4. **Move the pointer over the left or right side of the rectangle that defines the size of your video clip.**

 The pointer turns into a two-way pointing arrow.

5. **Click and drag a handle to increase or decrease the size of your video clip.**

6. **Click the Play button to view your edited video clip.**

7. **Click Done when you're happy with the images stored in your video clip.**

Even though trimming makes it appear as if the sections of snipped footage are gone for good, those trimmed parts still exist. FlipShare simply hides and ignores the sections as if they're gone based on your trim choices. As with all things that appear to vanish when you're working on a movie project file, the original files you imported into FlipShare remain intact regardless of how you transform the video clips you play with in the Workspace pane.

Adding titles

You might want to add titles to your movie, such as at the beginning or end. A title at the beginning of your movie can display the name of your movie. At the end of your movie, you can add titles that display the credits listing the cast and crew members who helped you produce your movie (even if your entire team adds up to just you and your dog).

Titles can appear by themselves, or they can appear superimposed over part of your video. To create titles for a project, follow these steps:

1. **Click a project in the Project Library list.**

2. **Click the Titles button on the iMovie toolbar or choose Window➪Titles.**

 A list of title styles appears in the Titles browser.

3. **Click and drag a title from the Titles browser to a video clip or in front of, behind, or between two clips in the Project Library pane.**

4. **Release the mouse button.**

 The Choose Background selection window appears, as shown in Figure 10-14.

5. **Click a background to select that background.**

 If you released the mouse button over a video clip in Step 4, your title appears superimposed over the video image. If you release the mouse button in front of, behind, or between video clips in Step 4, your title appears as a separate video clip in the position where you released the mouse button, as shown in Figure 10-15.

6. **Click the title balloon that appears over a video clip.**

 Your chosen title format appears in the Preview pane.

Figure 10-14: The Choose Background selection window.

7. **Double-click the text in the Preview pane that you want to edit and then type new text or use the arrow and Delete keys to edit the existing title.**

Figure 10-15: Titles can appear superimposed over existing video clips, or as separate clips, as shown here.

8. **(Optional) Choose Text⇨Show Fonts to display the Fonts window that lets you choose a different color, font size, and typeface for your text.**

9. **(Optional) Click the Play button that's superimposed over your Title in the Preview pane to preview how your title looks.**

10. **Click Done.**

11. **Click the Titles button to hide the list of available title styles from view.**

 All titles appear as brown title balloons in the Project pane.

To delete a title, click the title balloon and press Delete, or choose Edit⇨ Delete Selection.

Adding transitions

Normally, when you place video clips in a project, those video clips play one after another. Rather than abruptly cutting from one video clip to another, you can add transitions that appear in between video clips. To add a transition, follow these steps:

1. **Click a project in the Project Library list and then click the Edit Project button.**

 Thumbnail images of your selected project appear in the Project pane.

2. **Click the Transitions button on the iMovie toolbar or choose Window⇨Transitions.**

 A list of transitions appears in the Transitions browser, as shown in Figure 10-16.

3. **Click and drag a transition in the Transitions browser between two video clips in the Project pane.**

 Some different types of transitions include Cube (which spins a cube on the screen where a different video clip appears on each side of the cube) and Page Curl (which peels away one video clip like a piece of paper).

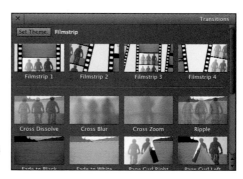

Figure 10-16: Transitions let you create unique visual effects in between video clips.

Hover your mouse pointer over any of the Transition thumbnails to watch an animated preview of how the transition works.

4. **Release the mouse button when a vertical line appears between two video clips.**

5. **Move the pointer over the transition.**

Move the pointer to the right, and the transition plays forward. To move the transition backward, move the pointer to the left.

6. **Click the Transitions button to hide the list of available transitions.**

If you chose a preset theme when you created your new project (see the earlier section, "Creating a new iMovie project"), the title and transition choices you can choose from are those associated with the theme.

Click the gear icon beneath a transition, and then choose Precision Edit or Transition Adjustments to display tools you can use to tweak your transition so that it appears exactly the way you want.

Adding audio files

To make your movie more interesting, you can add audio files that play background music or sound effects to match the action as it unfolds in your movie — a car honking, say, or maybe a telephone ringing. To add an audio file to a project, follow these steps:

1. **Click a project in the Project Library list and then click the Edit Project button.**

2. **Click the Music and Sound Effects button (denoted by the musical note) on the iMovie toolbar.**

A list of audio files appears in the Music and Sound Effects browser, as shown in Figure 10-17.

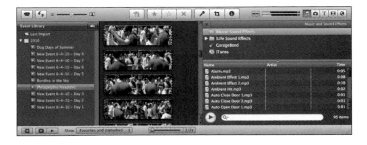

Figure 10-17: Audio files can add music or sound effects to your videos.

3. **In the Music and Sound Effects browser, click an audio file library to use, such as iMovie Sound Effects, iLife Sound Effects, GarageBand, or iTunes.**

A list of audio files appears.

4. **Click and drag an audio file to a video clip in the Project pane.**

 A red vertical line appears over the video clip to show you where the audio file will start playing.

5. **Release the mouse button.**

6. **Click the Music and Sound Effects button to hide the list of available audio files.**

Saving a Video

The point of editing your video and audio clips in an iMovie project is to create a polished movie. With iMovie, you can save your project to view on a computer, in iTunes, on an iPod or iPhone, or even on YouTube. You can save multiple versions of the same video project in different formats. That way, you can view one version of the video saved in the format suited for watching on your iPhone's screens, and post another version of the video saved in a format suited for viewing on YouTube so people can watch your movie using their favorite Web browser.

Saving a project as a digital video file

You might want to save your iMovie project as a digital video file so you can burn it to DVD later (using iDVD) or give a copy to someone who wants to view it on their computer.

To save a project as a digital video file, follow these steps:

1. **Click a project in the Project Library list.**

2. **Choose Share➪Export Movie.**

 The Export Movie dialog appears, as shown in Figure 10-18.

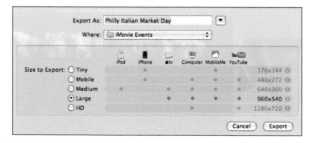

Figure 10-18: Choose the resolution for playing on different devices.

3. **From the Where pop-up menu, choose the location to save your project.**

 You can expand the menu by clicking the disclosure triangle to the right of the Export As field.

4. **Select a Size to Export radio button (such as Medium or Tiny) and then click the Export button.**

 The sizes define the frame size. Smaller frame sizes are designed for viewing on smaller screens, such as an iPhone screen. Larger frame sizes are designed for viewing on bigger screens, such as a computer or TV.

Saving (and removing) a video for iTunes

If you create a particularly interesting movie and store it on your hard drive, you might later have trouble remembering where you stored it. To make it easy to always find your favorite movies, you can save your movies in your iTunes library, where you can always find them whenever you run the iTunes program.

To save a project that you can play in iTunes, follow these steps:

1. **Click a project in the Project Library list.**

2. **Choose Share⇨iTunes.**

 The Publish to iTunes dialog appears, as show in Figure 10-19.

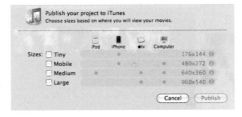

3. **Select or deselect one or more check boxes (such as Medium or Tiny) and then click the Publish button.**

Figure 10-19: Choose how large (or small) your movie appears when you play it in iTunes.

 The sizes define the frame size of your video. Smaller sizes make your video look best on small screens, such as on mobile phones. Larger sizes make your video look best on larger screens, such as on a TV set. Your movie now appears in your iTunes library on your hard drive.

After you save a movie to iTunes, you can remove it by choosing Share⇨ Remove from iTunes.

Saving (and removing) a project for YouTube

One way to show off your movie is by uploading it to the Web so that others can watch it online or download it and watch it whenever they want. The most well-known (and well-trafficked!) video-sharing site is YouTube.

When you capture an interesting video, you can save your project to YouTube. After setting up a YouTube account (at www.youtube.com), you can upload a video from iMovie to YouTube by following these steps:

1. **Click a project in the Project Library list.**

2. **Choose Share⇨YouTube.**

 The YouTube dialog appears, as shown in Figure 10-20.

3. **Click the Account and Category pop-up menus and choose the account and category options you want, and then type your password into the Password field. Enter your password.**

4. **Enter information to identify your video in the Title, Description, and Tags text boxes.**

 The information you type to identify your video can help others find it on YouTube when they want to see videos that match the category you select, such as Comedy or Travel and Events, or when they search for videos that match any tags you type in (separated by commas), such as *Italian Food*, or *Philly*, or *Dancing in the Streets*.

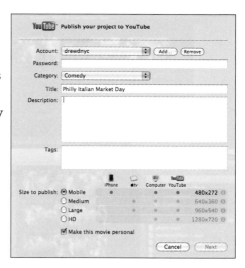

Figure 10-20: Choose an account, category, and resolution size to upload your video to the Web.

5. **Select one of the Size to Publish radio buttons and then click Next.**

 A dialog appears, warning about copyright infringement.

6. **Click the Publish button.**

 Presto! You're an Internet Video Superstar!

After you save a movie to YouTube, you can remove it by choosing Share⇨ Remove from YouTube.

Saving (and removing) a project in the Media browser

If you store your movie in Media browser, you can access and insert that movie into any program that uses Media browser, such as the iWork suite, many iLife programs (such as iDVD and iWeb), and non-Apple software, such as Toast (www.roxio.com).

To save a movie in the Media browser, follow these steps:

1. **Click a project in the Project Library list.**

2. **Choose Share⇨Media Browser.**

 The Media Browser dialog appears, as shown in Figure 10-21.

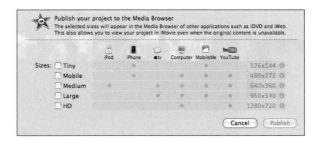

Figure 10-21: Use Media browser to choose different resolutions.

3. **Select or clear one or more Sizes check boxes, such as Tiny or Medium.**

 The sizes define the frame size, and the dots identify the type of devices that your video can play on.

4. **Click the Publish button.**

After you save a movie to the Media Browser, you can remove it by choosing Share⇨Remove from Media Browser.

Making Movies with Windows Live Movie Maker

In This Chapter

▶ Getting familiar with how Windows Live Movie Maker works

▶ Importing videos and pictures into Windows Live Movie Maker

▶ Creating, saving, and deleting movie projects

▶ Viewing and organizing videos

▶ Adding titles, transitions, music, and sounds

▶ Making a quickie movie with AutoMovie

▶ Sharing your movies

*I*f you've played with FlipShare on your Windows PC, you know how you can use it to quickly and easily transform videos you record with your Flip camera into movies you can share with others. But if you want to make fancier movies with your PC, consider graduating from FlipShare and moving up to Windows Live Movie Maker for your PC.

With Windows Live Movie Maker, you can turn your videos into finely polished movies that you can upload to video-sharing sites like YouTube, copy to and view on smartphones and portable gadgets like iPhones and iPods, or just watch on your desktop or notebook PC. You can also transfer movies you create with Live Movie Maker to a DVD to give to Uncle Art who doesn't have a computer but does have a DVD player hooked up to his TV. Whatever your personal movie distribution preference, making movies with Windows Live Movie Maker is sure to elevate your movie-making skills beyond what you can do with FlipShare.

Running Windows Live Movie Maker

If you're running Microsoft Windows 7 or Windows Vista on your desktop or notebook PC, you'll have no trouble following the steps I show you in this chapter. If you're running Windows XP, though, I'm sorry to report that you won't enjoy the full audience participation experience this chapter offers. The version of Microsoft's free movie-making program (Windows Live Movie Maker, as shown in Figure 11-1), runs on Windows Vista or Windows 7, but not Windows XP.

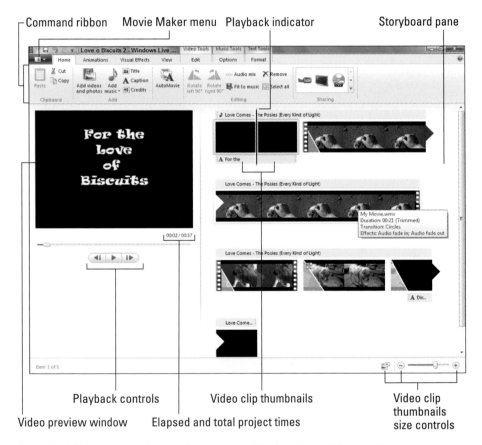

Figure 11-1: Windows Live Movie Maker runs on Windows 7 and Windows Vista.

If you're running Windows Vista or Windows 7 and you don't see Windows Live Movie Maker when you choose Start⇨All Programs⇨Windows Live, steer your Web browser to http://download.live.com/moviemaker, and download and install Windows Live Movie Maker (and any other free Live programs, like Windows Live Photo Gallery, which I show you how to use to import your videos in Chapter 5).

Live versus dead

To add a little confusion to this whole price-of-admissions thing, Windows *Live* Movie Maker is not to be confused with Windows Movie Maker for Vista, which comes preloaded with Vista, nor is it to be confused with Windows Movie Maker for Windows XP, which comes preloaded with Windows XP.

Does that mean you're totally blacklisted from the Windows movie-making business just because you're still attached to Microsoft's technically ancient (but still going strong) Windows XP operating system? Nope.

First, by reading this chapter, you can get an idea of how Windows Live Movie Maker looks, feels, and functions so that you can feel familiar with the program if and when you upgrade

to Windows 7 (or move to a computer running Windows Vista). Second, there's nothing stopping you from using the older but still-useful Windows Movie Maker program.

With the XP and Vista versions of Windows Movie Maker (non-Live? Un-a-Live?) you can turn your video files into complete movies with titles, transitions, sound effects and music, and rolling credits that appear when your movie reaches The End — albeit with fewer of the fancy flourishes Windows Live Movie Maker offers. (Feel free to rename the Start menu shortcut for Windows Movie Maker to Windows Movie Maker Dead if your sense of humor is of the morbid variety.)

Understanding the Windows Live Movie Maker Process

Windows Live Movie Maker (which I now refer to as simply *Movie Maker*) takes a multistep approach to turning you into a self-made movie-making machine. Movie Maker's multistep approach to making movies with video that you record with your Flip includes these steps:

1. Import your recorded video files into Movie Maker's Storyboard pane.

2. Arrange and edit your video files to into a cohesive movie.

3. Save your final movie as a digital video file that you can watch and share.

To begin editing video files and saving movies with Movie Maker, you first copy video files that you recorded on your Flip to your computer's hard drive.

Copying videos to your computer

A few of the most common ways you can copy video files from your Flip camera to your computer include

✔ Run FlipShare and use it to copy your video files to your computer. (I show you how in Chapter 6.)

✔ Choose the Movie Maker Import from Device command, and then use Windows Live Photo Gallery to select, copy, and organize the video files you want to copy to your PC. (I show you how in Chapter 5.)

✔ Drag and drop video files from your Flip's video files storage folder to a folder on your computer's hard drive where you want to store the video files, as shown in Figure 11-2. (I show you how in Chapter 5.)

Figure 11-2: Drag video files from your Flip to a folder on your computer's hard drive.

Whichever method you choose, the desired outcome is the same: Video files saved on your Flip camera are copied to your computer's hard drive. You can then work with those files to do interesting things, like create and edit a movie that you share with others.

I show you the ins and outs of connecting your Flip to your Windows or Mac computer in Chapter 5, and that's where you should go right now if you want to see how to copy video files from your Flip to your computer. When you understand how to do that, you can get on with this editing business covered in the rest of this chapter.

Importing videos into Movie Maker

After you copy video files to your computer's hard drive using one of the methods mentioned in the previous section, you import those video files (and picture files) to Movie Maker's Storyboard pane. You can then arrange

and edit those video files to make the eventual movie of your dreams. Video files you import into the Storyboard pane are referred to as *video clips*, or simply *clips*.

To add video files to the Storyboard pane, follow these steps:

1. **Launch Movie Maker (if isn't already running).**

 To launch the program, you can choose Start➪All Programs➪Windows Live➪Windows Live Movie Maker.

 The Movie Maker main window appears (refer to Figure 11-1).

2. **Click in the Storyboard pane, or click the Home tab and then click the Add Videos and Photos button.**

 The Add Videos and Photos dialog box appears, as shown in Figure 11-3.

Figure 11-3: Browse folders to locate videos you want to import into Movie Maker.

3. **Navigate to the folder containing the video file you want to add to the Storyboard; then click the file you want to add to select that file.**

 To select multiple files, hold down the Ctrl key and click each file you want to add.

 In addition to video files, you can also import picture files into the Storyboard pane. To import a picture file (or multiple pictures) into Movie Maker, simply choose a picture file instead of a video file (or files).

4. Click Open.

Your video files appear in the Storyboard pane, as shown in Figure 11-4.

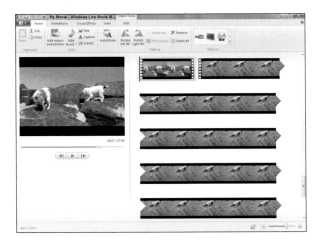

Figure 11-4: Videos you import into Movie Maker appear in the Storyboard pane.

If all you want to do is bang out a movie as quickly and easily as possible and skip all the detailed stuff that immediately follows, feel free to skip ahead to the section "Making a Quick Movie the AutoMovie Way."

Saving, creating, and deleting Movie Maker projects

After you import videos into the Storyboard pane, you're ready to start doing interesting things with those videos to create the movie you have in mind. Movie Maker refers to movies you create as *projects*.

After you import some videos into the Movie Maker Storyboard pane, save your movie project so you can return to it whenever you want without having to reimport your video files again or re-create whatever editing changes you make to your movie project. You can create a new movie project file anytime you want, and you can delete movie project files that you no longer want.

Click the Movie Maker menu (the farthest menu icon to the left) and choose one of the following:

✔ **New Project:** Create a new movie project.

✔ **Open Project:** Open a movie project file you already started and saved.

✔ **Save Project:** Save changes to the movie file you just began or have been working on; Movie Maker prompts you to name your project the first time you save the project.

✔ **Save Project As:** Save changes to your movie project as a new movie project file, leaving the project file you started with as you left it the last time you saved that file.

To delete a movie project, click the movie project icon in whatever folder you stored the file and drag it to the Recycle Bin.

When you delete a movie project file, any original video files that you imported into the movie project are not deleted from your computer's hard drive. Only the movie project file and any changes you made to the videos you imported are deleted, but not the video files themselves.

Viewing and Organizing Videos

As you work with video files (clips) in the Storyboard pane, you'll often want to view and review individual video clips (or every video clip) as you slice and dice your way to your eventual movie. You'll also want to add and remove clips as well as move your clips this way and that to organize them in a way that suits your vision for the story you want to tell with your eventual movie.

Watching and controlling videos

You watch your videos in the video preview window and control how they play using the preview window controls (refer to Figure 11-1). The controls are probably instantly familiar to you, and you use them to do things like play and pause your video, skip forward or backward one frame at a time, and jump directly to a part of your video to start watching at that particular part of the video.

As you watch a video, the video playback indicator in the Storyboard pane moves across the clip thumbnails to show you where what you're watching is located relative to all your other clips, as shown in Figure 11-5.

Playback indicator

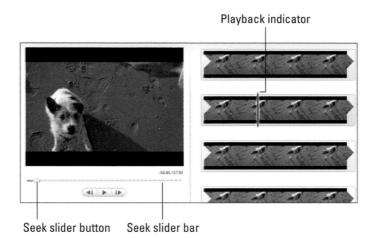

Seek slider button Seek slider bar

Figure 11-5: The playback indicator tracks the location of what you see in the video preview window.

To watch and control your video, use the following controls:

✓ **Play/Pause:** Click to start playing your video, and click again to pause watching your video, or press the spacebar or K to start and stop video playback. The elapsed time beneath the lower-right corner of the video preview window changes to reflect the time location of what you're watching.

✓ **Previous/Next frame:** Click the Previous or Next frame buttons (or J or L) to go backward or forward one frame, respectively. Click either button repeatedly to keep going backward or forward one frame at a time, or press and hold down J or L to quickly advance backward or forward.

✓ **Fast Forward or Rewind:** Click and drag the Seek slider button left or right to move forward or backward through your video; then let go of the mouse when you're at the location you want.

✓ **Playback indicator:** Click anywhere on a clip in the Storyboard to move the playback indicator to that location, or click and drag the playback indicator to the location you want and then let go when you're at that location.

Adjusting display options

To make viewing your videos and storyboard clips easier on the eyes, you can resize the video preview window and the Storyboard pane sections to achieve the best balance between the two. You can also adjust whether the video preview window displays your videos in either standard (4:3) or widescreen

(16:9) format, as well as change the size and number of thumbnails that appear in the Storyboard pane. (The format is based on whether your Flip captures standard [SD] or widescreen high-definition [HD] formatted video.)

To change the sizes of the video preview window and the Storyboard pane, click and hold down the mouse on the vertical divider bar (shown in Figure 11-6) between the video preview window and Storyboard pane. Drag left or right to adjust the main window layout to suit your style; release the mouse when you're satisfied with the layout.

The divider bar

Figure 11-6: Click and drag the divider to resize the two halves of the main window.

To change other Movie Maker display options, click the View tab and then click one or more of the following commands:

- ✔ **Zoom In/Zoom Out:** Increases (Zoom In) or Decreases (Zoom Out) the number of thumbnails that appear for clips. Increasing the number of thumbnails you see is handy if you have a lot of different shots and scene changes in a clip, and decreasing the number of thumbnails you see is helpful if most or all of your clips contain one or just a couple of different shots.

- ✔ **Reset:** Resets the number of Storyboard pane thumbnails to the default number of shots displayed when you began your project.

- ✔ **Thumbnail Size:** Sets how big or small your Storyboard thumbnail icons appear.

✔ **Aspect Ratio:** Offers these choices:

- *Standard* (4:3) for your Flip camcorder model that captures and saves your video files in that format

- *Widescreen* (16:9) for a Flip camera that is one of the high-definition (HD) models that captures and saves your video files in hi-def format

You can also use the Thumbnail Size pop-up menu and the Zoom In/Zoom Out slider control in the bottom-right corner of the main window to change those display options.

Organizing videos

You organize clips by clicking and dragging them around in the Storyboard pane. You can also add new video (or picture) clips, create a duplicate copy of an existing clip or clips, and delete clips.

The basic purpose of organizing your videos is to arrange your clips in an orderly way that follows the flow of the story you want your movie to convey. You might also want to duplicate a certain clip so that it plays a second or third or fourth time in a row — the sort of editing technique that's often used to hilarious effect in blooper videos, like that one of Junior taking his first baby steps and his drawers accidentally falling down, or the clip of Gramps dozing off during dinner and doing a nose dive into his mashed 'taters.

Moving or duplicating a video clip

To move a video clip, follow these steps:

1. **Click and hold down the mouse button on the clip you want to move to select and highlight that clip.**

 To select more than one clip, press and hold the Ctrl key and click each clip you want to select. Release the Ctrl key when you're done selecting all your clips.

2. **Drag the clip in front of or behind the clip where you want to move your clip and release the mouse.**

 A thumbnail of your selected clip appears when you drag your clip in the Storyboard pane, as shown in Figure 11-7. Your video clip appears in its new location.

To copy rather than move the clip, press and hold the Ctrl key when you perform Step 2. A copy of your video clip appears in the new location when you let go of the mouse, and the original clip you selected stays where it was.

Deleting a video clip

To delete a video clip, follow these steps:

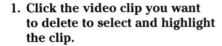

1. **Click the video clip you want to delete to select and highlight the clip.**

 To select more than one clip, press and hold the Ctrl key and click each clip you want to select, then let go of the Ctrl key when you're done selecting all your clips.

2. **Press the Delete key to make your video clip disappear.**

 Note: Deleting a video clip from the Storyboard pane does not delete the original video file stored on your computer's hard drive.

Figure 11-7: Drag a clip to a new location.

Right-clicking a video clip or in the Storyboard pane displays a contextual menu with commands you can choose, as shown in Figure 11-8.

Figure 11-8: Right-clicking a video clip (left) or in the Storyboard white space (right) opens a contextual menu.

Editing Video Clips in a Project

After you import your video files and rearrange your clips in a reasonably cohesive order, you'll probably want to edit your video clips to trim away sections of video that you don't want to appear in your movie. You might

also want to add textual elements, such as a title and credits to the beginning and end of your movie, neat transition effects (fades and dissolves), and maybe a favorite music track that can accompany your movie in the background from beginning to end whenever you watch your movie.

If any of these things sound appealing to you, you've come to the right place in this chapter. In other words, the real show is about to begin.

As you perform the editing-related tasks I write about in this section, you might notice extra tabs that appear above Movie Maker's Ribbon; and that certain Ribbon commands, such as animations and effects, appear (or don't appear) based on the task you're carrying out.

Click the scroll arrows or the More button to the right of the animation and effects icons in the command Ribbon to display a bigger list of all the icons you can click.

Adjusting the size of a video clip

Sometimes a video clip contains a little too much extra footage that you need to trim. Other times, you might have trimmed a little too much from a video clip, and you need to add more footage. In either case, you can adjust the size of your video clip by following these steps:

1. **Click a video clip in the Storyboard pane to select the clip.**

2. **Click the Trim Tool icon on the Edit tab.**

 The Seek slider bar beneath the video preview window changes to the Trim Tool slider bar, with start and end point sliders at either end, which you can drag to trim your clip, as shown in Figure 11-9.

3. **Click and drag the Seek slider bar to the right to the point where you want your trimmed clip to begin; then click the Set Start Point button on the Ribbon.**

The Seek slider button

Figure 11-9: Slide the start and end point sliders to trim your video.

4. **Click and drag the Seek slider bar to the left to the point where you want your trimmed clip to end; then click the Set End Point button.**

5. **Click the Save Trim button.**

 The Trim Tool slider bar closes, the Seek slider bar reappears, and your newly trimmed clip appears in the video preview window, sans the unwanted footage fat that you just trimmed away.

6. **(Optional) Click the Play button to watch your newly slenderized video clip.**

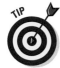

To undo a trim and restore the front and back parts of a video that you trimmed away, choose one of these options:

✐ **Press Ctrl+Z to Undo your trim.**

✐ **Drag the start point trim slider all the way to the left and the end point trim slider all the way to the right; then click the Save Trim button.**

Either way, Movie Maker says "fuggetaboutit" and restores the front and back parts of your clip that were there before you got all scissor-happy with the Trim tool.

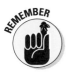

Although trimming a clip makes it appear as if the sections of footage you trim away are gone for good, those trimmed parts still exist. Movie Maker simply hides and ignores them as if they're gone, based on your trim choices. Like with all things that appear to vanish when you're working on a movie project file, the original files you imported into Movie Maker remain intact regardless of how you transform the video clips you play with in the Storyboard pane.

Splitting a video clip in two

Sometimes your video clips contain a number of different shots or scenes that you captured and saved, but now you don't necessarily want them to play in the order you shot them. Perhaps you want to move one of the shots to the front of your movie, or to the end of your movie, or somewhere in between. An easy way to chop a video into smaller and more manageable clips is to split the video clip into two video clips, as shown in Figure 11-10.

You can then split either or both of your newly paired clips into more clips, and then split those split clips into more split clips, and so on, and so on. . . . You get the picture.

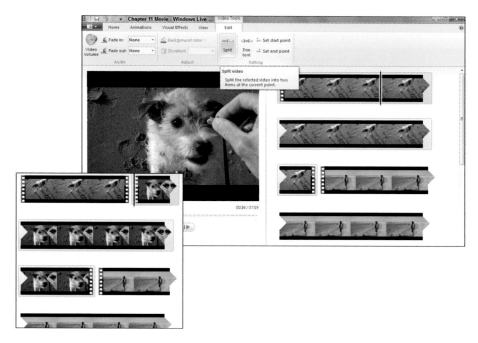

Figure 11-10: Use the Split command to split a single video clip into two.

To split a video clip into two clips, follow these steps:

1. **Select a video clip in the Storyboard pane.**

2. **Click and drag the playback indicator left or right to the point where you want to split your video clip in two.**

3. **On the Edit tab of the Ribbon, click the Split button.**

 Badaboom: Your single video clip is chopped into two video clips. Repeat as necessary.

Adding text titles, captions, and credits

Most movies you watch probably contain some text, and so you might want to add text to your movie. Three common text elements you might want to put in your movie include

- ✓ **Titles,** such as the name of your movie at the beginning of your movie, or titles to indicate parts of a movie (such as Morning, Afternoon, and Night, for instance) — and, of course, a title at the end of your movie to indicate, well, The End

✔ **Captions** to relay dialog in a language other than the one being spoken by your subjects in your movie

✔ **Credits** at the end of your movie to list the cast and crew members who helped you produce your movie (even if your entire team adds up to just you and your dog)

A button for each of those three types of text is located on the Home tab of the Ribbon. Clicking any one of those buttons creates a text field in the video preview window, and the Text Tools/Format tabs on the Ribbon appear, as shown in Figure 11-11.

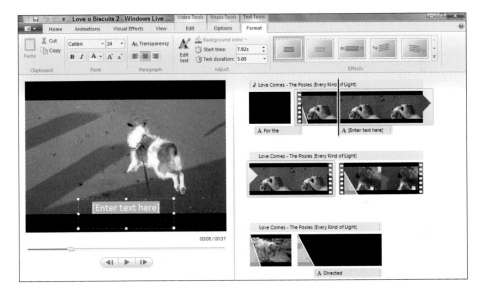

Figure 11-11: Customize your text.

Commands you can choose from the Text Tools/Format tabs include the font name and size you want to appear, transparency controls, timer settings to determine when and how long your text appears, and a bunch of special effects to control the way your text is displayed.

To add title, caption, or credits text to your movie, follow these steps:

1. **Click the clip where you want to add your text.**

 You can drag the playback indicator to the exact position you want.

2. **On the Home tab, click one of the text buttons.**

 A text box appears in the video preview window.

Note: Where the text box appears in the video preview window (and where the text element is positioned in the Storyboard pane) depends on which text command button you click. The Title command positions the playback indicator at the beginning of your movie and puts a big text box in the middle of the preview window, and the Credits command situates the playback indicator at the end of your movie and displays a text box with the word CREDITS already filled in for you.

3. **Type your text and then use the other Text Tool commands to customize your text, as shown in Figure 11-12.**

Note: How much text you can fit on the screen depends on the type of effect you choose. Displaying all the text in the r-e-a-l-l-y long movie title shown in Figure 11-12 is possible only if you choose the Scroll effect, which makes the text appear to "crawl" up from the bottom of the screen to the top, like the opening in *Star Wars*.

Figure 11-12: Customize how your text appears.

Hold your mouse over an effects icon to see an example of how that effect will affect how your text appears. Click the More drop-down button in the bottom right of the Effects area of the Ribbon to display a larger list of the effects you can choose.

In the Storyboard pane, you can do these things with text items:

✔ **View metadata.** Hold your mouse pointer over a text item to display information about it, such as the text itself, the duration time it appears, and any effect you selected.

✔ **Move it.** Click and hold on a text item, and then drag and drop it to another location in the Storyboard pane.

✔ **Edit it.** Double-click a text item to edit the text; the text appears in the video preview pane.

✔ **Delete it.** Click a text item and then press Delete to delete the text item.

✔ **Copy and paste it.** Right-click a text item and choose Copy from the contextual menu that appears. Then right-click a location in a clip and choose Paste from the contextual menu to paste a copy of your text item in that location.

Adding animated transitions

Normally, when you place video clips in a project, those video clips play one after another. Rather than abruptly cutting from one video clip to another, you might want to add transitions (which Movie Maker calls *animations*) that appear between video clips. To add an animation, follow these steps:

1. **Click a clip in the Storyboard pane to select the clip, and then click the Animations tab.**

 The animation gallery of choices appears.

2. **Click the scrollbar arrows or the More button to display all transition options. Then click an animation effect icon to apply that animation to your clip, as shown in Figure 11-13.**

 Your chosen animated effect is displayed in the video preview window.

Figure 11-13: Apply an animation effect to your transition between clips.

3. **(Optional) Click the Duration field and type in the length of time you want your animation to play, or click the drop-down button to choose a preselected duration time.**

4. **(Optional) If your selected clip is a photograph, the icons in the Pan and Zoom section of the Ribbon become active, and you can click one to add that animated transition effect to your selected photo.**

Adding special effects

You can add special visual effects to your clips to enhance your clips, or just to make them look weird. Choosing the Sepia Tone visual effect, for instance, can make your clip look like it was shot in the Old West era, while adding the Mirror effect can turn your clip upside down or the other way around.

To add a visual effect to your video, follow these steps:

1. **Click a clip in the Storyboard pane to select the clip, and then click the Visual Effects tab.**

 The Visual Effects gallery of choices appears.

2. **Click the scrollbar arrows or the More button to display all visual effects options; then click a visual effect icon to apply that effect to your clip, as shown in Figure 11-14.**

 Your chosen visual effect is displayed in the video preview window.

3. **(Optional) Click the Brightness icon on the Ribbon and then adjust the slider left or right to increase or decrease how bright (or dim) the clip looks, as shown in Figure 11-15.**

Figure 11-14: The Sepia effect can make your video look ancient.

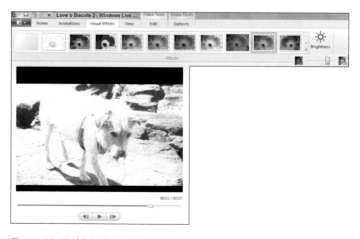

Figure 11-15: Slide the brightness slider to lighten or darken your clip.

Adding audio files

To make your movie more interesting, you can add audio files that play background music to complement the mood of your movie. You can also add sound effects to match the action as it unfolds in your movie — a car honking, say, or maybe a telephone ringing. To add an audio file to a project, follow these steps:

1. **Click the Home tab; then click the Add Music button to display the Add Music drop-down menu, as shown in Figure 11-16.**

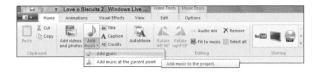

Figure 11-16: Add a song track or sound effect file to your movie.

2. **Choose one of the following:**

 • *Add Music* to add a song or other audio track that plays during your entire movie (providing your song is as long or longer than the entire length of your movie)

 • *Add Music at the Current Point* if you want to add a song or just a sound effect, such as a dog barking, at the current location of the playback indicator

 The Add Music dialog box appears.

3. **Navigate to the folder containing your music track or other audio file; click the file you want to add and then click the Open button.**

 The Music Tools tab appears and a music item named after your selected audio file appears in the Storyboard pane.

4. **(Optional) Use the following options to adjust how and when your audio file plays (see Figure 11-17):**

 Figure 11-17: Adjust how your audio file plays.

 • *Fade In* and *Fade Out* to adjust the speed with which your music fades in and out (None, Slow, Medium, Fast).

 • *Set Start Time*, *Set Start Point*, and *Set End Point* to adjust when your audio file starts playing and when it ends playing, based on where you drag the Seek slider beneath the video preview window. Then click the button that does one of those three things.

You can do things with audio items in the Storyboard pane, such as

- ✔ **View metadata.** Hold your mouse pointer over an audio item to display information about the item, such as the name and duration of the audio file.

- ✔ **Move it.** Click and hold an audio item, and then drag and drop it to another location in the Storyboard pane.

- ✔ **Delete it.** Click an audio item and then press Delete to delete the audio item.

- ✔ **Copy and paste it.** Right-click an audio item and choose Copy from the contextual menu, and then right-click a location in a clip and choose Paste from the contextual menu to paste a copy of your text item in that location.

Making a Quick Movie the AutoMovie Way

Want to skip all the editing nitty-gritty associated with transforming your videos into a final movie and cut right to the chase? Thanks to Movie Maker's AutoMovie feature, you can quickly and easily transform one or more video clips into a full-on movie, complete with an opening title, music that plays in the background as you watch your movie, and a closing title that displays The End when your movie finishes playing.

To create a quick movie using the AutoMovie feature, follow these steps:

1. **Copy your recorded video file (or files) from your Flip to your computer. Then import the video file you want to include in your movie into Movie Maker.**

 Refer to the related earlier sections in this chapter if you're unsure how to copy and import your video files to your computer and into Movie Maker.

 Your video file (or files) appear in the Storyboard pane (refer to Figure 11-4).

2. **Click the Home tab and then click the AutoMovie icon on the Ribbon.**

 A dialog box appears, asking whether you want Movie Maker to help you make a movie quickly, as shown in Figure 11-18.

Figure 11-18: The AutoMovie feature walks you through quickly creating a complete movie.

3. **Click OK.**

 A dialog box appears, asking whether you want to add a song to your movie.

4. **Click Yes if you want to add an audio file to your movie, or click No if you don't want to add an audio file. Then skip ahead to Step 5.**

 The Add Music dialog box appears.

5. **Navigate to the folder containing your music track or other audio file and click the file you want to add, and then click the Open button.**

 Movie Maker adds your selected audio file as an audio item in the Storyboard pane and displays a message saying that your AutoMovie is complete.

Voilà! You're a movie maker! Click the Play button beneath the video preview window to watch your movie.

You can make simple changes to your movie, like double-clicking the My Movie and The End title text items in the Storyboard pane to change the text that appears, or double-clicking the audio item in the Storyboard pane to adjust how your song plays. You can also play around with Movie Maker's animation and visual effects to add even more features to your movie.

If you're happy with your AutoMovie just the way it is, you can show your movie to others by saving your movie as a file that you can burn to a DVD, send as an attachment in an e-mail, or upload to YouTube. I show you how to save and share your movie in the remaining sections of this chapter.

Saving and Sharing Your Movie

The point of editing your video and audio clips in a Movie Maker project is to create a polished final movie. With Movie Maker, you can save your project as a movie file to view on a computer using Windows Media Player or another video-playing program, or burn that movie file to a DVD that you can play on another computer or DVD player connected to a television.

You can also save your movie in a format that's especially suited for watching on a portable media playing device, such as Microsoft's Zune players and certain smartphones. And you can save your movie in a format that you can easily upload to YouTube or another Web-based video-sharing Web site.

Whichever way you choose to share your final movie, you must first save your movie project file as a playable movie file, which you can then share any number of ways.

Saving a project as a movie file

You might want to save your Movie Maker project as a playable movie file so you can burn it to DVD later (using Windows DVD Maker), or give a copy to someone who wants to watch your movie on their computer.

To save a Movie Maker project as movie file, follow these steps:

1. **Click the Movie Maker menu and choose Save Movie to display the Save Movie submenu, as shown in Figure 11-19.**

2. **In the Save Movie menu that appears, choose the type of movie file you want to save based on how you intend to share the movie file.**

 What you choose here determines a number of attributes about your saved movie file, such as the video quality, definition format (4:3 standard definition or 16:9 high-def), and actual file size of the saved video file.

Figure 11-19: Choose how to save your movie file.

 Choosing one of the High-Definition options, for instance, creates the highest-quality movie file to watch but also the largest sized file when it comes to how much space the video file will use up on your computer's hard drive.

 Choosing the E-mail or Portable Device option creates a lower-quality movie file that takes up less storage space on your computer's hard drive (and on your intended recipient's hard drive), or less space on a portable player device.

3. **Type a name for your movie.**

 And make a mental note of where you're saving the file.

4. **Click OK.**

 A progress dialog box appears while Movie Maker saves your movie file in the folder of your choosing. The dialog box closes when Movie Maker is done saving your file.

E-mailing a movie file

To e-mail a movie file you saved using the For E-mail or Instant Messaging menu choice, right-click your saved movie file and then choose Send To⇨ Mail Recipient. Windows opens a blank e-mail message using your preferred e-mail program (such as Outlook).

You can also share your movie file by dragging and dropping it into a new e-mail message or into an instant messenger chat window.

If you're using a Web-based e-mail service, such as Yahoo!, Gmail, or Hotmail, compose a new e-mail message and click the Attachment button or icon and select your saved movie file to upload your file into your new mail message.

Burning a movie to DVD with Windows DVD Maker

Burning a copy of your movie file to a DVD disc using Windows DVD Maker allows you to create a disc you can give or send to other folks so they can watch your movie using their computer or DVD player connected to their television.

Windows DVD Maker is included with Windows Vista Home Premium and Windows Vista Ultimate editions; and with Windows 7 Home Premium, Windows 7 Professional, Windows 7 Enterprise, and Windows 7 Ultimate editions. If your version of Windows doesn't come with Windows DVD Maker, you can download a DVD burning program for free, like Free Movie DVD Maker (www.sothink.com/product.htm#free), or for a price, like Nero Burning ROM (www.nero.com).

To burn a movie file to a DVD disc using Windows DVD Maker, follow these steps:

1. **Click the Movie Maker menu and choose Save Movie⇨Burn a DVD. Type a name for your movie file in the Save Movie dialog box that appears, and then click OK.**

 A progress dialog box appears as Movie Maker saves your movie file in the folder of your choosing, and then the dialog box closes after Movie Maker is done saving your file. Windows DVD Maker program launches, and its window appears.

2. **Double-click the date in the DVD Title text field and type a name for your DVD.**

3. **(Optional) Click the Options link in the bottom right to open the DVD options window and click any options you want to change.**

Click the How Do I Change My DVD Settings? link to open a help window that describes these options.

4. **Click Next to advance to the Ready to Burn DVD window.**

5. **(Optional) Click the scroll bar to browse different menu styles for your DVD, and then click a style to select it, as shown in Figure 11-20.**

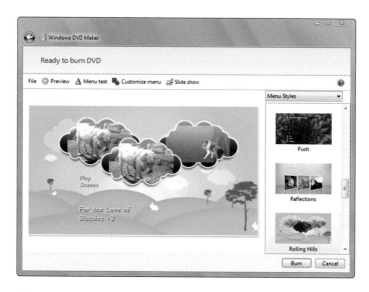

Figure 11-20: Customize how your DVD menu will look.

6. **(Optional) Click the Menu Text, Customize Menu, or Slide Show buttons to further adjust or customize those elements of your DVD.**

7. **Click the Burn button.**

A dialog box appears, prompting you to insert a blank DVD.

8. **Insert a blank DVD into your computer's DVD drive.**

9. **If the Windows AutoPlay dialog box appears, click the Close button to close the AutoPlay dialog box.**

10. **If a dialog box appears, warning that your DVD already has content on it, click Yes if you want DVD Maker to overwrite any content on the disc with your new DVD movie, or click No if you want to eject the DVD and insert another DVD.**

A progress dialog box appears while Windows DVD Maker burns your movie file to disc, followed by another dialog box that lets you know when your DVD is ready.

Uploading a movie to YouTube

One way to show off your movie is by uploading it to the Web so that others can watch it online or download it and watch it whenever they want. The most well-know (and well-trafficked!) video-sharing site is YouTube.

After setting up a YouTube account (www.youtube.com), you can upload a video from Movie Maker to YouTube by following these steps:

1. **Click the Movie Maker menu and choose Publish Movie⇨Publish on YouTube.**

2. **In the YouTube sign-in dialog box that appears, enter your username and password and then click the Sign In button.**

3. **In the Publish on YouTube dialog box that appears (see Figure 11-21), type in the required fields and choose the appropriate selections (like choosing the category that matches your movie, and whether you want to keep your movie private, or share it with the world at large).**

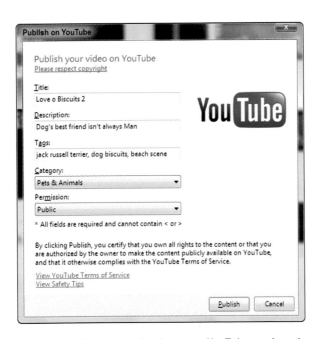

Figure 11-21: Type in details about your YouTube movie and choose your sharing options.

4. **Click the Publish button.**

 A progress dialog box appears as Movie Maker saves your movie file. A processing dialog box follows as Movie Maker uploads your movie file to YouTube.

5. **When the completion dialog box appears, telling you that Movie Maker has finished uploading your movie file to YouTube, click the View Online button.**

 Your Web browser opens to your YouTube Web page.

Want to upload your movie to your Facebook profile or your Google Picasa Web page or another Web-based site or service? No problem. Click the Movie Maker menu and then choose Publish Movie⇨Add a Plugin. Movie Maker launches your Web browser and opens the Windows Live Photo & Video Blog Web page. The Windows Live Photo & Video Blog is where you can download plug-in file installers that you can run to give Movie Maker the ability to upload your Movie Maker movies on other Web sites besides YouTube.

Part V
The Part of Tens

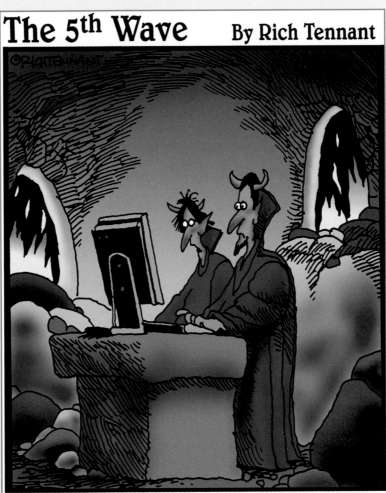

In this part . . .

1 n this part, co-author Drew Davidson takes the starring role by opening your eyes to a number of shooting and editing issues and concepts. Drew provides simple shooting tips for improving the quality of videos you capture, and practical editing tips to help inform your decision process when cutting together (and cutting out!) your clips into a bigger-picture movie.

charlie072005

charlie072005b

charlie072005a

Chuck

Ten Super Shooting Tips

*Y*our Flip is probably the easiest-to-use video camcorder in the world. Because your Flip doesn't take itself too seriously, neither should you. Point and shoot to your heart's content, and let your Flip worry about adjusting the light and focus. Because you can't adjust any of those settings the way you can with more "serious" video cameras, you're free to concentrate on your subject at hand.

Just remember to keep your hand as steady as possible when you shoot because your Flip lacks any kind of image stabilization feature like many other camcorders have. Helpful info like this is just one of the tips you'll find in this chapter that aims to help you make the most of your Flip video shooting sessions.

Change layout

14 Aug 2003 **Footage**
 #8187440°

Shoot Happens

Size matters. In the case of your Flip, small is good. Tucking your Flip into your pocket or backpack means that you're always armed and ready to capture video whenever you want, wherever you want. You never know when a great shooting opportunity will present itself. Unique encounters with interesting characters. Celebrity sightings. A less-than-virtuous act in progress that you show to authorities to help bring a suspected perpetrator to justice. Animal behavior. Acts of nature. The sky's the limit.

Here's an interesting case and point: In 2003, when Drew (co-author) was living in New York City, he always carried what was at the time the smallest video camera you could buy. One day, he found himself trapped underground in a subway car at the start of what would become the very big, very long blackout you might recall seeing in the news. Low and behold, a shooting opportunity! After the fear subsided, Drew whipped out his camcorder and started shooting, capturing events as they unfolded, as you can see in Figure 12-1.

Figure 12-1: Spontaneous shooting for fun — and profit!

From the evacuation of the dark subway tunnel with scores of fellow straphangers, to hoofing his way across the Queensborough Bridge with millions of suddenly self-reliant urbanites, to catching the final battery-draining shots of the Manhattan skyline as night descended, eerily enveloping the island in nearly complete darkness, Drew captured it all on video. And while his spontaneous afternoon and evening of unexpected shooting was fun and exciting, it also turned out to be quite lucrative: Getty Images (the stock photo and film agency; www.gettyimages.com) added Drew's footage to its video catalog, and it wasn't long before royalty checks from sales of the videos started rolling in.

Brace Yourself

The Flip's greatest strength — its small size and lightness — is also its greatest weakness. Simply put, the lack of stability is the Flip's Achilles heel. Although many camcorders have built-in stabilizers to help make your shots look smoother, your Flip does not (not yet, anyway). That means you have to brace your Flip as best you can to minimize shaky shots. One simple trick is to hold your Flip with both hands while pressing your elbows firmly to your midsection. Instant stabilizer action, which means smoother-looking shots. You can also take advantage of your environment to stabilize your shots. Get creative. While shooting, leaning against a wall, a piece of furniture, a fire hydrant, or the shoulders of a really solid friend can all work to your stable-shooting advantage. Keep in mind that zooming in and out may increase shakiness, so use the zoom feature only when it's absolutely critical to capturing your shot.

Sometimes, of course, unstable footage is, stylistically speaking, acceptable and even exciting — the sort of thing you see in documentaries or cheaply shot box-office breakthrough films (such as *El Mariache* and *The Blair Witch Project*). So what might have nauseated and disturbed audiences in the early 20th century is now imbued with an almost subconscious sense of truthfulness and reality. If that's the look you're shooting for, by all means, go for it. Just keep in mind that, like human nature, there's a fine line between artistically stylistic instability (see the "Keep It Moving" section, later in this chapter, to see what we mean), and indecipherable gobbledygook.

Seek Stabilizing Relationships

Another option for achieving more stable shots is to use a tripod or monopod attached to the base of your Flip. (See Chapter 15 for a few favorite picks.) Compact and lightweight tripods are generally better suited for capturing spontaneous shots than heavier, high-end tripods. And because spontaneity is perhaps your Flip's greatest virtue, using a monopod can be an especially well-balanced match for your Flip. In case you're not familiar with *monopods,* they're basically a single (mono-) pole that screws into the tripod mount on the underside of most every camera or camcorder. Then you stand the pole on the ground and steady it with your hand rather than let it stand up for itself the way a three-legged tripod does.

In some locations — such as museums, places of worship, and government buildings — monopods are not welcome. So consider acquiring a collapsible monopod that you can keep stowed in your bag, or leave your monopod at home if you're visiting any of those locations. You may also want to call ahead to ask whether your monopod can accompany you on your visit to one of those or other possibly monopod-unfriendly locations.

You can easily make your own monopod. All you need is a broom handle (or a length of dowel you can pick up for a few bucks at any home improvement store), and a couple of really thick rubber bands to bind your Flip to the pole. Instant monopod.

Shoot with an Eye on Editing

Shooting with an eye on telling your eventual story — from beginning, through the middle, 'til The End — will make for a finer final cut. Storytelling is the ultimate goal of any movie-making project, after all, even the most basic of home movies. When capturing video, keep these points in mind:

- **Get a variety of shots.** A little of this, a little of that, and from every angle. Close-ups. Wide shots. High shots. Low shots.

- **Be inventive, and don't be shy.** The Flip's small size generally minimizes self-consciousness on your part as well as your intended (or intentionally unaware) subject. You can get up close and personal, so don't be afraid to.

- **Exercise prudence.** Your Flip camera isn't nearly as intimidating as a big movie camera or even a standard camcorder, so you can easily get in someone's face for close-ups. (See the preceding bullet.) However, some people won't want you to capture them on video, for personal or business-related reasons, so always be polite and considerate.

And don't forget about copyright infringement. If you intend to use someone's personage for commercial reasons, you must have that person's explicit permission.

To learn more about the digital video copyright and permission matters that you should know about when shooting video, check out the article "Digital Video . . . Copyrights and Permissions" at `http://bit.ly/pandc`.

- **Plan your shots in advance.** If you're shooting with the intention of creating a dramatic feature or documentary, having a plan — and maybe even your own shooting script — will help ensure that you capture all the shots you'll need when you return to the editing suite (that is, your computer) and you begin cutting together your movie.

As an example, consider how you would plan to shoot your best friend's wedding. Instead of randomly shooting video, keep the bigger-picture story in mind while you record the day's events. From morning preparations, to candid comments from family and friends, to the obvious main event, and to the "¡Adiós, amigos!" and cleanup aftermath, shooting your video as if you're telling a story with words and moving pictures will make for a more moving and memorable movie after you pull it all together.

Sound (track) Advice

Keeping an ear tuned to sound matters can benefit your eventual movie in a meaningful way. In fact, sometimes it's the audio that steals the show and makes your movie funny or entertaining. Be aware of your environment and listen for interesting sound opportunities that can enrich the videos you capture. Although you can add sound effects and music in the editing process, it never hurts to capture great commentaries or reactions, monologues, and conversations that the involved parties don't necessarily know you're recording to video — but keed in mind that any surreptitious shooting you do should be the kind that the person you're recording wouldn't mind once you let them in on the gag. Otherwise, you can find yourself in a heap of trouble if you record someone or something you shouldn't record without proper permission.

Light Up Your Life

The basic tip here is lighten up! Not you — your shots. Make sure what you're shooting is well lit so your shots are clear. Achieve this lightness of being by paying attention to your surroundings:

- ✔ Turn some lights on or off.
- ✔ Move lights to balance how your subject appears in the viewfinder.
- ✔ Draw the curtains if there's too much light on your subject.

The most basic thing to avoid is pointing your Flip directly into the light source. Your Flip automatically adjusts brightness based on the brightest and darkest points in your shot. If you shoot directly into a light source (including the sun), your Flip will darken everything surrounding the bright spot to the point of nearly blinding you to whatever else you want to capture in your shot.

Listen Up!

Your Flip has surprisingly strong sound-capturing capabilities, providing that you're close to your subject or whatever other sound source you want to capture with your video. If a big moment in a shot you want to capture depends heavily on hearing what's being said (for instance, the exchanging of vows during a commitment ceremony), let the audio you want to capture dictate where you position yourself with your camera. (Okay, it's not like you can crouch behind the couple during their ceremony, but you can seat yourself near speakers that may be set up so the whole room can listen in.)

And don't forget to be mindful of your own noise-making when you shoot — satisfied sighs or allergy inducing sniffles and other bodily sounds can really distract the viewer from your handiwork. In other words: Silencing yourself is golden!

Framed!

Ah, the language of framing: foreground, background, z-axis, low-angle, high-angle, wide-shot — and don't forget every Oscar-winning actor's or actresses' most cherished shot of all, the close-up. Call them by those names or call them whatever you want. Most of the time, how you frame your shots comes naturally and instinctively. If your intended audience will watch your videos on YouTube, Facebook, MySpace, or other Web-based service, your videos will probably play on a computer screen rather than a widescreen HDTV. As such, try to make sure your subject is squarely in frame and try to fill your frame as fully as possible. A band shot from hundreds of feet away might be interesting in and of itself, but worming your way to the front to capture the event up close and personal can wow your eventual viewing audience nearly as much as you were when you got the shot in person!

Keep It Moving

Move the camera. This advice might seem to contradict the advice in the "Brace Yourself" section, earlier in this chapter. However, with some experimentation and practice, moving your highly portable Flip can produce fun and exciting results that capture a moment or an experience in a way your audience can really feel (even if sometimes that feeling is nausea).

Grip your Flip with all your might and capture that rollercoaster ride. Strap your Flip to your bike helmet and record your bumpy descent down the mountainside. Point your Flip out the window while you railroad your way across the countryside. And maybe even try lowering your Flip out the window to capture video of your dog making nice with the just-out-of-reach squirrel shouting from his place on the hanging tree branch.

As You Like It

What truly moves and affects you will move and affect others. Bottom line: Shoot what interests you. Go on a shooting walkabout. Think of anything and everything as potential subjects you can shoot, but don't overthink your shots. Just shoot. If you love what you see, shoot it, and chances are that others will love seeing what you shoot, too.

13

Ten Excellent Editing Tips

In This Chapter

▶ Cut the bad bits

▶ Easy does it

▶ Edit for story

▶ Slave to the rhythm

▶ Viewer consideration

▶ Cuts and crossfades

▶ Affecting effects

▶ Graphically speaking

▶ Two-track mindset

▶ Experimentation is encouraged

*S*hooting anything and everything that interests you with your Flip without worrying about capturing the perfect shot every time is what makes your Flip such a great and liberating creative partner. As you can read in Chapter 12, the things you find really interesting and capture on video will probably be interesting to others, but that doesn't mean all 20 minutes of that waterfall you recorded and burned to a DVD is interesting. Sure, a few seconds or even a minute or two can be interesting to watch, but 20 minutes? Probably not — especially because the little kid who was standing nearby and out of frame cried through the entire video.

In this chapter, find some choice editing tidbits that can hopefully help you make editing choices (and cuts) that result in more interesting-to-watch video shots and longer-length movies.

Cut the Bad Bits

This is the essence of editing. Although you want to tell a story to your viewers, you also don't want to lose their interest. Shorter really is almost always sweeter. Trim your clips down to the best parts and piece those trimmed clips together with other nicely trimmed clips to tell your story. You might find yourself shooting way more footage than you actually need or want because your Flip is easy to take with you wherever you go. That's fine, but keep your audience in mind when it comes time to review those lengthy clips you shot — then trim them down to nicely sized pieces that you can show on their own or as part of your bigger-picture story.

Easy Does It

Although making liberal cuts can help to keep your clips and overall movie more interesting, that doesn't necessarily mean you need to cut too much or too fast. Sure, short, fast cuts tied together can achieve a frenetic music-video style that's suited for that kind of movie, but it doesn't work as well for straightforward storytelling or even family videos. As the great feature film editor Walter Murch points out, if you were touring Rome and you had a tour guide who never paused on some of the great sites you were seeing to let you really appreciate and learn more about what you're looking at, you probably wouldn't have the most memorable time. Give your shots the time they need to convey to the viewer what matters most in the clip while being careful not to dilly-dally too long after what matters most has served its purpose.

Edit for Story

Edit to tell a story. For instance, if you're shooting a friend's wedding, try to capture a shot of the sun rising. Or Dad taking out the trash and tying his tie. Aunt Edna commenting on all of her years as a single gal, and cousin Jon extolling the shared joy of 50 years of marriage with his lovely wife Nicole. Set up things and build the characters and setting to create a context and contrast for the main event. Build up to the big moment: the vows and the kiss that seals the deal. This creates tension and suspense. Lastly, create a feeling of resolution, perhaps the young ones falling asleep in their chairs at the reception after the newlyweds have driven off into the sunset. And come to think of it, a closing shot of the sunset can make for the picture-perfect ending to a lovely day.

Slave to the Rhythm

Editing to a rhythm is a fun style that can become an obsession if you don't watch out. Editing to the rhythm basically means timing your edits to the beat of a song that plays during the shot or the entire video. At the same time, this style can be especially challenging if action occurring in a shot appears to also create "a beat," possibly conflicting with the edit or cut acting as your marker of time.

Well-executed editing to the rhythm can often depend on the music you select, be it a hard-driving repetitive beat, or a jazzy and syncopated complex beat. The best way to judge whether the style is working for a particular clip is to gauge whether you feel an emotional impact as you watch the video. If you're feeling something interesting as you watch, chances are your audience will respond the same way, too.

As for the music you use in your video, you're free to use any song you want for your own viewing pleasure, but you can't upload those videos to Facebook or YouTube without the express permission of the artist whose song you used in your video. To learn more about copyright and permission matters and why they matter to you even as an armchair movie-maker, check out the article "Digital Video...Copyrights and Permissions" at `http://bit.ly/pandc`.

Viewer Consideration

If you're creating a video or movie that will play in the background at some event or party or ceremony, try to match your creation to the content of the situation. On the other hand, you can do the exact opposite by contrasting your content with the theme of the gathering. For instance, you can really liven up a 50th anniversary party if your background video features slide-show stills of the happy couple when they were babies, and footage of baby animals or puppies and kittens.

Whether you opt for the match-up or mix-it-up approach, using crossfades to transition from one picture or video clip to the next works perfectly for most settings where your video or movie will play in the background over the course of a gathering.

Cuts and Crossfades

How you open and close your movie, as well as how you progress from one shot to the next, comes down to making creative decisions. When you open your movie, depending on your software, you might want to go from black to your opening shot. A straight cut from black is often jarring, but a fade can ease the viewer into your movie. If you're using a fancier transition, consider your content and try to match your transition choice to complement your subject. In movie-making lingo, this is called being "motivated." For example, a transition of blowing leaves works as a nice opening for shots of children running through a pumpkin patch to pick a pumpkin, and an iris transition in the shape of a star is perfect for your movie celebrating the 4th of July. As for riddling your movie with tons of transitions, consider writing the adage "less is more" on a sticky note that you keep nearby when you're editing. No truer words.

Affecting Effects

Effects are always fun to play with to change the look of your shots. Simple effects, like turning your footage into black and white, can give your subject a timeless or artsy feel. Slow motion is another effect that can add an artsy feel to your movie. Don't overdo, though: Going crazy with effects and using too many of them can be distracting or downright irritating, so use them sparingly! As with the previous tip, sticking to the adage "less is more" is something especially fitting when it comes to using (and abusing) special effects in your movies and short videos.

Graphically Speaking

Graphics, still images, and titles go a long way to rounding out your video, giving them a more professional look and feel. FlipShare, iMovie, Windows Live Movie Maker (see Parts III and IV for more about these programs), and most other video-editing programs let you create titles to open your movie, close your movie, and roll credits. Titles are also useful for conveying information during a movie. For instance, you could add a title with the name of the season if your movie unfolds over the course of a year. Or add titles with information that conveys a location or a person's name. (These are known as *intertitles*.)

If you want to achieve the look and feel of an old silent movie, titles can convey your characters' dialog, or they can achieve the same result when used to translate your subject's language and appear as subtitles. Mixing

graphic or photograph still images, such as a scanned wedding announcement or a baby photo of a friend, can enrich your moving picture. Many programs let you "pan and scan" your graphics (also known as the Ken Burns Effect), which makes them feel as if they were real footage.

Two-Track Mindset

Thinking in terms of two audio tracks when you edit your video or movie means that you can augment the recorded voices and other sounds you captured in your video footage with a music track or recorded narration you add to your video when you edit the video. FlipShare offers basic controls to choose whether your music or other extra audio file you add plays louder or softer than the audio in your video, and iMovie and Windows Live Movie Maker offer greater flexibility and control over how loudly (or softly) your different sound sources play.

Experiment, Experiment, Experiment

Get to know your video-editing program and the many tools it offers for editing your creations. Even a simple program like FlipShare has some features you can use to make your videos look (and sound) better than if you didn't use those features, such as adding titles and credits or choosing a music file that plays in the background as your video plays on the screen. After you decide what software you want to use to edit your movies (and basics are given in this book for several systems), delve deeper into the program's manual or online help — or better yet, buy a *For Dummies* book to show you how to really make the most of your preferred video-editing program! And always remember that it's okay to try new things with your videos because the Undo command (Ctrl+Z/⌘+Z) is always just a press away.

Index

Internet

Blogging For Dummies,
3rd Edition
978-0-470-61996-4

eBay For Dummies,
6th Edition
978-0-470-49741-8

Facebook For Dummies, 3rd
Edition
978-0-470-87804-0

Web Marketing
For Dummies,
2nd Edition
978-0-470-37181-7

WordPress
For Dummies,
3rd Edition
978-0-470-59274-8

Language & Foreign Language

French For Dummies
978-0-7645-5193-2

Italian Phrases
For Dummies
978-0-7645-7203-6

Spanish For Dummies,
2nd Edition
978-0-470-87855-2

Spanish For Dummies,
Audio Set
978-0-470-09585-0

Math & Science

Algebra I For Dummies,
2nd Edition
978-0-470-55964-2

Biology For Dummies,
2nd Edition
978-0-470-59875-7

Calculus For Dummies
978-0-7645-2498-1

Chemistry For Dummies
978-0-7645-5430-8

Microsoft Office

Excel 2010 For Dummies
978-0-470-48953-6

Office 2010 All-in-One
For Dummies
978-0-470-49748-7

Office 2010 For Dummies,
Book + DVD Bundle
978-0-470-62698-6

Word 2010 For Dummies
978-0-470-48772-3

Music

Guitar For Dummies,
2nd Edition
978-0-7645-9904-0

iPod & iTunes
For Dummies,
8th Edition
978-0-470-87871-2

Piano Exercises
For Dummies
978-0-470-38765-8

Parenting & Education

Parenting For Dummies,
2nd Edition
978-0-7645-5418-6

Type 1 Diabetes
For Dummies
978-0-470-17811-9

Pets

Cats For Dummies,
2nd Edition
978-0-7645-5275-5

Dog Training For Dummies,
3rd Edition
978-0-470-60029-0

Puppies For Dummies,
2nd Edition
978-0-470-03717-1

Religion & Inspiration

The Bible For Dummies
978-0-7645-5296-0

Catholicism For Dummies
978-0-7645-5391-2

Women in the Bible
For Dummies
978-0-7645-8475-6

Self-Help & Relationship

Anger Management
For Dummies
978-0-470-03715-7

Overcoming Anxiety
For Dummies,
2nd Edition
978-0-470-57441-6

Sports

Baseball
For Dummies,
3rd Edition
978-0-7645-7537-2

Basketball
For Dummies,
2nd Edition
978-0-7645-5248-9

Golf For Dummies,
3rd Edition
978-0-471-76871-5

Web Development

Web Design
All-in-One
For Dummies
978-0-470-41796-6

Web Sites
Do-It-Yourself
For Dummies,
2nd Edition
978-0-470-56520-9

Windows 7

Windows 7
For Dummies
978-0-470-49743-2

Windows 7
For Dummies,
Book + DVD Bundle
978-0-470-52398-8

Windows 7 All-in-One
For Dummies
978-0-470-48763-1

Available wherever books are sold. For more information or to order direct: U.S. customers visit www.dummies.com or call 1-877-762-2974.
U.K. customers visit www.wileyeurope.com or call (0) 1243 843291. Canadian customers visit www.wiley.ca or call 1-800-567-4797.